Digital Portrait Photography

For three J's and an M

Digital Portrait Photography

ART, BUSINESS & STYLE

— STEVE SINT —

LARK BOOKS

A Division of
Sterling Publishing Co., Inc.
New York / London

Editor: Matt Paden
Book Design: Sandy Knight, Hoopskirt Studio
Cover Design: Thom Gaines

Library of Congress Cataloging-in-Publication Data

Sint, Steve, 1947-
 Digital portrait photography : art, business, & style / Steve Sint. -- 1st ed.
 p. cm.
 Includes index.
 ISBN 978-1-60059-335-2 (PB with flaps : alk. paper)
 1. Portrait photography. 2. Photography--Digital techniques. I. Title.
 TR575.S56 2009
 778.9'2--dc22
 2008019091
10 9 8 7 6 5 4 3 2 1

First Edition

Published by Lark Books, A Division of
Sterling Publishing Co., Inc.
387 Park Avenue South, New York, N.Y. 10016

Text © 2009, Steve Sint
Photography © 2009, Steve Sint unless otherwise specified
Illustrations by Sandy Knight, © 2009, Lark Books
Cover Photos: Front Cover: © Len DePas / Back Cover Photos: © Steve Sint
 Front Flap: © Steve Sint (top), © Louise Botticelli (bottom)
 Back Flap: © Jan Press (three images: the couple; businesswoman; and family portrait), © Steve Sint (model with arms crossed)

Distributed in Canada by Sterling Publishing,
c/o Canadian Manda Group, 165 Dufferin Street
Toronto, Ontario, Canada M6K 3H6

Distributed in the United Kingdom by GMC Distribution Services,
Castle Place, 166 High Street, Lewes, East Sussex, England BN7 1XU

Distributed in Australia by Capricorn Link (Australia) Pty Ltd.,
P.O. Box 704, Windsor, NSW 2756 Australia

If you have questions or comments about this book, please contact:
Lark Books
67 Broadway
Asheville, NC 28801
(828) 253-0467
www.larkbooks.com/digital

Manufactured in China

ISBN 13: 978-1-60059-335-2

For information about custom editions, special sales, premium and corporate purchases, please contact Sterling Special Sales Department at
800-805-5489 or specialsales@sterlingpub.com.

acknowledgements

It's impossible to write a book of this scope without getting help, ideas, and input from friends and coworkers.

With that thought in mind, the following acknowledgements and thanks are in order:

Botticelli Portrait Studio, *botticelliportraits.com,* 631-470-1358

Canon U.S.A., Inc., *usa.canon.com,* 800-652-2666

Filis Forman, makeup artist, *filisforman.com*

Jan Press PhotoMedia, Livingston, NJ, *janpress.com,* 973-992-8812

Jim Morton / Dyna-Lite, Inc, *dynalite.com,* 908-687-8800

Lindsay Silverman, Senior Technical Manager, Nikon Inc., *nikonusa.com*

Liz & Joe Schmidt Photography, Inc., *lizjoephoto.com,* 516-887-7900

Phil Bradon, *macgroupus.com,* 914-347-3300

Photography by Len DePas, *lendepasphoto.com,* 202-362-8111

Sallee Photography, *saleephotography.com*

Michael Zide, *michaelzide.com,* 413-256-0779

• • •

A special thanks to Radek — for always making sure

there's a fresh card in my camera and a whole lot more.

• • •

A special thanks to Jenise, Nadia, Carol, and Randi — for always making sure

I know where I have to aim my cameras next.

• • •

A special thanks to K for being a careful, passionate, and supportive reader.

Digital Portrait Photography

ART, BUSINESS & STYLE

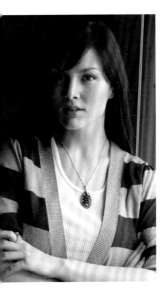

IMAGE OPPOSITE PAGE © LEN DEPAS; IMAGES THIS PAGE, TOP TO BOTTOM © STEVE SINT, © LEN DEPAS

© LEN DEPAS

introduction

As I scan the portrait photography titles at a Barnes & Noble store or online, I often laugh to myself. There are books on location portraiture, studio portraiture, executive portraiture, family portraiture, child portraiture, candid portraiture, wedding portraiture, boudoir portraiture, portrait lighting, natural light portraiture, portrait posing, non-posed portraiture; you get the idea—the list is almost endless. While each author breaks the subject of portraiture down into smaller and smaller segments looking for a winning title, they all seem to forget that every portrait subject has a face and all faces are basically the same; sure, they're all "different," but still, they're the same where it counts. Not only are faces the same, but also the people behind the faces are the same when it comes to their portrait. They all have the same fears, the same desires, and the same end goal for their portrait. In a nutshell, nobody wants to look ugly and everybody wants to look beautiful! Segmenting portraiture down too far ignores the big picture—that in the end, good portraits are about making everyday people look great. That's what will make your customers, family, or friends happy, and it's what will ultimately give you years of satisfaction as a portrait photographer.

As a professional photographer and author for over 30 years, I've shot a lot of pictures. I've photographed close to 4,000 weddings and done literally thousands of family and commercial portraits; in fact, I crossed the million-exposure mark 10 or 15 years ago and now I'm closing in on the two million mark. I've had cameras turn to dust in my hands! If I add all the portraits of brides, grooms, and relatives I've done at weddings to the portraits of parents, grandparents, and kids at all the family portrait sessions I've shot, and then throw in all of the executive and employee portrait assignments, I've probably taken more than a million portraits. What has this gotten me other than a very calloused shutter button finger?

The answer is passion—not just to know what works but, more importantly, I want to understand why it works. The result is that when I'm faced with a slightly different scenario than I anticipated, I can apply something I learned in a similar situation because the underlying foundation is the same. Imagine a well-organized, immediately accessible card file of facts tucked into a crevice in your mind and you've got an idea of what's in my head. In this book I intend to open up my card file for you!

Much of the knowledge I share in this book is about two very important aspects of portrait photography that are often overlooked or never even considered by many photographers. The first is control, and the second is shooting "clean" pictures.

So what's this control all about? Simply put, it's how you, as a portrait photographer, have the ability to create a type of magic by turning the everyday into something special. True beauty is a rare thing. Grace is rare, too. In fact, they are so rare

that very few people are blessed with even one of them, let alone both. But you will find that most people have an inner beauty and grace that is just as nice but less easily seen. The problem is that, sometimes, physical limitations overpower and hide the beauty and grace we as a society appreciate. As a young photographer I spoke to my first mentor about this issue and his only comment was that it was all a matter of control. At that time I was so insecure about my lack of knowledge that I said, "Yeah, yeah, I understand." But what I was thinking was more along the lines of, "What is he talking about?"

Years later, after much practice and a lot of thinking, I understood exactly what he was talking about. It turns out that skilled professional photographers are magicians, practicing a photographic sleight of hand and, like what a magician does, it all boils down to control. Magicians often control the angle at which the audience can see their act, or through another technique

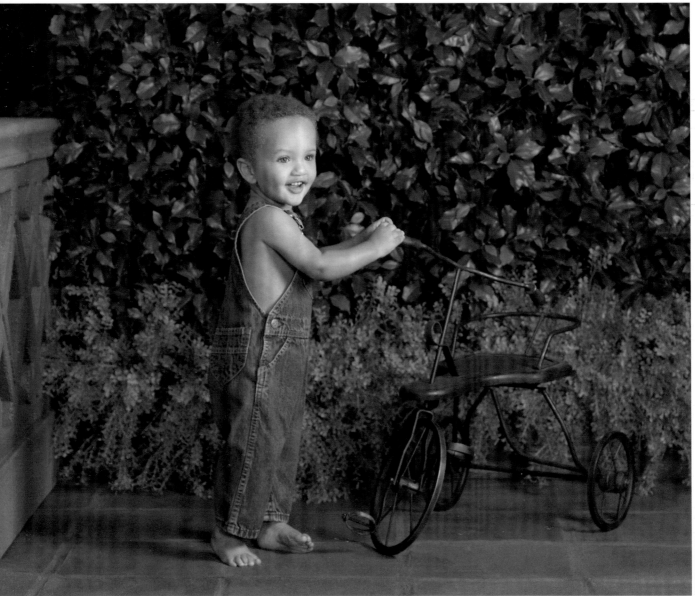

© LOUISE BOTTICELLI

called misdirection, they shift the audience's attention from what exists in reality to what the magician wants them to see. In a way, photographers use the same techniques. I regularly pose and light my subjects to minimize their imperfections and accentuate their attributes; both are things you'll learn to do in the Lighting and Posing chapters. For this control to be most effective, it must extend beyond the mere choice of lights, posing, and wardrobe to a much more involved encouragement of our subjects by understanding their state of mind, something you'll learn about in the Portrait Psychology chapter.

All this is done so the viewer sees what I want them to see and misses what I want hidden; it's a game of smoke and mirrors. So, I not only want to control my set, which includes the photography session and the subject, but my grander goal is to control what the viewer is seeing. Because my portraiture is a collaboration between me and the subject, the viewer is more likely to see what the subject brings to the table when I have hidden things that would interfere with the message. Usually my goal is to create a controlled, perfect (or as perfect as I can make it) environment in which my subject feels comfortable and has space in which to bring something of themselves to the portrait. In the end, I control my set and my subject so that my subject can control what the viewer sees.

Shooting "clean" is learning how to correct and hide flaws in your subjects as you shoot the photograph, not after. There is no doubt that Photoshop is a great tool. But as I will point out occasionally on the following pages, if you shoot 100 eight-hour days per year and spend one hour of post-production time for each hour of shooting, you will be sitting at your desk or workstation 800 hours per year! This translates into 20 forty-hour work weeks, which makes for approximately five months of computer work. By shooting clean, you'll spend less time sitting in front of your monitor and more time taking, making, and selling portraits; all of which will make you a better photographer and, most likely, a more successful business person.

While this book is about control and shooting clean, there is one thing that it is not about, and that's photojournalistic portraiture. One might say that there are two types of portrait photography, the traditional kind covered in this book and the photojournalistic kind. The main difference between the two can be summed up by the term subject awareness. In traditional, posed-portrait photography, the subject is obviously aware that their picture is being taken; in fact, they've usually paid for it! Pure, unadulterated, photojournalistic portraiture, on the other hand, implies that the subject is unaware of the camera, the photographer, and the fact that their picture is being taken. When the subject hires you, the very fact that they have hired you makes them aware their portrait is being taken; this often results in what should be more aptly described as "photojournalistic-style" portraiture, where the subject is aware of the camera but is not posed, lit, or directed by the photographer. Ultimately, trying to delineate where the two different styles of portrait photography blend and overlap may be an exercise in futility. What is important in this case is that pure, photojournalistic or photojournalistic-style portraiture won't be covered in this book. So if you know that's you're thing, this title is not for you. However, if you're interested in professional portraiture that is a collaborative effort between you and your subject, then you're in the right place—this is your book!

My editor at *Popular Photography* magazine once told me over lunch that the most interesting thing about my writing was that the reader always got the feeling I knew the information "in my gut." After I've shot those one million portraits, everything I will share with you in this book is indeed "in my gut." After pushing my shutter button that million times, one might say that I've been there, done that. I make decisions about what's right for any given subject almost instantaneously, noting both perfections and imperfections that other people and my subjects don't even see, choose not to notice, or deny—until they look at their portrait! After you read this book, you'll begin to understand how to interpret the many elements of a portrait situation the same way—from lighting, to framing, to posing, and more—and you'll make informed decisions on the fly with great results.

In the 70s, there was a photographic columnist named Pete Nicastro who wrote for *Studio Photography* magazine. Even though I wrote columns for the same magazine, I read and reread every one of Pete's columns. He often said that by blindly learning and following rules, a photographer was killing his or her own creativity. After all, if you only follow rules, aren't you nothing more than a rat in a maze, always ending up at the same destination? The answer that works for me is to learn and remember all the rules, but to use a pin to constantly prick that great photographer hiding within me and remind myself that there are moments when all the rules I worked so hard to learn should be set aside, and to go with my gut feelings. While you'll see that this book is filled with rules about what works and what doesn't, it is always important to remember that "all rules are meant to be broken." This doesn't mean the rules are not valid, because they do provide a roadmap of which way to go while you work towards being a better portraitist. However, it can also be rewarding and challenging to try things in new and imaginative ways, which might reveal exciting results for you and your subject. In photography, like any art, creativity is often the key to fulfillment and success.

I must share one earth-shattering revelation before we jump into the thick of things. Everything you are going to read about in this book is interconnected. Your choice of camera settings is interconnected to the style of lighting you choose. Your choice of lighting style is interconnected to the type of lighting equipment you choose. Your choice of lighting equipment is interconnected to the lens focal length and f/stop you choose. Your choice of lens and the f/stop you set it to are interconnected to your subject and the statement you're trying to make about him, her, or them. Even something as seemingly innocuous as the subject's pose or the location the subject is photographed in is interconnected to both the lenses and lighting you make the picture with! It is all part of one grand, interconnected scheme of things and, although hard to believe, there will even be times when the success or failure of a portrait you take will be based on how you say "hello" to the subject. Therefore, while any single chapter in this book will be helpful to you, its importance in relationship to all the other chapters can't be minimized. Everything you do, from meeting the subject to delivering the final photographs, and everything in between, is all interconnected. This revelation is arguably the most important thing you can come away with from reading this book. Let's get started!

© SALLEE PHOTOGRAPHY

chapter one
portrait psychology

It would be great if we had the time to spend eight hours with a subject as we searched for the *perfect portrait.* The perfect portrait is captured with a perfect subject, photographed with perfect technique, lit by perfect lighting, in front of a perfect background, while the subject emotes the perfect expression. Considering all the perfection that must come together at a specific (and perfect!) instant, it's obviously hard to get a masterpiece every time. Even if portrait photographers rise to the occasion and get all the technical bits together at the perfect moment, will our subjects be up to the task of being perfect at the same instant?

Sadly, because perfection in portraiture involves two or more unique entities with individual wills, for photographers without the proper people skills, the whole process is often a hit or miss proposition with the perfect result happening as much by luck as from talent or knowledge. Sadly, in this speed-conscious world, we can't afford to invest eight hours in one picture and run a profitable business. Equally true, our subjects usually can't invest that much time either. This chapter is about getting to that final, perfect moment faster by having a general understanding about your subjects' fears and desires about their portrait, and the things you can do to help them.

working a subject

As a portrait photographer, you have an interesting role to play. You want to get your subject to like you, but you also have to be able to direct them physically and emotionally so you can get the best shot possible. This can be tricky, and it comes down to getting the subject to trust you, a topic covered in-depth later in this chapter on page 19. I always direct my subjects. Unlike a photojournalist, a portrait photographer is not being paid by a newspaper or magazine to expose the truth about a subject; instead, we are being paid by our clients to show the truth about them as they see it! As I point out throughout this book, my only goal is to show my subject in their best light, accentuating their positive physical attributes and minimizing their negative ones, while simultaneously leaving them space in which they can express their own unique individuality. Believe me, that's a tall order! What follows is a selection of techniques that I have used successfully in the direction of my subjects. As you read through them, realize that you don't (and shouldn't) blindly apply all of them. Instead, think about incorporating those that best mesh with your personality and style. If you were to read this chapter and end up "working" a subject exactly like I do, you'd be nothing more than a clone of me! While I have been a successful portrait photographer for over thirty years, you will serve yourself better, be more successful, and feel more fulfilled in your work if you use this information to augment your own unique style.

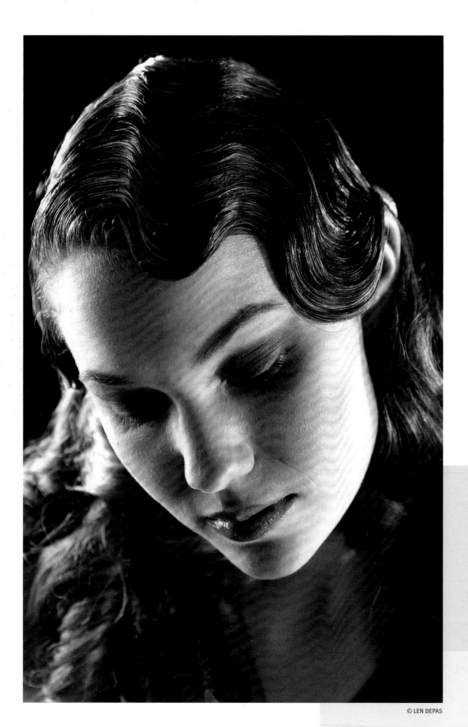

By learning how to understand a subject and give them the right kind of support, you'll often get to the perfect collaborative moment where you can direct them, but they still have plenty of space in which to express their personality.

Although this might sound strange to a photographer, many people absolutely hate having their picture taken—even when they are paying to have it done! They approach it with as much trepidation as a root canal procedure or a tax audit. Why is this? Although there are probably many reasons, I think a few main issues are responsible for the majority of these feelings.

Because a fearful subject is not conducive to the creative collaboration I want, I expend more effort on relating to the subject than I do on thinking about the technical bits involved in the photography part of a portrait session. After all, photographic technique is something that is consistent, and it therefore becomes second nature to an experienced photographer, while dealing with a human subject is a constantly changing scenario. Before we can work to allay a subject's fears, we must first identify what those fears are. So that's where we'll start.

sources of fear

There is a Japanese proverb that says every man has three faces. One he shows to the world, a second he shows to his family and friends, and a third that he shows to no one but himself. I think this is probably true of all people, and it is the basis of one of our subjects' fears. A good portrait photographer, one who knows how to "work a subject," has the potential to pry open the subject's inner self and get a glimpse of that third face. To many, this can be a reason to fear being in front of a portrait photographer's lens.

Second, most subjects aren't comfortable with the way they look. When we look into a mirror, we don't really see a true image of ourselves. We gloss over imperfections (perceived or real) and don't notice a double chin, a receding hairline, a crooked tooth, a lazy eye, or any number of other things that I lump under a category called "warts." Standing in front of the mirror, when we gloss over our imperfections, I think our third face is aware of them but we choose to ignore them. Sadly, for many subjects, once in front of the camera, the limitations they see but choose to ignore must be faced. Very few subjects are completely secure with their own self worth and at peace with their warts; most still worry about them.

Although not directly connected to the fear factor, there is another point about mirrors that affects your subjects' perceptions, and it has its root in both an optical illusion and familiarity. Here's the scoop: When a portrait subject (or anyone for that matter) looks into a mirror, they are not seeing a true image of themselves. They are looking at a reversed image of themselves: left becomes right and right becomes left. As the years pass, they become familiar with the face in the mirror, they get used to it, and that helps hide imperfections to the point that they go unnoticed. A photographic portrait is not reversed and, suddenly, the familiar small mole on their right cheek becomes a huge, new mole on their left cheek! It's the exact opposite of the saying "familiarity breeds contempt." I think, at least when it comes to a subject's feelings about their appearance, familiarity breeds comfort and acceptance, while it is newness and unfamiliarity that breed the contempt.

I can't even count how many subjects I've photographed who wear long sleeves in the heat of August to cover heavy (or thin) arms, or hide behind family members to cover their bellies, or shave their heads to disguise a receding hairline, or use heavy base makeup to cover a miniscule freckle, or refuse to smile because of a missing tooth or a gummy grin, or will only face one way for a portrait so as to only expose their "good" side—well, the list just goes on and on. It has been written that even a brave, national hero such as George Washington refused to smile in his later life for fear that people would see what the ravages of time had done to his teeth.

Not surprisingly, I have found that little children are unaffected by this fear of how they look, because they are generally unaware of the social implications of appearance;

© JAN PRESS PHOTOMEDIA, LIVINGSTON NJ

Young kids aren't usually reserved in front of the camera because they haven't started to be self-conscious about their appearance yet.

teenagers are very self-aware because of the cruelty of their peers; young adults are confident because their bodies are in their prime; middle-aged subjects are often more self-aware thanks to signs of aging; and elderly subjects often seem unworried because they understand and accept the process of aging. While both the very young and the old are unaffected by this fear, it is for different reasons; the former is based on a lack of knowledge and the latter is based upon the peace of mind gained from experience and knowledge.

The third fear I run into most often deals with the subject relinquishing control to the photographer. Society and many religions talk about how each person is in control of their own destiny, and this concept brings comfort to many. Whether your subject is strong and in control of their destiny or weak and blown about by the winds swirling around them, almost all people like to feel that they are in control. Enter the portrait photographer—someone who can take control from them and, worse still, has the power to expose them, their foibles, and their imperfections. I have found that the more powerful the subject, the less comfortable they are with relinquishing control. Be they a politician, a judge, a CEO, a mid-level manager, a matriarch, or anyone used to having their word taken as law, all are uncomfortable taking, as opposed to giving, directions.

Now that we have a basic understanding of some of the forces of fear at work on the average portrait subject, let's explore what we can do about them.

The first and probably best thing you can do to help overcome your subject's fears is to look inside yourself. All of the fears your subjects have are within you, too—after all, we're all cut from the same basic bolt of genetic cloth. The easiest way to connect to your subject is to follow the golden rule. This means I won't say or do anything to a subject that would make me feel bad if it was said or done to me. Sometimes this is not easy, and often your efforts go totally unnoticed. But both personally and professionally,

kindness is the best way to go. You'll feel good about your work, your subject will feel comfortable, and you'll get a better portrait. You'll never get the perfect portrait from a subject who's been made to feel bad about the way they look, or anything else. In the business world, this might be referred to as professionalism, and I'll share a quick story with you that helps drive this point home.

A long time ago (July 2, 1977 to be exact), I was working for a studio shooting an extremely expensive wedding at the Waldorf Astoria hotel in New York. At the end of the evening I walked over to the bride's mother to thank her for having us at the party and to offer my congratulations. I then added that I was getting married the following day (which, by the way, is why I remember the date of her daughter's wedding with such clarity). The mother looked at me and said, "I'm sure your wedding will not be as nice as this one, but you have a nice time anyway." Without batting an eye or letting my expression show my shock at her incredibly callous response, I smiled and said, "Thank you for your kind words." Unbeknownst to me, the studio owner was within earshot of this exchange, and as my assistant and I packed up my gear, he came over to me, put his hand on my shoulder and said, "I heard what was said to you and I want to thank you for being a consummate professional." Today, over 30 years later, the rude woman is long forgotten (except when sharing outrageous "war" stories over a beer), but the studio owner and I are still good friends. More importantly, I didn't thank her just because I knew my boss was within earshot. I responded the way I did because I am a professional and I refuse to ever let anyone push me to the point that they can rob me of my professionalism and compassion.

All of this—from realizing that you have imperfections you choose to ignore, to you being as mortal as everyone else, to following the golden rule, to always respecting your professionalism—can be lumped under one word: Compassion, for both yourself and your fellow humans. This compassion will serve you well in life and, within the context of being a portrait photographer, it will help you become more intimate with your subject by earning their trust.

© LOUISE BOTTICELLI

Have compassion. By understanding the fears and desires of your subjects, you can more easily relate to them and build a trusting relationship.

As a portrait photographer, you are in the business of getting your subject to trust you. If you are observant, which is almost a prerequisite for a professional or advanced amateur photographer anyway, you are immediately aware of your subject's imperfections. Based on your experiences and the suggestions you read about in this book, you will learn ways to work around many of the things your subject knows about but is afraid to admit. Sadly, all our combined experience can't be brought to bear if your subject doesn't trust you; and without their trust, you'll never get to the point of taking a great portrait. So how do you get from being not only compassionate, but to also having your subject fully trust you? There are many ways to quickly build a trusting relationship between yourself and the subject.

wardrobe

Wardrobe? Yes, wardrobe. But not the subject's—I'm talking about yours! What does your choice of clothing have to do with psychology for the portrait photographer? In truth, quite a lot.

An important part of friendship is trust. People trust their friends and if that is true (and I believe it is), then I want to be my subject's friend! Some may say that my last statement is disingenuous, but that's not really the case. The dictionary first defines a friend as "a person whom you know well and whom you like a lot, but who is usually not a member of your family." The second definition is "someone who is not an enemy and whom you can trust." That's it! That's exactly who I want to be. In fact, the example used to illustrate the second usage is even more apropos; it says, "You don't have to pretend anymore—you're among friends now." Once again, the dictionary's example is perfect for the relationship I'm trying to create. At this point, some of you may be asking what this dictionary tour has to do with your wardrobe?

Friends are often chosen because of similar tastes, interests, and goals. People often look for their equal when making friends because it eliminates jealousies and usually makes for having more things in common. Lastly, people generally trust their peers more easily. With those thoughts in mind, I try to choose my wardrobe so that it matches my subject's attire. That means you'll see me in a dark suit at an executive portrait session, casual but neat attire for a family portrait session, and jeans and a T-shirt when I'm shooting the workers on the factory floor. What is that old cliché? Oh yes: The clothes make the man. Better still, consider this one: If you want to walk with kings, then you should dress like one.

Many photographers think that part of their creativity is their choice of clothing when, in reality, it's the creativity in the photographs that is most important. In fact, while many photographers seem to use their fashion sense to make a statement about who they are, I look at any comments or thoughts that my subjects have about my clothing (be they positive or negative) as a distraction from my goal, which is to make my subject the center of my attention. Red Skelton, a famous comedian from television's early days, was once asked why he took off all his jewelry before he went on stage. His response, which I will paraphrase using today's vernacular, was that he wanted his audience to concentrate on his face and not be distracted by his "bling." My kind of guy!

making physical contact

Upon meeting any subject, I immediately shake hands with them. I have an ulterior motive when I do this. Sometimes in the course of a portrait session I have to touch my subjects, either to arrange them or correct something like a misaligned tie knot or a flipped-up collar wing. Actions of this type are an invasion of their personal space and can be intrusive, resulting in making the subject defensive, which is the antithesis of trust. The best example of this defensiveness is a teenage boy who flinches when you approach the boundary of his space. His flinching is usually caused when either a parent or grandparent reaches towards him to pinch his cheek or kiss him, or it might even be caused by a learned reaction when one of his peers throws air punches at his face. His flinching is the result of having learned that pinches and kisses hassle him, and sometimes a harmless air punch mistakenly lands. By shaking hands when I first meet a subject, I am acclimatizing them to my touch and exhibiting to them that I'm not a threat.

compliment them

Upon meeting any subject at the shoot, I always find something about them to compliment. It can be as simple as saying "I like your tie" to a man, or "What a pretty pin" to a woman. For a child (but only if they are old enough to understand what a compliment is), I will usually pick something that denotes their maturity. My compliment usually puffs my subject up and makes them feel happy about themselves. There is a benefit in doing this: A happy subject is a more secure subject, who then becomes a more relaxed subject, and when someone is relaxed, they look better.

There is one important limitation that you must be aware of when employing this technique: You must be sincere in your compliment. Insincerity can kill the friendship and trust you are trying to create immediately. So if you can't find anything about your subject to compliment, then don't try to fake it. In general, I like people; it's why I'm a portrait photographer. I can find something to like about almost anyone, and you should be able to find something you like about the vast majority of your subjects as well! In fact, you might consider it a litmus test of your own aptitude for portrait photography. If I can't find something to like about someone, I will of course still photograph them, but I just skip the idea of complimenting them. Every so often I'll compliment a subject and they'll respond that I probably say the same thing to all my subjects. When this happens, I look that subject directly in the eye and say, "No, sometimes I just say hello." Although some might think my response is corny or unbelievable, to my subject it seems genuine because it is totally true. Which brings me to another attribute of great import in garnering trust—honesty.

One of the benchmarks that people measure in trusting someone is whether or not a person is honest. Truth is *very* powerful when it comes to trust. To be very blunt, and to repeat myself because it's important, here are two points worth reconsidering: If you can't find something nice about your subject to compliment, don't ever try to fake it. And if you often can't find something nice about your subject to compliment, maybe you should reexamine your choice of portraiture as a specialty!

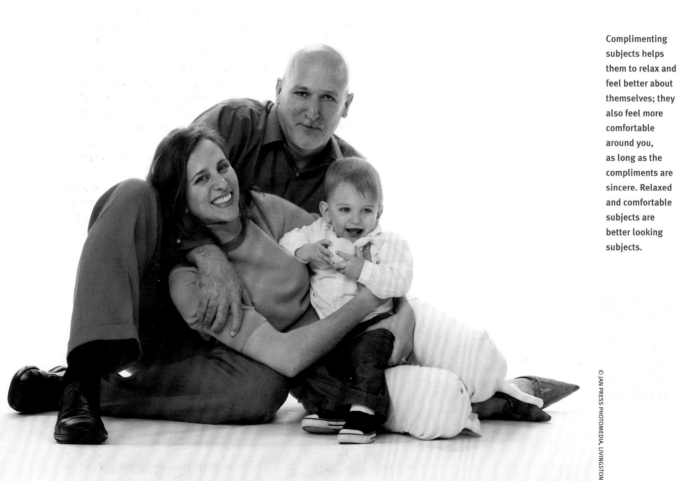

Complimenting subjects helps them to relax and feel better about themselves; they also feel more comfortable around you, as long as the compliments are sincere. Relaxed and comfortable subjects are better looking subjects.

remember their names

I make it a point of remembering my subject's name. It personalizes my relationship with them, and that is helpful to me as I try to gain their trust. To give someone a direction by saying, "Sir, please move closer to your wife" leaves me as an outsider, someone who is not a friend and hence not trusted. Conversely, saying something like, "Jim, snuggle closer to Mary" puts my direction on a different level, that of an old friend worthy of trust.

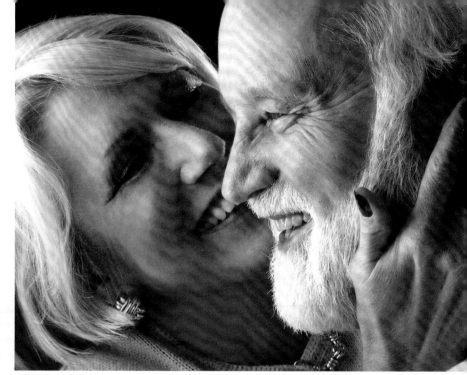

Remember your subjects' names. It's hard to give direction and inspire intimacy if you come off as distant to your clients.

© LEN DEPAS

© JAN PRESS PHOTOMEDIA, LIVINGSTON NJ

Tell your subjects your plan, and hear what they want. If they feel involved in the process, they will feel more invested in the end result and really shine.

talk to your subject

It's amazing to me how many photographers talk into the back of their cameras. Or worse still, they mumble about technical baloney in which the subject isn't the least bit interested. I sometimes like to say that we (still photographers as a whole) take "silent pictures" because, unlike videographers or cinematographers, our final product doesn't have a soundtrack. So it's okay (and in fact, it's a good thing) to talk to your subject during a shoot. But if you do speak to your subject, then speak clearly and don't mumble. Always remember that what you are trying to do is communicate in an understandable fashion. If it's difficult to understand what you are saying, it becomes a distraction for your subject that masks the task at hand, which is making great portraits.

One fear not mentioned at the beginning of this chapter is the fear of the unknown. I didn't mention it because most subjects have had their photograph taken at one time or another, so it is not an entirely unknown experience. But I have also found that subjects are much more agreeable if I tell them what my plan for their portrait session is. In the first place, knowledge is power, and by giving them information I am empowering them. And this gives them back some of the control we covered earlier, further garnering their trust. Second, as I discuss details with them, whether they be pre-production details such as their choice of clothing, or details at the shoot itself, like the choice and selection of backgrounds, it opens the door for the subject to get involved with the process. Once your subject is involved, they have a vested interest in the final product. Take a guess what happens. A subject with a vested interest is a more willing participant in the collaborative process. Of course, remembering that all rules are made to be broken, there are times that none of these ideas work. Some subjects couldn't care less about a collaborative process; this kind of subject is one who just wants to get it done and move on. And as a professional, you should be flexible enough to roll with the punches and change your methods when necessary.

building the trust relationship

It isn't necessary for you to use all of the techniques for building trust I reviewed here; you should pick and choose the ones that fit your style and those that are the easiest for you to do. I must also point out that using just a single technique is not as effective as using them in multiples, because used as a group they have a tendency to reinforce one another. By way of a further explanation, if I were to assign an arbitrary scoring system to using them, it might show that using one of them will get you 10% of the way to being trusted, while using two of them in concert would get you 25% of the way there, and using three of them might result in getting to 40% of your goal. In general, everything you say or do to a subject should be aimed at achieving a single goal, which is gaining your subject's trust.

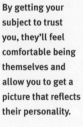

By getting your subject to trust you, they'll feel comfortable being themselves and allow you to get a picture that reflects their personality.

Be prepared to shift gears and change your approach quickly. I've photographed people who are fielding (or making!) phone calls between exposures and who could care less about my idea of a collaborative effort. I've had executives walk onto a set and start off by saying, "I've got five minutes," before they even say hello. Although these types of responses limit my ability to portray them, I am willing to forego my ideas about rapport if that's the only way I can get a picture.

It is important to realize and accept that many of your subjects might not even want to have their picture taken, let alone waste their time at a portrait session. While some less experienced portrait photographers may find this hard to believe or understand, it's an unfortunate downside of the business. I can not only attest to the fact that this happens often, but that you can run into it with every type of subject.

Consider these facts. In the business world, mid-level executives are usually directed to have their picture taken; they don't have any say in the matter. This means they have to change or rearrange their schedules, change their wardrobe choices, and possibly be in close proximity with other mid-level or higher-level executives whom they either don't like, or may even be afraid of. For lower-level workers, the situation is worse because they have even less control over how, when, and where their portrait is taken. With all the news stories about disgruntled employees snapping under life's stresses, you must be aware that not all of your business subjects are content and at peace with their lot in life, and a photographer can represent just how little control over things they do have. While the idea of a disgruntled employee coming into a portrait session toting an Uzi is slightly farfetched, I must point out that in every group of employees you will find both content and disgruntled ones—it's a simple fact of life.

Do you want more examples? Parents plan a portrait session and then their kids are dragged away from the baseball field, scrubbed, stuffed into uncomfortable clothes and new shoes, and dragged kicking and screaming to meet the photographer.

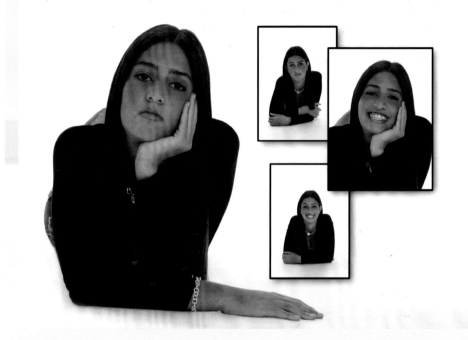

Sometimes your subjects aren't always happy about having their picture taken. But by remaining flexible and rolling with the punches, nice portraits can still be had from a reluctant subject.

Then, horror of horrors, a stranger (you!) demands the kid hugs or even just get close to a sibling they either hate or find disgusting. Even in the wedding world, bridesmaids and ushers are forced into renting or buying clothing that is often uncomfortable or unflattering, and then they have to endure a photographer's direction. It is important for you to understand that the person commissioning the portrait (and therefore paying the bill) is often not the person in front of your camera.

I try to leave my ego at the door when I do a portrait session. I'm always trying to satisfy either my subject's desires, or the desires of the person who hired me, instead of mine. At the same time, I'm also trying to find a happy medium between what I know will work and what won't mesh with my subjects' need for speed or their distaste for being in front of the camera. It's often as if you are walking on a thin tightrope and you must be mindful that on some days your magic will work and on some days it won't. Professionalism demands that on the days when it doesn't work, the idea is to change your approach in order to find a new way that will. And finally, I just can't see myself telling a magazine's photo editor that I couldn't get the shot I was hired for because the subject wouldn't shake my hand or just plain didn't like me.

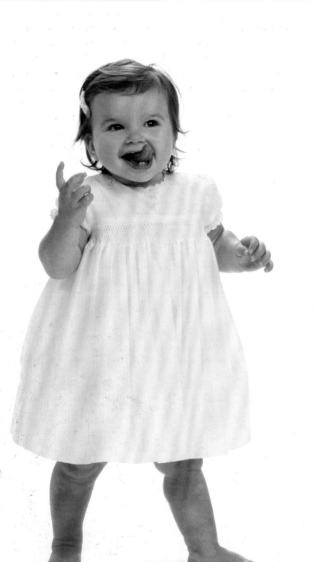

Some portrait photographers use professionals "kid wranglers" to keep children entertained and cooperative.

Many portrait photographers have had the same thing said to them so many times that they've developed a repertoire of responses that will elicit a smile or otherwise move the subject in the direction the photographer wants them to go. Some photographers who specialize in child portraiture even go so far as hiring other professionals (called kid wranglers) whose job is to keep the kids amused and interested while the photographer takes the pictures. While it isn't necessary to wear a clown outfit or have a stuffed animal or puppet sitting on top of the camera for adult subjects, a photographer can still use witty repartee to get the subject to respond. But using jokes can be a loaded gun that can backfire in your face all too easily. Here are some tips about how to choose and use jokes and witty one-liners to get your subject relaxed, and not personally insulted or disgusted with you.

Although I have nothing against using jokes and in fact use them myself, I can summarize the first rule with three little words: keep them clean! Too many photographers use what I call bathroom humor, or jokes with a sexual overtone. These kinds of jokes can just as easily turn off as turn on your subject. Worse still, once your subject is turned off by something you say, it is very difficult to reverse their feelings about you and it can color the entire portrait session.

Try to use funny lines that the subject can relate to on a personal level. Here are some examples that I've used with good—and sometimes great—results. I've photographed young attorneys and said something like, "Wow, it's a possibility that I may be photographing a future Supreme Court Justice!" For a young married couple with their eight-month old baby, I often say, "Let's make believe that little Sarah sleeps eight hours a night!" For a portrait of just the mom and dad after I've photographed them with their five kids, I might say something like, "Okay, imagine this: It's 11 AM at your house on a Sunday morning, the sun is streaming in through the kitchen window, you two are drinking your coffee and reading the paper...and all the kids are still asleep!" For an 18-year old boy I might say, "Your dad told me that if you smile in this picture, he's decided to buy you a new Corvette!" For a 13-year old I might substitute "A cell phone with unlimited minutes" for the teenage buzzword Corvette. At this point, I'm sure you get the drift of what I'm saying. Note that all of my examples are clean, and that each is worded so as to be relevant to the subject.

To recap, it's fine to use jokes; just remember that anything you say can affect the rest of a portrait session either positively or negatively—so choose your words carefully.

I once photographed a psychologist who had written a book. Halfway through the shoot he turned to his publisher, who was present, and said, "This guy is good, he gives me something easy to do and when I do it he makes a big deal about it. He makes me feel great." Although I had not been conscious that I was using this technique, his pointing it out made me recognize it. I began to consciously employ it and now it is part of my portrait photographer's bag of tricks. Here's how it works: I ask my subject to do something simple and when they do it, I acknowledge it as if it were an act worthy of the Nobel Prize.

I have found it to be such a successful technique that I will illustrate it with an example. I'll ask a subject to lower their chin by a measly quarter inch. To make my meaning even clearer, I'll hold up my hand with my thumb and pointer finger about a quarter of an inch apart so the subject can get a visual confirmation of the distance. The subject complies and instead of just moving on, I say something like, "That's *perfect*—it's *exactly* the right amount!"

What I find amazing is that even though it is an easy thing to do, especially when I've given the subject a visual clue, some people drop their chin by two inches! When this happens, every so often, every fiber of my being wants to scream, "No Dummy! I said a quarter of an inch! Didn't you see my fingers? A teeny, tiny quarter of an inch! Not two inches!" But I never do. I have found that negative reinforcement never works. So instead of me calling them "dummy," I take a breath, put on my best smile and say, "No, no, just a quarter of an inch, just a little bit."

My subjects often comment that I have the patience of a saint, or a mother will say (after I have photographed her five-year old) that she can't understand how I do it and that she would have killed her kid a few minutes ago. Although I always respond by saying that I took a Valium right before the session, which is keeping with my usual style of elevating my subject and never myself, it still feels good when my subject notices what has happened. There is an old saying that you move a donkey by using a carrot and a stick, one for positive reinforcement and the other for negative. While that might be true for moving donkeys, I have found that in a portrait photography scenario you should forget about the stick and always use the carrot.

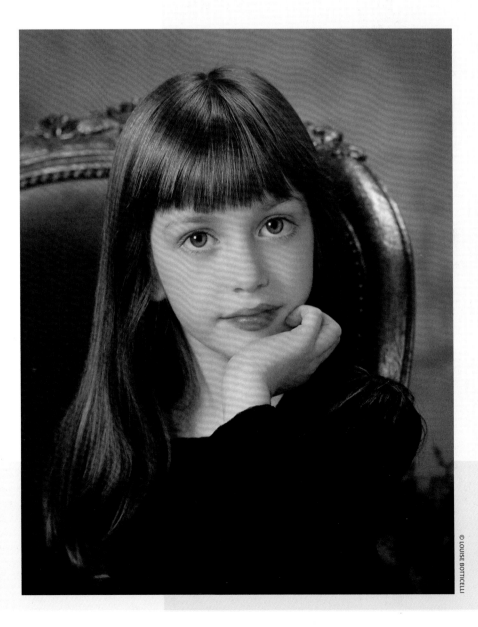

When your subject performs even a simple task that you request of them, like lowering their chin, praise them for it. It will make them feel better about themselves and more at ease with following your direction.

If there are other people present, even someone as innocuous as my assistant, and I notice something about my subject that is not attractive, or a feature I want to hide, I never make a general announcement about the problem or how I intend to fix it. Instead, I leave my camera position, walk up to my subject and get face to face with them and discuss the issue privately, speaking quietly. There are obviously many reasons why this is the best approach; let's look at the top three advantages of not making the issue general knowledge. In the first place, following both the golden rule and being a compassionate, professional photographer, this type of discussion is nobody's business but the subject's and mine. The fact that I don't discuss it openly is almost always appreciated, and it allows me to become closer to them. Second, by not exposing my subject to public ridicule, whether it is real or imagined, the subject is more apt to trust me. Third, by keeping the conversation private, I am making the subject and myself co-conspirators. Co-conspirators are on the same team, usually working towards a common goal, and that helps to reinforce the collaboration between the subject and myself that I'm trying to generate.

In all my years of using this technique, I have never had a subject who wasn't grateful that I've handled this type of potentially embarrassing situation in this manner. Now that I've covered the volume knob on voice control when speaking to a subject, I must mention a more important part of speech: Your tone.

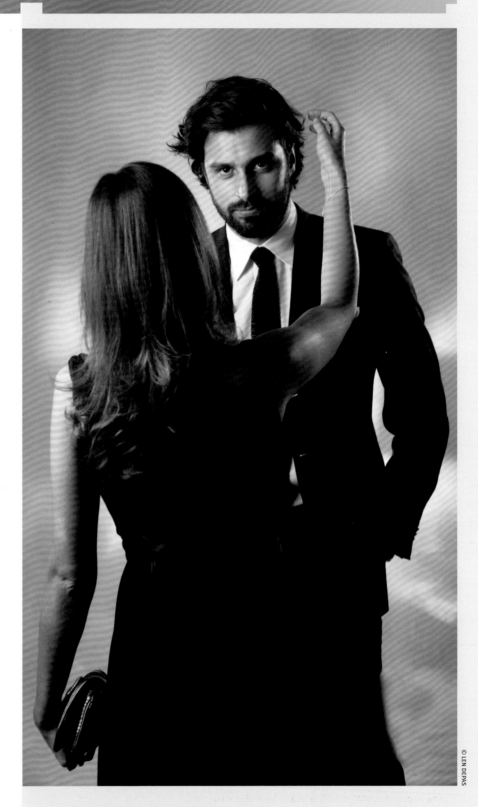

© LEN DEPAS

How's your subject's hair? If it needs to be fixed, get conspiratorial. By approaching the subject privately and not broadcasting their shortcomings across the room, you'll build a trusting relationship that will help in the collaborative portrait process.

the voice

For a long time I wasn't aware of the importance of tone of voice until it was driven home to me after a shoot one day. I was doing a book jacket portrait for an author while her husband videotaped the session for fun. After the shoot was over, he played the tape back for us— and I had a revelation! While I used a soft, engaging tone of voice when talking to my subject, my tone to my assistant was harder and had a biting edge. For my subject I would choose words like *thank you, please, easy, good, perfect, nice, terrific,* and *great* all were said in a soft and gentle tone. At the same time, both my choice of words and my tone were different for my assistant. He got: *quickly, we're waiting, get me,* and *give me,* all said in a much more curt, businesslike tone. Listening to the tape, the contrast between my two voices was very apparent. Imagine the tone you'd use while cooing to a baby as you try to get it to smile and you'll get the idea of what a perfect subject voice sounds like. Looking at it from the opposite tack, be sure to avoid using a shrill or irritating voice when you speak to a subject.

I fretted about how I sounded when speaking to my assistant on the drive back from the assignment. But my assistant raised an interesting point. He said that my tone of voice while speaking to him helped the portrait session because it accentuated the difference in my tone when I spoke to my subject. He went on to say that my choice of words and the tone of my voice when I spoke to him would reinforce feelings in the subject that she was the most important thing in my life at that particular moment. Jointly, we decided that the difference in my tone was a very good thing, and that I should keep it in my bag of tricks.

Another old saying states, "It's not what you say but how you say it," and I believe that to be true. I have found that even if I chide my subjects for inaction ("Aw, come on…you're not even trying!"), I can get away with it as long as there is a smile on my face and I don't fall out of my soft-edged subject voice. Of course, if you're faced with a 50-person group photograph, all bets about cooing to your subjects are off. When faced with such a mob, it is time to forget about cooing and dust off your strongest *basso profundo* voice. Just remember that there are differences between single subject, small group, and mob psychology voices.

© LEN DEPAS

How you use your voice can make or break a portrait session. Talk to your subjects in a way that makes them feel important and the center of your attention—after all, they should be!

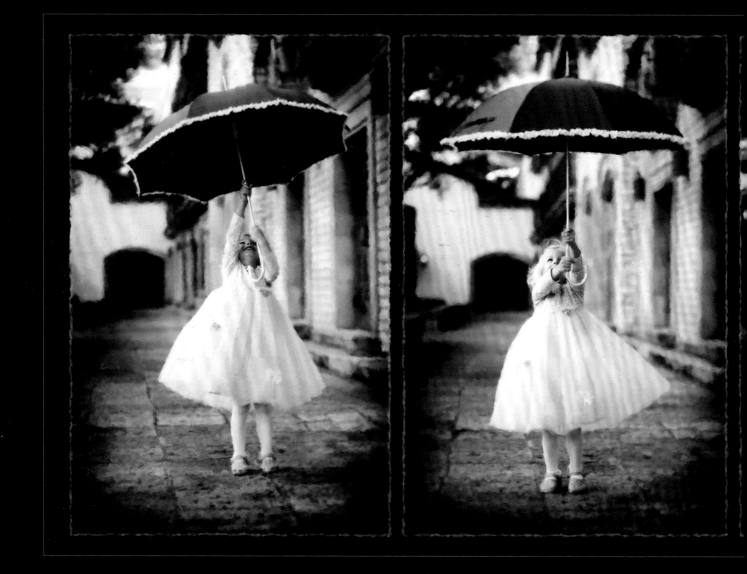

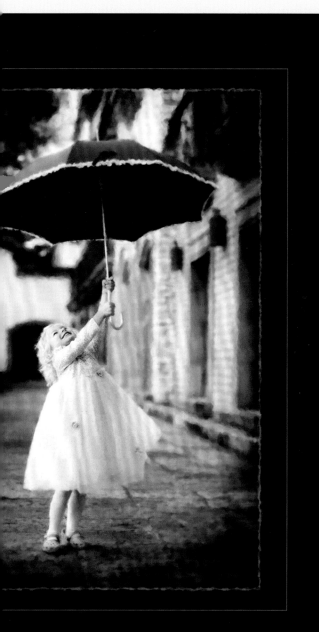

creating a comfortable atmosphere

Every idea expressed in this chapter has one goal: To create a fear-free, happy subject that is relaxed, in part because they are confident that you will do them no harm. The subject is comfortable enough with you and their environment (which is created by your control of the portrait session) that he or she let's you freely apply your technical expertise to the collaborative effort.

Imagine a little bird landing on your hand and sitting there. The bird is so comfortable in the knowledge that no harm will come to it that when your hand slowly closes, the bird doesn't feel the need to take flight and escape. Further, the hand can open and close numerous times and still the bird does not panic and flee. Finally, the hand opens and the bird, at peace with both the hand and itself, straightens up and starts to sing in its beautiful, strong, unique voice. The bird sings in your hand!

While this may sound as if I'm a snake oil salesman pushing some Zen-like mumbo jumbo, it is the best way I know of to describe the relationship I work to achieve between my subject and myself. There may be some of you who will never understand this or choose not to try these techniques, even though I think this is probably the most important chapter in this book. But for those who are willing to try and for those who succeed, I can promise you an amazing feeling of accomplishment. And right after the bird sings in your hand for the very first time, the experience will be something that you'll be happy to spend the rest of your life chasing after again and again.

Framing, an important cornerstone of portrait composition, is how you position your subjects within the confines of the photograph. This includes whether you choose a vertical or horizontal orientation for the picture.

Ultimately, framing is the art of arranging all of the elements within a photograph to achieve a desired effect—which is usually a visually appealing picture.

chapter two
framing

framing basics

In olden times, post Daguerre and pre SLRs, before cameras handled creative decisions by automation, cameras had separate focusing and framing devices. The two operations, done before pushing the shutter button, were separate and distinct. First you focused and then you framed the photograph. With the advent of the SLR, framing, as a distinct act separate from focusing, started to diminish in importance. With the advent of auto focus, the art of framing was often relegated to the scrap heap altogether. It is a pity that framing has been so absorbed into the automated picture-taking process, because it still deserves the importance of being treated as a stand-alone, photographer-controlled decision.

Neophytes often base their framing decisions on which way is easiest to hold the camera. Obviously, ease of holding the camera has little to do with pictorial value. Other beginner photographers practice a kind of default framing style that makes the composition dependent on where their camera's auto focus sensors are located. In fact, there was a joke that started when the first 35mm SLRs had a rangefinder spot in the center of their viewing screens: The composition of photographs would be better if you superimposed a bulls-eye over the exact center of the final print. Ironically, the sad end result is that framing has become a lost art and that loss is illustrated today in many mediocre photographs. These glorified snapshots could have easily been much better if some basic framing techniques were applied. Luckily for photographers who shoot portraits, there are some basic framing rules that can make your photographs a hit with your clients, friends, and family members.

Let's start off with three basic types of portrait photographs, the full-length, the bust, and the close-up. Full-length, as the name implies, is a head-to-toe photograph of a person or persons. Bust-length, which is slightly trickier to define, refers to photographs of people that run roughly from the head to the waist, mid stomach, or chest area. Relatively speaking, the close-up is a new addition to professional portraiture and by "new," I mean the last 40 to 50 years or so. This is because today's SLR cameras offer more accurate viewing and focusing systems, along with the ability to use longer lenses more easily. Let's start off by reviewing the first two types of portraits and see how different numbers of subjects fit into a vertical or horizontal frame.

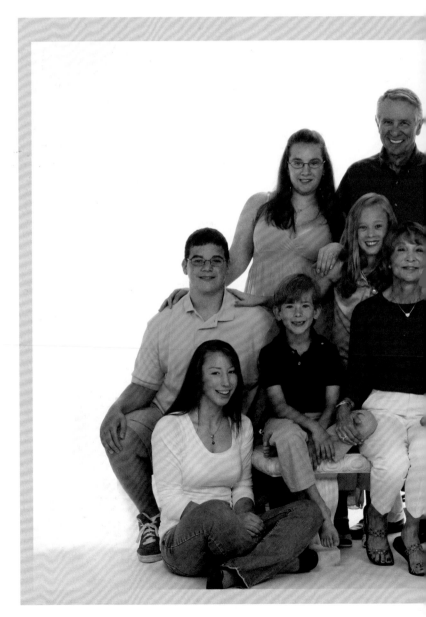

full-length framing

Verticals

A standing or sitting individual is most often a vertical subject, unless there is something significant in the background that lends itself to a horizontal shot. Vertical pictures of standing or seated subjects leave little room for excess background, and make your subject the center of attention. As far as numbers go, one to four standing people fit nicely into a vertical composition.

Unless there is something interesting in the background, a single subject is usually shot as a vertical.

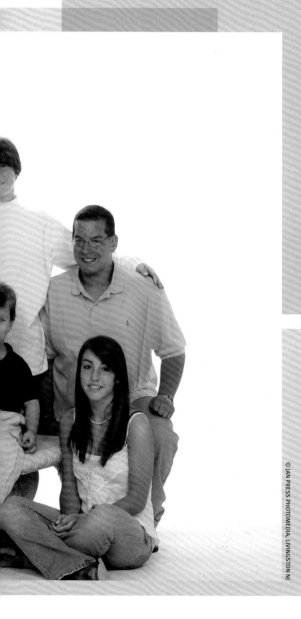

Horizontals

As mentioned, horizontal shots work best when the background is important, or when shooting a full-sized portrait of a large group. Six or more standing subjects fit into a horizontal composition nicely. With larger groups, no matter if some are standing, some are sitting, or even if a few are lying on the foreground floor, if six or more are standing, the group fits into a horizontal frame.

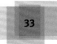

Five Is the Problem

While one to four subjects fit well into a vertical, and six or more fit best into a horizontal, five subjects fit into either depending upon how they are arranged and how wide each individual may be. Political correctness aside for a moment, let's speak in realistic terms of space and volume. Generally, if all the subjects are standing, five wider individuals may fit more naturally into a horizontal frame while five thinner subjects can often fit a vertical one. There's no hard and fast rule; experiment to find what works best for each scenario you're working with.

A Rule-Breaking Moment

It is important to remember that you can fit more than five people into a vertical full-length composition if you can arrange the standing subjects one in front of the other—such as kids in front of their parents. Or, if you can, seat one or two of the subjects and have the others next to and/or behind them. Good examples are portraits with the parents seated and their children standing behind them. Another option is having one subject sit in a chair, another perch on the arm of the chair, a third or fourth sit on the floor at the base of the chair, and perhaps two or three more standing behind the chair. You can even add an infant or toddler sitting on someone's lap. A full-length family photo like this has seven subjects fitting into a vertical composition. So much for rules!

Five, six, or more subjects can be shot in a vertical composition, as long as the group's width is exchanged for height. By posing subjects in front of one another for this picture, the composition is tall instead of wide, and seven subjects easily fit in the frame.

Trading Spaces

All the exceptions mentioned above have one thing in common for full-length portraits: In every instance, I have traded subject width for height—fitting more faces into the composition by placing them vertically at differing heights. However, note that this technique will partially obscure relatively unimportant body parts such as feet, legs, and torsos as additional subjects' faces block them. To create more interesting compositions, you can also arrange the subjects' faces on different levels within the portrait.

The Power of Positioning

This brings me to two last points involving a seated subject in full-length portraiture, which will be discussed in more detail in the Posing the Body chapter on page 148:

1. When only one subject is seated, there are political implications to consider. If you seat the mom in a family portrait and she becomes the center around which the family portrait will be built, this adds maternal implications to the portrait. Seat the father and he becomes the center of the family—the portrait now has a different, paternal feel rather than the maternal one. The same holds true for a portrait of a group of executives. The CEO should never stand in the back row! When a single subject is seated in the middle of the composition he or she becomes the center of the photograph and hence the most powerful—take a wild guess which executive you ask to sit down? It's always the CEO. If you decide to seat two subjects, then a subject standing between them becomes the central and most powerful in the composition—take another guess which executive is in the center of that composition? You guessed it—the CEO.

2. Seating a subject with a pet or child in their lap, or having them sit behind a desk or table is an easy way to make them look great. Seating someone beautifully when you see the whole body is just more difficult. In this case, you have to deal with their feet, legs, crotch, stomach, and posture—all of which can be done aesthetically; it just takes more preparation before the first shot is ever taken. For a full description of posing seated subjects, see page 157.

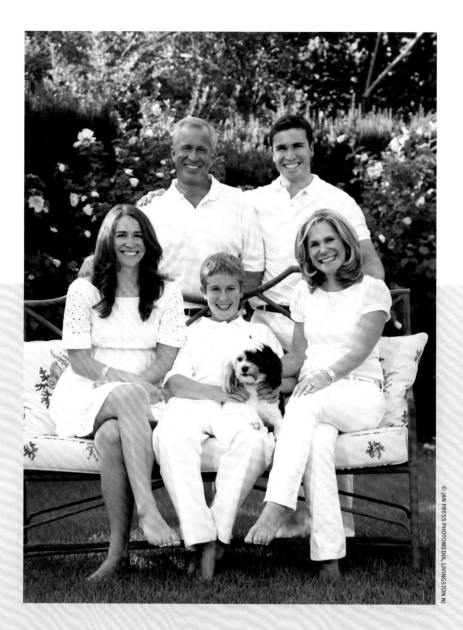

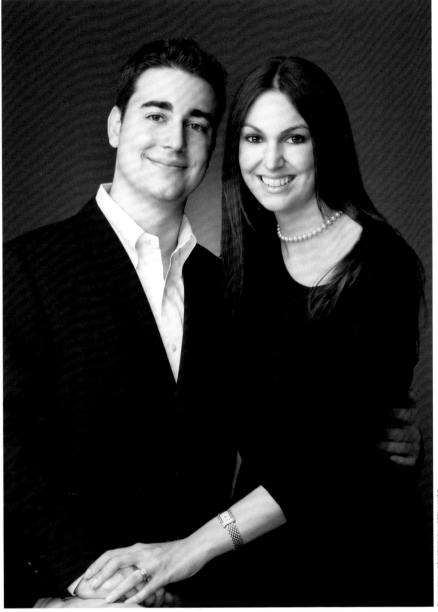

bust-length framing

Bust-length framing uses rules similar to full-length framing, but differs in the number of subjects at which the crossover from vertical to horizontal framing occurs. One or two subjects nestle nicely into a vertical frame, while four or more subjects fit best into a horizontal frame.

Framing three subjects is the problem in bust-length portraits. Three wider subjects framed as a bust-length portrait fit into a horizontal frame while the three thinner subjects fit into a vertical one. All of the ways to exchange subject width for height that I described in the full-length section hold true for bust-length portraits.

There is also an important consideration to mention if you use a chair to seat one subject while another stands in a bust-length composition. Depending upon how you crop the final photo, either in-camera or in post-production, you run the risk of making the seated subject appear much shorter than they actually are. I find it's imperative that you make sure your framing includes enough of the subject so the viewer knows they are seated. You might want to make sure the tallest subject is seated and the shortest is standing. Another suggestion is to use a chair with arms and make sure that you include part of the chair in the photograph to help identify that the seated subject is indeed seated. Regardless of the solution you choose, it is a definite no-no to have just the head and shoulders of a seated subject sprouting up from the bottom of your frame.

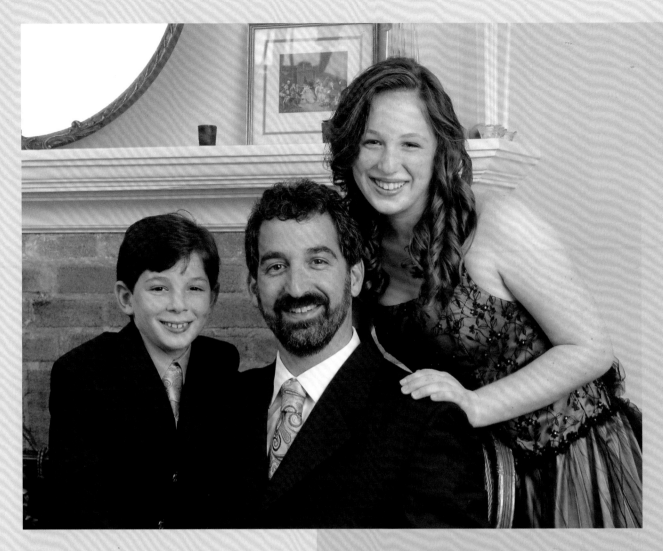

This is a perfect situation for seating the father because he's so much taller than his son. By including a bit of the chair back in the composition, the viewer can tell that the father is seated and not just short.

Just as in full-length framing, the physical widths of your subjects must be taken into account when deciding if your triangle of subjects fits into a vertical or horizontal composition.

stuck in the middle

Often amateur photographers fall into a trap when they can't decide whether they want to compose a full-length or bust-length picture. When this happens, they often end up in a nether world somewhere between the two. I call this type of picture the "dreaded ankle chop!" Neither fish nor fowl, this type of photograph is often the result of being afraid to commit to one composition or the other, and the photographer tries to cover both of the bases. The resulting photograph ends up failing at both. While I believe that there are times when an ankle chop is the only picture you can get, or there is pictorial value in doing it, it is something worth avoiding in most instances.

As always, remember that rule breaking is okay. A backlit subject walking through a field of grain, or a family standing in rolling surf up to their mid calves might be the perfect place to do an ankle chop on purpose. But notice that it's an element of the composition producing this crop, and not the edge of your picture. Also note that a great expression on your subject's face will always trump perfect framing. If your subject emotes perfectly, just push the shutter button and sort out the framing details later. Thankfully, in this digital age there's always the delete button so you're not wasting precious film and processing costs when you succumb to a shoot-from-the-hip moment.

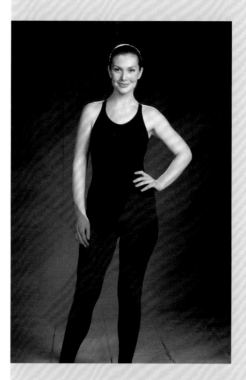

An example of the dreaded ankle chop. Try to avoid this like the plague unless you have a good reason for doing it.

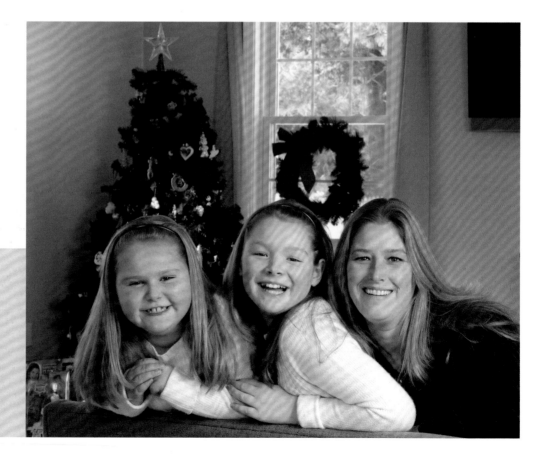

When it comes to every rule about portraiture, a great expression always trumps the rule. In this instance, the expression trumps the framing rules that will follow, but the same great expression could just as easily trump a lighting or posing rule.

the shape of things

Moving in for a tighter portrait, the issue becomes how to fit an oval into a rectangle. While this might sound like gibberish, to those interested in photographing people, it is a cornerstone of many great portraits. If I were to substitute the word "face" for the word "oval," you can easily understand my meaning—faces are essentially ovals and photographs are usually rectangular. When it comes to fitting basic shapes together, a phrase such as "fitting an oval into a rectangle" really gets to the crux of the issue. From here on, I will use "oval" and "face" interchangeably when talking about subjects in a portrait.

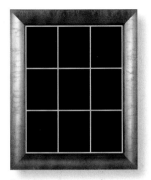

figure 1

the single oval and the rule of thirds

So, we are going to put the single face—the oval—into the vertical composition. But where to place that single oval in the rectangle is a question that has intrigued artists for centuries. Artists, and this includes photographers and the painters before them, have all faced this decision. Probably the most accepted placement for the face in a traditional portrait uses the "rule of thirds" theory. The rule of thirds divides the rectangle into 9 smaller ones by placing two lines across the rectangle horizontally and two lines across it vertically, creating a grid. Each set of lines divides the rectangle's horizontal and vertical sides into three equal parts. Classical composition suggests that for pictorial subjects, the primary subject should generally be placed at one of the intersections of the four lines **(see figure 1)**. But for many traditional portrait applications, you need only use the two horizontal lines **(see figure 2)**. Using the "single person is a vertical" rule and this "simplified rule of thirds," the subject's eyes are placed on the higher of the two horizontal lines and centered between the left and right boundaries of the rectangle. While the resulting effort can be considered a "clean" portrait, it's not very unique and certainly not daringly creative.

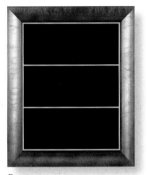

figure 2

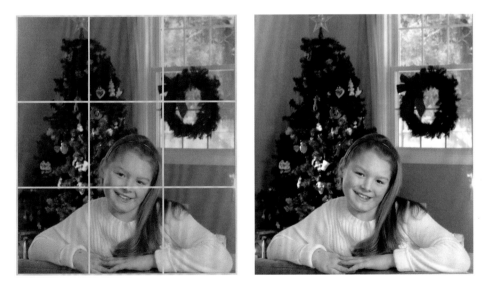

Here's what a generic face would look like when framed following the simplified rule of thirds.

While this portrait follows the simplified rule of thirds quite closely, it also places the subject's eyes on the lower line instead of the upper one. I did this specifically to include the Christmas decorations within the frame.

Even though the subject's expression is great, the lighting is perfect, and the pose is totally natural looking, this portrait—done for a model's portfolio—is just a clean portrait. In truth, it's squeaky clean—shaking things up can often yield interesting, more artistic results. But always remember the end use of your image—your client's desires should always be clearly understood and put first.

taking it a step further...

Using the "single person is a vertical" rule and the "simplified rule of thirds" will almost always result in an average viewer saying: "Whoa...now that's a good picture!" The two rules are worth knowing because of that, but elevating a "good picture" to a higher plane (maybe even to art) is another story entirely!

I've spent the better part of my life trying to figure this out and, consistently, as I sit here clicking off thousands (maybe tens of thousands) of images in my mind, the most memorable are almost always more than just another pretty face. So, for the moment, in an effort to break new ground, let's throw out both the "single person is a vertical" rule and the "simplified rule of thirds." While it's certainly good to know (and remember) these rules, breaking them can sometimes lead to a creative result.

To help you in your search to break new ground, here are examples of the two rules being broken. But the very fact that I am explaining them here means that they aren't new ground at all. Try using my "rule breaking" as a springboard for your own ideas.

Time for a rule bending moment. While this portrait follows the whole rule of thirds quite closely, it is also an example of a single subject placed in a horizontal frame instead of a vertical one.

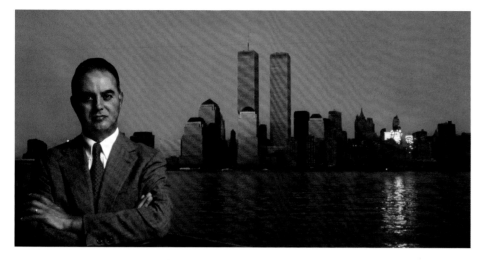

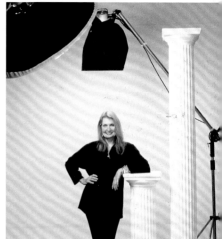

Although I took this photo a long time ago, the skyline of the New York financial district was the perfect background for this executive. To include the skyline in all its grandeur (and to balance his position with the highlight on the river), I had to throw away the idea of using a traditional print size.

This portrait of photographer Nancy Brown would be fine if I just framed her. But by pulling back and including some of her studio's décor and equipment, I told the viewer more about who she is.

1. Include something more than just the face of the subject, something that reveals more information about the person to increase the viewer's understanding of them. This is often called an environmental portrait because it includes part of the subject's surroundings. If this means using a horizontal or even a square frame to include the extra information, then so be it.

2. If you are committed to a horizontal format for a single subject, throw away the simplified rule of thirds and break your rectangle into quarters (or even fifths, if you care to). Then, while you are at it, throw away the idea that a portrait has to be a traditional size. 4 x 6 inch (10.2 x 15.2 cm), 5 x 7 inch (12.7 x 17.8 cm), 8 x 10 inch (20.3 x 25.4 cm), 11 x 14 inch (27.9 x 35.6 cm), and other standard-sized photographs are nice because camera and framing stores have those frame sizes in stock—but those standard-sized frames are an awful reason to determine what size rectangle your subject must fit into.

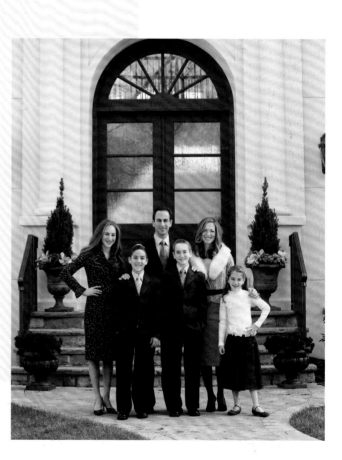

This effort, this goal to create something more than just "pictures," and the search for how to get your portraits above the competent (but often mundane) is not easy. But the effort of breaking new ground, in and of itself, is a worthy goal. If you want to see a roadmap for breaking rules, I suggest you take a long, serious look at a book entitled *One Mind's Eye*, a collection of portraits by Arnold Newman. This book is out of print, and therefore difficult to find, but it is worth the effort of searching for.

In environmental portraits, the background should be considered another subject in the photo. You are including it to say something about the lives of your subjects, so be sure the background is shot in such a way that your point is clearly made.

Now that putting a single subject into our rectangle has been covered, the next logical progression is to explore putting two, three, or four ovals within the frame.

putting a second oval into the rectangle

Let's cover two subjects first. If we follow the simplified rule of thirds described previously and arrange two subjects' faces side by side with all four of their eyes along one of the horizontal lines, it would result in a surprisingly dull picture. Why, you might ask? In the first place, with both faces arranged in the upper third of the composition, you end up with acres (a slight exaggeration!) of dead, uninteresting space that fills the lower two thirds of your composition.

The second reason requires a bit of background information: Lines running in different directions in a composition create certain feelings in your viewer's mind. Vertical lines create a feeling of tension; horizontal lines create a feeling of peacefulness (and dullness!); and diagonal lines create a dynamic sense of movement because the viewer's eyes follow along them. The feeling of movement associated with diagonal lines is worthy of further exploration when we place two ovals within our rectangle.

Instead of placing all four eyes of our subjects along a straight, horizontal line, which, as already explained, is both dull and creates a lot of unused, empty space, consider instead placing the two faces offset from one another—making one higher and one lower. This way, a line through the centers of the two faces becomes a diagonal, and our viewer's eyes travel along the diagonal line we've created, moving from one subject's face to the other.

Remember, there can be political implications to your composition. In this case, a hierarchal implication could be suggested by which face is placed higher in the frame. That being said, in an executive portrait situation I almost always put the higher-level person in the upper position.

aligning faces

More important is where the lower face aligns with the upper face. Should the eyes of the lower subject align with the upper subject's nose? The mouth? The chin? Although the easy answer would be for me to say, "It depends," you might then respond by saying, "It depends on what?" So let's look at this point more carefully. I've said that every subject is unique; however, the basic shape of their faces can be pigeonholed into two general categories: round and long, though they are both still ovals. There are also other geometric shapes such as rectangular (blocky) and heart shaped (pointy at the bottom), but these sub-categories fit within the round and long general categories. Regardless, round faces are always wider than long ones, and it is this distinction that affects where they might align!

Look for frames within frames. One of my favorite tricks is to arrange my subject(s) within the triangle created by the raised top of a piano. That makes two ovals, within a triangle, inside a rectangle. Consider windows, doorways, and archways as likely framing aids, too.

Two round faces. Note how the eyes of the lower face align with the chin area of the upper face.

Two long faces. Note how the eyes of the lower face align with the upper lip area of the upper face.

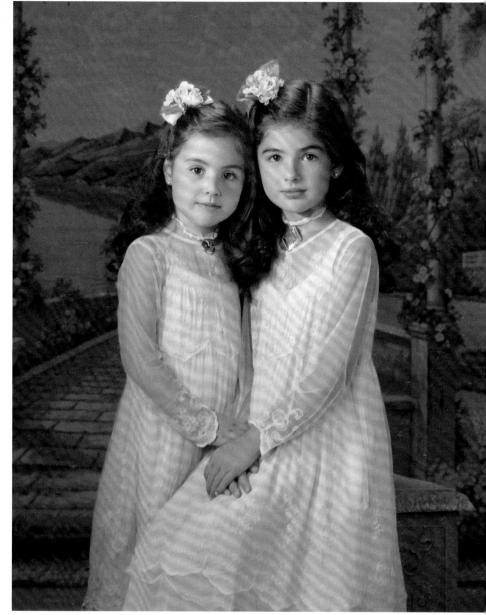

© LOUISE BOTTICELLI

If your subjects have round faces and you align the eyes of the lower subject with the nose of the higher individual, you have shortened the perceived height of both faces when viewed as a whole, and this makes the faces look even wider and more round. This is because the combined width of the subjects is now larger than their combined height. In these cases, it's better to align the lower face's eyes with the chin of the upper subject.

The inverse is also true. If your subjects have long faces and you align the eyes of the lower subject with the chin of the upper face, you have lengthened the perceived height of both faces because the combined width of the subjects is smaller than their combined height. Instead, try aligning the lower face's eyes with the nose of the upper subject when shooting long faces.

As a general rule (obviously ripe for breaking!), round faces benefit from lengthening the vertical component of the composition by aligning the lower face's eyes with the upper subject's mouth or chin. Long faces benefit from shortening the vertical component of the composition by aligning the lower face's eyes with the nose or mouth. Notice that in both scenarios, the mouth is a shared point of alignment because it might be considered the perfect place to align two "average" (if there were such a thing!) faces. Keep in mind there are infinite gradations between the general round and long categories, with "average" being only a midpoint. This brings me to a final point that should always be remembered: When dealing with faces, a difference of just a quarter or half-inch in width or length is a very big deal, and even though it seems a tiny amount, keep this fact in mind when composing a portrait with two or more faces. It can have a huge impact on the final picture!

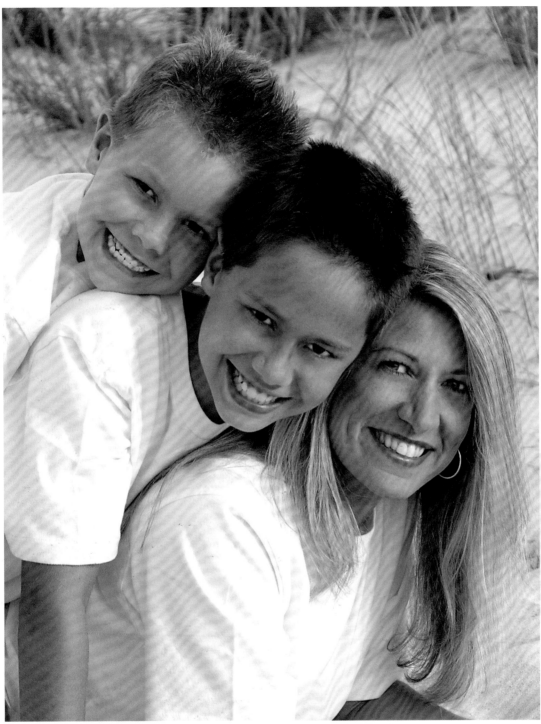

© LIZ AND JOE SCHMIDT

three in the frame

Three ovals within the rectangular picture frame can follow the same diagonal line guidelines as two ovals, but the difference in alignment between the faces must be tightened up so you don't end up with a tall, thin composition, unless that's the effect you're trying to achieve.

However, the third oval presents other interesting possibilities. A triangular arrangement might come to mind immediately. Quite simply, you can arrange each of the three ovals at the corners of the triangle. Using this arrangement, you have two possibilities. Two of the faces can be positioned along the bottom of the frame while the third is centered above, or you can have one face centered at the bottom of the frame and the other two faces towards the top, flanking the central, lower one. Each possibility is workable, but I prefer the two faces towards the bottom of the frame because they then form a stable base for

the triangle. Conversely, with one face at the bottom of the frame, the resulting triangle is resting on a single face which represents a point and gives me the uneasy feeling that the triangle will topple over. While I will use this arrangement if the subject calls for it, such as a small child flanked by two parents, I prefer the stable feeling created when two faces are in the lower position.

To play devil's advocate for a moment, you could also arrange two of the ovals along one side of the rectangle with the third oval on the opposite side of the frame. Or use a triangular format that doesn't follow an equilateral triangle, one in which all three sides are different lengths. While which type of triangular arrangement you choose is dependent upon both your preference and the type of subjects you're photographing, either can work and should be remembered as a possible treatment of three ovals within the rectangular frame.

and finally, we have four

Four faces within the rectangle can be handled either as a modified triangle, with the fourth face at a midpoint on one of the triangle's sides, or as if you were handling two pairs of two faces. This means that all the arrangements I've touched upon for both two and three faces will work in modified form for four subjects as well.

As I've repeatedly said, and will repeat once again, all of these rules and ideas are nothing more than jumping off points for your own creativity in how you arrange your subjects' faces within the boundaries of your frame. There are no rules in this game that are unbreakable and, in fact, any idea that you come up with that is different than the ones I've offered are worth exploring! That being said, I am also a firm believer in learning the lessons of history, and I've studied how artists (painters, sculptors, and photographers) have handled and chosen from the same options that we still work with today. Importantly, our subjects have often seen the same artwork that we as photographers have seen, so they are often pleased with photographs that emulate these compositions. This in itself is a point well worth remembering.

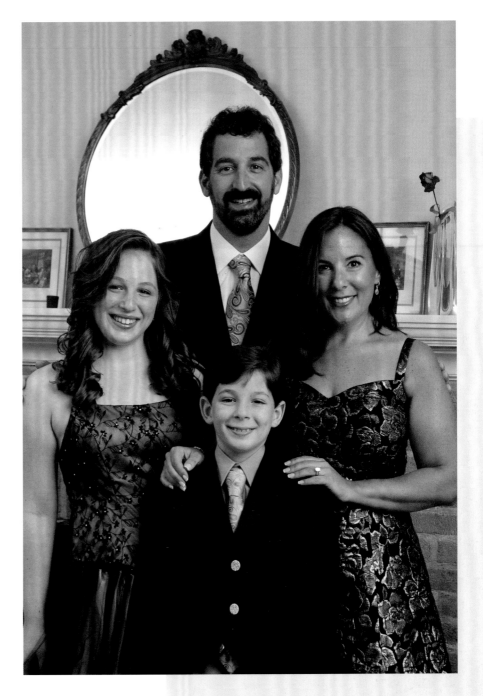

Because of the perfect relative heights of my subjects in this example, I threw caution (and triangles!) to the wind and arranged my four subjects in a diamond shape.

With all my admonishments about not putting subject's heads in one straight, horizontal line, one would think they should never do a portrait arranged in this way. But there are no hard and fast rules—sometimes it's best to go with what feels natural.

framing vs. format

Let's spend a bit of time on the format of the final portrait prints you're going to make. In my pure, idealistic days I filed out the 35mm negative carrier of my Omega enlarger to prove to the world that I was only showing full-frame prints. As if that little, ragged black border around my pictures somehow made them better! This artificial impediment means that if you shoot a 35mm or D-SLR camera, all your photos must be in a 2:3 proportion; if you shoot a square format roll film camera, all your photos must be in a square 6:6 proportion; and if you shoot a 4 x 5 camera, all your photos must be in a proportion of 4:5. But who really cares? Does this mean that if I want to shoot a panoramic photo in the proportions of 6:17 I have to buy (or rent) a 6 x 17 Linhof or Fuji camera? Of course not, thanks to cropping. It is the subject or the application that determines a photo's format, and not necessarily the camera.

Although photographers raised on a 35mm or digital SLR often revere the 3:2 proportions of the 35mm frame as something approaching perfection, I disagree with this premise for many portrait situations. Although I can appreciate its beauty for many pictorial subjects, I don't think it is particularly suited for most portraits. The 3:2 proportions are too long for both vertical and horizontal portraits. There are some who will argue that the standard 8.5 x 11 (21.6 x 27.9 cm) page size and the 5 x 7 (12.7 x 17.8 cm) print size are not really the same as true 4:5 proportions, but I can say that both are close enough for most practical purposes!

working with proportions

Although I once was, I am no longer hung up on the proportions of the film or the chip size in my camera. As proof of this I can attest to the fact that I've shot tons of huge family and employee group photographs that fit best into the longish proportions of the 2:3 frame, and thousands of portraits that can fit into the 4:5 proportion, but look less tight and more comfortable as squares at the 6:6 proportion. Equally true, I've shot hundreds of panoramic environmental portraits in weird proportions such as 6:12 and even 6:17 because that's what looked best for the subject at hand.

Thankfully, a solution to this dilemma is easy. My 6 x 6 cm cameras have four pieces of very fine Chartpak tape on their viewing screens to define both vertical and horizontal 4:5 proportions, and I've taught myself to disregard the last 1/8 inch on either side of my 35mm film cameras' viewing screens. Likewise, while my current D-SLR can provide 3872 x 2592 pixels (approximately 3:2 proportions), I'm usually only interested in 3240 x 2592 (8:10 proportions). To some this may seem strange, but I'm also perfectly willing to use all 3872 of the pixels available from my camera if that's what the subject requires.

It is also worth mentioning that both society and technology have an effect on the perception of what is professional. While the professionalism associated with the current proportions of the 8 x 10 (20.3 x 25.4 cm) format has been reinforced by the proportions of printed publications, television screens, and computer monitors, that is beginning to change. In other words, changes in technology or culture can sometimes affect society's tastes. The current crop of HDTV and LCD computer monitors is closer to the 3:2 proportions than the more traditional 4:5 proportions of the past. This means that as high-definition and widescreen technology becomes more widely accepted, the 3:2 proportions may become the more accepted standard. Most importantly, you should always be aware that what's considered "correct" or "good" is forever in a state of flux, and those definitions can change as easily as what's considered "in" or fashionable.

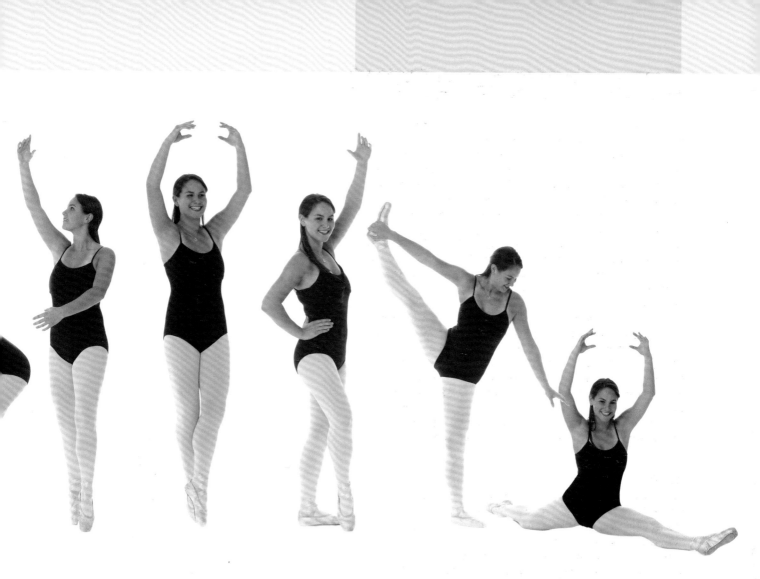

Technological and societal changes always have an effect on what is considered professional and up-to-date. Thanks to widescreen TVs and monitors, proportions typically reserved for landscape photography are becoming more popular.

framing for profit

Many portrait photographers offer framing services that can often become very profitable. I realized this many years ago when I bought a signed watercolor and took it to a framing shop. While the price of the print was $150, the tab for the framing, non-glare glass, and custom, acid-free mat was close to three times the cost of the artwork! Custom print sizes demand custom frames and these are always sold at a premium over standard-sized frames. If you offer framing services, the custom frame should also mean a premium in your profits.

scale

Okay, we've covered how to fit single subjects, groups of subjects, and faces of subjects into the frame, so the next issue is how large we make the items in the frame. You're probably going to hate this, but the answer is "It depends." What I am talking about here is a thing called scale, and your scaling choices depend on a few things.

First is how the picture will be used. An actor's headshot should be just that—the actor's head. An environmental portrait demands that the subject is smaller within the frame so there is room to include background details. The picture's purpose should play a role in the scale of the subjects.

© LEN DEPAS

© JAN PRESS PHOTOMEDIA, LIVINGSTON NJ

Another factor to consider is how big the final print will be: Are you making a 24 x 30-inch (61 x 76.2 cm) family portrait for the living room wall, an 8 x 10-inch (20.3 x 25.4 cm) print for a piano or end table, or an 8 x 10-inch (20.3 x 25.4 cm) public relations portrait of an executive in all its glossy glory? Subject scale is often determined by viewing distance. How far away will the viewer be when they look at the picture? Will they be holding the print in their hands and looking at it? That's usually seen from a distance of about 15 to 18 inches. Is the photograph to be hung over a fireplace? That usually means a viewing distance of 3 to 10 feet (1–3 m). Is it a boardroom portrait seen from the end of a 20 or 30-foot (6–10 m) long table? Obviously, you want your subjects to be easily viewable and natural looking from their intended final distance. Keep this in mind as you compose and crop your portrait photographs.

Generally, I have found that the subject's head shouldn't be bigger than life-size. If you make it larger, there is a risk of the subject looking like a cartoon; you might even say that a larger than life-sized head has a scale that is gross. To imagine this, think of Andy Warhol's huge print of Marilyn Monroe's face—it's almost a caricature. There are photographers who like to get in really close and fill their frame with a big face. I occasionally even do it myself. If this is your cup of tea, and your style, then remember to consider the following.

Understand that a larger than life-sized head demands more perfection from your subject. An insignificant mole becomes much more significant if the portrait is blown up to 24 inches (61 cm). Likewise, a slight case of beard stubble on a chin can pass in a smaller than life-sized image, but can also quickly morph a CEO into a derelict on a larger than life representation. This in itself is a good reason to discuss grooming with the subject beforehand, and to plan your portrait session well before the 5 o'clock shadow hour rolls around.

Even if you keep the subject's head size smaller than lifesize, how large it is in relationship to the frame has to be considered too. There is a composition rule that states shapes (such as an oval face) whose edges just touch the edge of the frame create tension. The point where the shape touches the frame edge is called a tangential point and, in general, it's something to avoid. You can go in closer or back off so as not to graze the edge. But I can tell you from experience that if you fill the frame of a 5 x 7 (12.7 x 17.8 cm) print so the subject's face just touches all four sides of the print, your result will not play to accolades!

If you're going to go for a big face within the frame, my suggestion is to not stop at a point where the four sides of the face meet the frame's edges but, instead, move in even closer and go for it!

break these rules!

Although these rules are helpful, it is very important to remember that nothing in photography is cast in stone and that every rule can be broken if the spirit, subject, or the way in which the picture will be viewed (such as on a computer monitor) demands it.

Often during a portrait session I perspire. This is not because the work is physically difficult, but instead because dozens (hundreds? thousands?) of options are flashing through my head. As I zip through my list mentally, while also chatting with and relating to my subject, I choose to observe some rules and discard others as irrelevant or unimportant. Breaking rules can be creatively and financially rewarding; however, if magazine photography is your goal, you'll never get the cover shot if you don't frame your portrait as a vertical. So break or follow the rules, but base the choice on the final outcome you desire.

chapter three
lighting basics

Forget about your cool camera and all of your cool lenses, at least for a moment. Why, you ask? Well, to put it bluntly, if you don't have knowledge about light, these tools are worthless. So even if your camera and lenses are top-of-the-line, you'll never get the consistent, quality results you and your equipment are capable of without understanding the connection between light and photography.

One of the most important considerations in your portrait photographs is the quality of light that illuminates your subjects. As photographers advance in knowledge, they rightfully become more interested in the quality of light rather than the quantity of it. So before we get into all the equipment, and all the different ways it can be used to modify or enhance lighting, we'll take an in-depth look at the two basic types of light: soft and hard.

the types of light

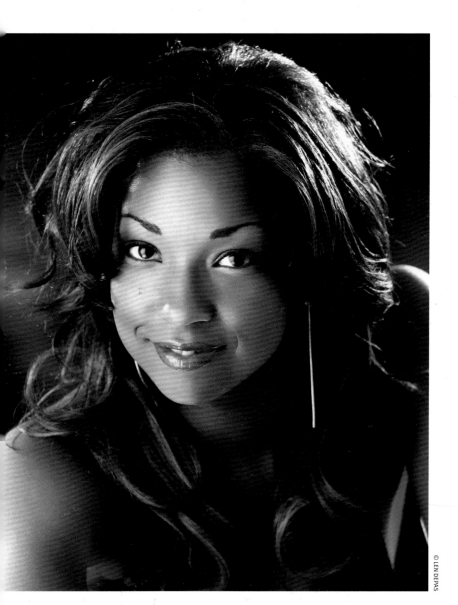

© LEN DEPAS

The face of this subject is primarily lit by a soft, large, main light that illustrates the type of soft-edged shadows a broad source creates. What I find particularly interesting is the second main light (or reflector) below the primary one (you can see it in the catch lights in the subject's eyes). Usually, a single light from directly below the subject is associated with the term "horror lighting" because it creates a shadow above the subject's nose and lights their eye sockets unnaturally, but here, because it's used in conjunction with a higher main light, it adds a sparkle to the subject's shadow side cheek and dimple.

If you've done a small amount of portrait photography in the past, you're probably familiar with the difference between soft and hard lights. But even if you're new to the concepts, you probably already have a good idea of what makes for nice lighting in a portrait, from your everyday experience. As you may have noticed, people look best when lit by a broad, smooth light source (a soft light) that lacks the crisp, harsh shadows often associated with hard light. We'll review how to identify these light sources, and how to use them for your portraits.

soft light

Before photography was invented, painters had their studios fitted with big, north-facing windows because they wanted their subjects lit by a large, but not harsh, light source. Today, every photographic catalog has a lighting section filled with reflectors, diffusers, big umbrellas, and bank lights, all of which can be classified as light modifiers and, for the most part, large light sources. In fact, these light sources are so common that almost everyone's mental image of a fashion photographer includes lights flashing into big umbrellas. Big lights are so ingrained in our society's concept of photography that most people can't imagine a studio photographer without them. Why are they so ubiquitous now, and why did artists of old paint by the light of a large, north-facing window?

The answer to both questions is that big light sources, often called broad light sources, create beautiful, diffused "soft light" that flatters the illuminated subjects. And once you understand why this soft light works so well for taking pictures, you will take advantage of commonly available light sources to create beautiful light for your portraits.

the anatomy of soft light

Experienced photographers will tell you that broad light sources "wrap around" the subject they are aimed at, or that they put out a soft light. But because light rays only travel in straight lines, they can't really wrap around anything. What these photographers are trying to put into words is how a big light source differs from a little, or point, light source. That difference is best exemplified in the shadows they create.

Figure 1 shows a person being illuminated by a broad, 55-inch (139 cm) umbrella. **Figure 2** uses a flash, or 2 x 3-inch (5 X 7.6 cm) point source, to illuminate the same subject. Both light sources are five feet (1.5 m) from the subject (but in the umbrella figure, the distance is measured from the center of the umbrella's surface and not from the light source), and the two figures are drawn to the same scale. Notice that the size of the broad light source lets its edge rays reach farther around the subject so, in a way, the broad source does "wrap around" the subject, but not because the light rays bend or curve. Since broad source lights are larger, they cast smaller, less harsh shadows on your subject.

umbra and penumbra

Not only does a broad light source make smaller shadows than a point light source, but the edge of the shadow's pattern is also more graduated. That is why broad light sources are often called soft lights.

A shadow is made up of two parts called the umbra and the penumbra. While the umbra part of a shadow is the total absence of light, the penumbra is the lighter part of a shadow that is partially illuminated. Point light sources have a very small penumbra (basically irrelevant in real-world situations), while broad light sources have a much larger penumbra. It is this larger penumbra that makes the shadow's edge more gradual (softer), and this is what helps minimize the subject's flaws. Look at **figure 3** to see where the penumbra is. **Figure 3** is the same as **figure 1**, but this time I have shaded the penumbra in turquoise and the umbra in red.

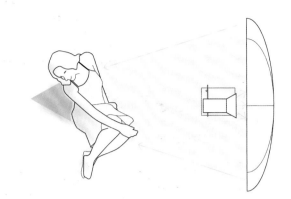

figure 1
This figure illustrates the shadow created by a broad light source.

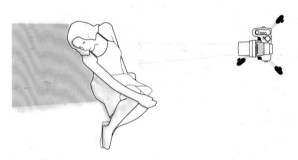

figure 2
This figure shows the shadow created by a point light source (a typical flash unit).

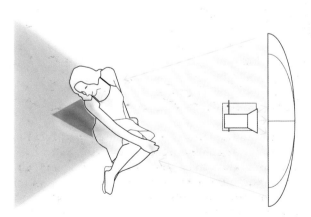

figure 3
Here, you can see the two parts of a shadow: the umbra (in red) and penumbra (in blue).

what it really means

To illustrate what this means in a real-world situation, I cut the eraser off a pencil and glued it to a mannequin's forehead. I then took a picture of the eraser with the 55-inch (1.4 m) umbrella light and the 5-inch (12.7 cm) diameter point light source. Bearing with me for a moment, let's make believe the eraser is a large pimple on your subject's forehead. Accepting the fact that this would be a very big pimple in real life, notice how the broad source light minimizes it **(figure 1)** while the point source light accentuates it **(figure 2)**. It's actually the shadow each light source creates that calls more or less attention to the pimple.

figure 1
Note the penumbra caused by a broad light source.

figure 2
Now compare figure 1 to the image shown here, where the shadow cast by a point source light includes much more umbra than penumbra.

natural broad sources

If you don't yet work with photographic lights or flash units and prefer available light, learning the concepts covered in this section will improve your photos. However, keep in mind that while you can use natural, available light to make nice portraits, understanding and using photo-specific lighting equipment allows you to make beautiful portraits when quality natural light isn't available. After all, a professional doesn't have the luxury of only doing assignments on perfect days. That said, let's talk about the most obvious natural light sources: the sun and sky.

Because we know that a small flash is a point source and a large umbrella is a broad source, we can apply these traits to their larger, natural counterparts. Therefore, the sun can be considered a point source while a big patch of open sky without the sun in it is a broad source. Since broad sources of light create the most pleasing portrait photographs, it's generally this type of light that we're looking for, and it's often referred to as open shade. Open shade can be found in just about any outdoor area that is shaded from the direct rays of the sun and is still lit by a large section of the sky. Imagine shooting a subject on the west side of a building at about 10 AM and you're getting an idea of how open shade looks. Broad lighting is one reason why so many pros (including myself) look for open shade when shooting outdoor portraits. And while the sun offers better, more natural color than the bluish sky found in open shade situations, simply changing your camera's white balance—either by using an open shade preset or changing the Kelvin temperature from 5600K to 5900K or 6300K—can correct for those open sky blues in a jiffy. By placing your subject in open shade, you'll end up with a quality of light that will minimize your subject's skin imperfections, and the resulting photograph will be one your subject will probably prefer over one lit by direct sunlight.

Another example of a naturally occurring broad source is the sky on a cloudy day when the sun casts no distinct shadows. Like open shade, cloudy days are also bluish in color and the color balance adjustment mentioned above can also correct this problem. In fact, if you adjust your camera's white balance and are careful not to include the sky in your background (because it's often bland), this type of light is amongst the most flattering for portrait pictures. At the same time, a point worth considering is that while open shade or an overcast sky offers a beautiful quality of light, it is missing another important feature—directionality. While the omni-directional light found on cloudy days is pretty, light from a single direction is an important tool in the portrait

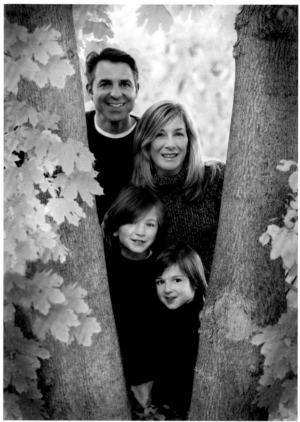

Shooting on overcast days helps keep contrast low and makes subjects look natural. Just remember to adjust your white balance to compensate for the bluish color common to cloud-diffused light.

photographer's bag of tricks. Single-direction soft light creates shadows, and these shadows can make your subject look three dimensional instead of flat like a cardboard cutout. Shadows are also important to the portrait photographer because they can hide subject imperfections. So while I prefer soft light for the majority of my subjects, what I really want is soft, directional light.

When the sun isn't shining directly in through a window, it makes a pleasing broad light source. Windows with a northerly exposure never have sun shining directly into them, which is why painters almost always used them in their studios. Keep in mind when shooting with northern window light that you will probably need to adjust your white balance (see the Kelvin temperature chart on page 95).

hard light

The opposite of broad light sources are small point sources, which create hard-edged, inky black shadows. Hard lights produce light that looks crisper than a soft light, making the details of your subject appear to be etched from a block of granite. Hard light will accentuate wrinkles and laugh lines, hair, and any skin imperfection it wipes across. So, when would you want to use it to light a portrait subject? Good question—the answer is, not often. But before you dismiss the idea of using a hard light for portraiture, note these exceptions: It works very well for the craggy sea captain types, subjects with ripped muscles, and it's perfect for the hard-edged stare of a business magnate. Furthermore, when you combine it with a soft light, it can also be used as a hair light (discussed in detail on page 128), or to accentuate a detail such as expressive eyes. While using a soft light is the general rule, a hard light's edginess makes the rule sometimes worth breaking.

In this portrait of artist and sculptor Yankel Ginsburg (below), you can easily see the hard-edged shadows created by a hard light. Portraits created using this type of lighting are often great in black and white because the lack of color accentuates the drama. Since no fill light or reflector was used to open the shadows on the subject's face, the hair light's spill (hitting the subject's unlit cheek and ear) helps define the unlit side of the subject's face.

By placing your subject in open shade, you'll get a more flattering quality of light.

Before we can continue, we have to spend a moment on lighting vocabulary so that we are all on the same page. Don't worry; there won't be a test! But after you read this chapter, if you understand the concepts so well that they become ingrained, you'll be better prepared to satisfy both your subjects and yourself as an artist and business person. While we won't cover some of these concepts for a while, just familiarize yourself with the terms for the moment and stick the information in the back of your head.

Bank (softbox):
A hollow, soft- or hard-sided box or trapezoid with a light shining into it from one side and exiting from the other side after passing through a diffuser. (figure 1)

Barn door:
A flat plate of any material attached to the side of a light that limits the width or height of the light's beam. (figure 2)

Continuous light source:
The sun or any other continuously shining light source.

Diffuser:
Any translucent piece of material that interrupts a light's beam and spreads it out, making it softer before it illuminates the subject (see the definition for Translucent on the following page).

Fill (light):
A light usually positioned on the opposite side of the subject from the main light whose job is to lighten the shadows caused by the main light.

Grid:
A piece of metal honeycomb that is positioned in front of a hard light to narrow its beam. (figure 3)

Instantaneous light source:
Electronic flash unit. (figures 4–7)

Latitude:
The range of illumination levels that can be recorded by a camera's sensor while preserving detail in both the shadow and highlight parts of the subject.

Main (light):
The primary light that illuminates a subject.

Modeling light:
A modeling light (or lamp) is a continuous light source, often an incandescent or halogen bulb, which is built into (or combined with) a flash unit to approximate the light the flash tube will produce. This helps in positioning the flash.

Opaque:
Any object or material that doesn't let light pass through it is opaque.

figure 1

figure 2

figure 3

figure 4

figure 5

figure 6

figure 7

figure 4 A small battery powered flash unit (Nikon SB-800)
 mounted in a camera's hot shoe.
figure 5 A Profoto Compact 300 self-contained,
 AC powered flash unit.
figure 6 A Dyna-Lite 1000 watt-second pack.
figure 7 The head used in conjunction with the pack.

Pattern:
The shape and size of a light's beam when it hits the subject.

Reflector:
Any surface that casts the light beam in another direction. Reflectors might be round and surround a light, or they might be a flat surface.

Snoot:
A tubular-shaped device that limits the angle of a light's beam. A snoot modifies light similar to a grid but it is more bulky.

Spill:
The part of a light's beam that is wider than, and thus not contained by, a reflecting surface.

Translucent:
A material, such as frosted glass, that allows light to pass through it while diffusing it. Translucent materials change the quality of the light passing through them, creating a broader light source. (figure 8)

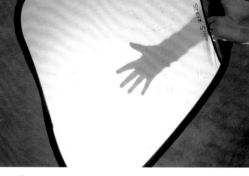

figure 8

Photographic umbrella:
An opaque or translucent umbrella with a white or reflective inner surface that you aim a point source light into. The light from the point source bounces off the umbrella's inner surface and is then redirected to illuminate the subject with broad light. Or, in the case of a translucent umbrella, the light passes through the inner surface of the umbrella and exits through the outer surface on its way towards the subject. In this second case, the umbrella is acting as a diffuser.

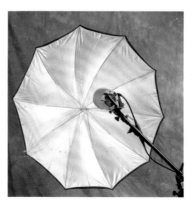

So now you understand the differences between soft and hard light, and hopefully you have decided that a broad source is the best choice for the majority of portrait situations. You also have some definitions that will help you understand the concepts that follow. In the last two sections, I focused on the general qualities produced by broad and point light sources. Before I get into the big guns of lighting equipment in the following section, let's first look in detail at windows as a broad source of naturally occurring light. Just like in the days of portrait painters long ago, great pictures can be taken with nothing more than the light coming in through a window. So if you're shooting on a budget and are short on lighting equipment, or just want to focus on natural lighting, windows are a minimalist tool that can produce great results.

Windows are a broad light source that are in almost every room, produce only natural light, and are usually the shape of a bank light. In fact, the only difference between a window and a bank light is that a bank is easily movable and a window is not movable at all! So, the trick is to position the subject to achieve the lighting effect you want. Sometimes I laugh when a young photographer who hasn't thought this through shows me a photograph of a subject standing in front of a window with their back towards it, and then claims that it is a portrait done by window light. Usually it's a flash on the photographer's camera that lights the subject, and the window is not a helpful light source at all, but simply the background. In this instance, the window lights just the back of the subject—the side not seen by the camera.

Obviously, this is not what I mean when I suggest using window light. As a general rule, light sources that illuminate the subject are usually best left out of the portrait's frame.

The trick is to shoot across the window's light, with your subject on one side of it and you on the other. If you scrunch yourself up against the wall, move your subject a little bit away from the wall, and then turn your subject towards the camera (and thus towards the window) you'll end up with the window creating the light you would get from a bank light placed 45° off the lens's axis. **Figure 1**, which is a diagram of this scene, will help you sort out the details.

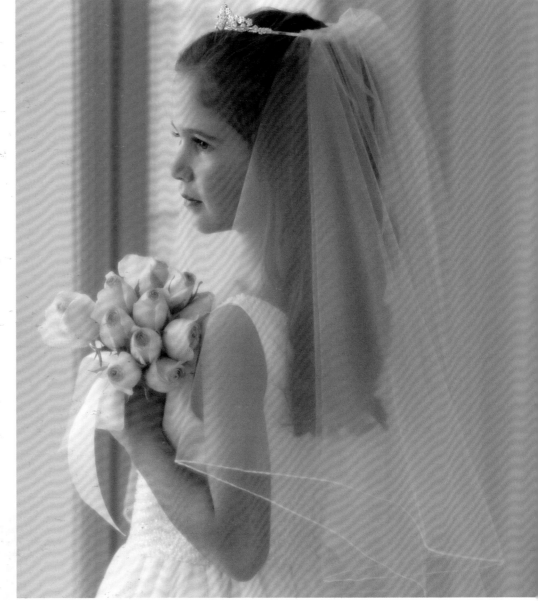

Using windows can be a great way to light a subject when looking for a minimalist approach to lighting.

© LOUISE BOTTICELLI

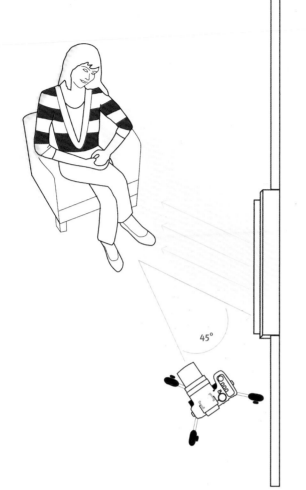

figure 1
Try using this setup to get nice results using window light.
Remember, your subject should always be turned towards the
window; otherwise, you'll end up with a silhouette.

hatchet lighting

Sometimes photographers get half of the positioning game right
by placing themselves to one side of the window, but then place
the subject so the window is directly to the subject's side. In
this instance, the light from the window hits the subject along
a vertical axis, with half of the face fully lit and the other half in
inky black shadow. While this is all well and good if you want
to replicate the lighting on the *Meet the Beatles* album cover,
it might not be to your, or your subject's, liking. This kind of
lighting is called hatchet lighting because of the sharp edge
between the light and dark sides of the subject, and used
without modification it is something I usually try to avoid.
There are two easy fixes for this, but before I point them out
it is time for a rule breaking moment.

So I just used the word "fix" to describe changing
the extreme contrast that results in hatchet window lighting
when, in reality, there may be nothing to fix. Portraits of this
nature are roughly equivalent to a similar photograph that,
as mentioned above, graces the cover of a Beatles album.

This dramatic photo was taken by placing the subject at a 45° angle to
the window and shooting across the light.

An example
of hatchet
lighting, where
half of the
subject's face is
lost in shadow.

Who am I to argue with the correctness of a Beatles album cover? Sometimes "fixing" a picture results in a portrait with less impact, and oftentimes to fix or not to fix a picture boils down to a matter of taste or intention. Generally, I try to avoid inky black shadows in my portraiture, but in certain situations, inky black shadows can add impact and drama to your photographs.

correcting harsh shadows

There are two good ways to fix hatchet lighting. The first involves adding some light to the shadow side of the face. This can be accomplished by using a fill flash, but it requires delicate control over the flash output so that it doesn't overpower the main window light. Another possibility that doesn't require a flash unit, is easier to control, and still uses minimal equipment is to use a fill card or a reflector. While a fill card can be something as simple as a white piece of cardboard, a reflector designed for photography can be used more easily in other photographic situations. It is also more portable because it collapses for transport or storage. Plus, if you choose a translucent reflector instead of an opaque one, it can do double duty as a tool to soften (diffuse) a hard light source.

Reflectors/Diffusers

I currently use three different brands of flexible reflector/diffusers, and all consist of a spring steel hoop with a white translucent cloth stretched over it. These can be folded into itself, making it about $1/4$ smaller than when it is snapped open. While there are other brands, the ones I currently use are the Flexfill from Visual Departures, the Lastolite Tri-Grip imported by Bogen (which is smaller than the other two and has the advantage of being able to be held in one hand), and my current favorite, the LiteDisc made by PhotoFlex. Although all are relatively inexpensive, for years I made mine from a diffusion material called Tough Lux (available at setshop.com) stapled over simple square and rectangular frameworks made from four pieces of 1 x 2 lumber held together by inexpensive angles found in hardware stores. While these are still perfectly suitable, and maybe even better because you can make them whatever size you want, you do give up portability in exchange for their low cost and customization possibilities.

Be aware that if you do try making your own diffusers, Tough Lux can give you terrible paper cuts, and the spun fiberglass materials often used for light diffusion by cinematographers can leave uncomfortable, microscopic shards of glass fiber in your skin (and possibly lungs). Approaching these materials with caution is a good idea.

Adding light to the shadow side of the face helps open up the shadows for a more traditional portrait picture.

Regardless of whether you use flash or a continuous light source (such as a quartz halogen light), one step up from using available light, or available light combined with a reflector or diffuser, is to add a single artificial light source to your portrait lighting arsenal. But before I delve into the ways to use a single light, I have to take a time-out to relate a short story to you.

When I first started in professional photography, I worked as an apprentice to a New York photographer. While I worked for nothing at first, I eventually got a salary that was in the form of bartering. I worked from 9 AM to 5 PM, and in return he allowed me to use his dark room from 5 PM to 9 PM For a young, starry-eyed beginner, this was great! I led a simple monastic existence; my wardrobe consisted of one pair of jeans and a few tie-dyed T-shirts, and my diet was made up primarily of all the photographic paper and developer I could eat and drink. My camera gear consisted of a Canon TL-QL, but I soon depleted my meager life savings on a used Leica M-4, two lenses, and a Gossen Luna-Pro light meter. The reality of my budget crisis led me to declare that I only shot pictures using available light. In making that declaration, I also conveniently glossed over the fact that I didn't know how to use lights anyway. One afternoon, as I extolled the virtues of working by available light, my boss posed a question. He asked me that, if I had a car (a farfetched concept at the time) that had an 800 watt-second studio flash unit in the trunk (even more unlikely) when I was on an assignment, wouldn't that light also be "available?"

As I sputtered, trying to figure out an answer to his joke, it occurred to me that he was right. His point was that there is no such thing as an artificial light. Light is just light. It doesn't matter if it comes from nature or from a box assembled at a factory in Hoboken, New Jersey. Regardless of where it comes from or who made it, what you should be interested in is whether it is of sufficient quantity and, more importantly, quality enough to allow you to make beautiful pictures. There's no point in limiting yourself with artificial impediments about where the source of your light comes from.

There is a lot you can do with only a single light (or flash unit). While all of the D-SLR manufacturers would like that single light to be one of their brand-specific flash units slipped into their camera's hot shoe, the primary result of a camera-mounted flash is a featureless, frontal light whose quality is the rough equivalent of a coal miner's helmet lamp. In fact, when used in the direct flash mode, it's main attribute has little to do with quality and more to do with providing enough quantity of light to make the photograph. While a single, camera-mounted flash unit has the tremendous advantage of portability and compact size, everyone with even a small bit of photographic knowledge understands the limitations imposed by a single, direct, hard light mounted above the camera's lens. This book is not about portability or compact size, but instead about great portraiture. So let's look at other ways to use that single flash mounted in your D-SLR's hot shoe.

Here is the built-in fill flap on a Nikon **SB800** (top) and a bigger one made from a 4 x 6 index card that I prefer (bottom). Even though the card is held on by a rubber band and has to be replaced whenever it gets hopelessly crumpled, I prefer it because it is twice as large and works well in average-sized rooms with white ceilings.

ceiling bounce

One method of modifying the light from a flash unit is bouncing the flash unit's light off the ceiling. Most shoe-mounted flash units have this ability thanks to a swivel mount in the flash head that allows it to be aimed upwards. However, unlike many photography pundits, I find using ceiling bounce alone results in lighting that is very unappealing. Often, the ceiling adds a color cast to the light, and although I find many shades of white or off-white ceilings will give you passable color, using a light blue or light green ceiling will result in your trying to correct the color cast on your computer. But let's assume, for now, that you are bouncing flash off a white ceiling and review some of the results you might expect.

Although using ceiling bounce will give you light that comes from a natural direction (above, like the sun) the resulting light direction will also create shadows in the eye sockets, under the nose, and under the chin of your subjects. Additionally, any horizontal wrinkles in your subject's face will be amplified because the ceiling bounce will create a shadow under each of these lines.

Camera manufacturers know all about this, because many of the shoe-mounted flash units come equipped with a small white reflector card that can be positioned behind the flash's primary reflector; when used, it pushes a small amount of the upward-traveling light forward, which fills in the shadows created by the ceiling bounce. Actually, an entire cottage industry has grown up around curing the problems created by ceiling-bounced light, because used without some form of augmentation, it is not very flattering.

To name a few, Stofen makes a translucent cap for many flash units, LumiQuest has a variety of small, flat accessory reflectors that, when attached to the flash head with Velcro®, push some of the light forward, and Gary Fong offers rubbery-type reflectors that accomplish approximately the same thing. Although ceiling bounce when used with any of these modifiers can create passable lighting, the most generous compliment I can pay it is that it should be reserved for working fast with the least amount of equipment.

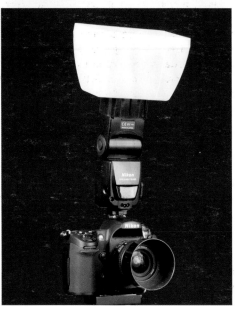

top: This is the standard diffuser cap that comes with a Nikon SB800, which is similar in size and shape to Stofen's version.

middle: This is the Gary Fong LightSphere, which many photographers call a "Fong Dome."

bottom: This is my current favorite (because it is the largest)—the Harbor Digital Designs Ultimate Light Box. I feel the size of the Harbor Designs box is the best if you're working with small, battery-powered flash units.

wall bounce

Although I'm not a great fan of ceiling bounce with or without some form of modifier, that doesn't mean I'm against all forms of bounce lighting. Not counting using umbrellas (which is really just another form of bounce lighting), I am also a great fan of wall bounce lighting. Like using ceiling bounce lighting, getting great in-camera results from wall bounce requires that the surface the light bounces off of is either white or some shade of white. Color casts—and the effort required to fix them with computer manipulation—are best avoided if at all possible.

One primary advantage of bouncing off the wall instead of the ceiling is that the direction of the light is from the side as opposed to overhead. This has a lot of benefits. First, you eliminate the eye-socket shadows associated with ceiling bounce, as well as the less bothersome, but still unpleasant shadows under your subject's nose and chin. Second, because the main light is coming from the side of your subject's face as opposed to above it, the wall-bounced light can create shadows that will make the face appear more three-dimensional.

At the very beginning of this book I discussed the idea of looking for global rules so that you can take something you learned in one situation and apply it to a different one. Well, wall-bounced flash emulates the lighting that you can achieve when using a window for your light source. This means that you might want to avoid bouncing a light off the wall directly opposite your subject (it will give you hatchet lighting), and instead aim your bounce light so the splash of light hits the subject at a 45° angle. You can usually accomplish this by aiming your light so it hits a spot on the wall that is about halfway between the camera and your subject. Equally true, just as when using a window for your light source, wall bounce is often more pleasing when you add a fill reflector to redirect some of the wall-bounced light into the shadow side of your subject's face.

Every one of the previously illustrated ceiling bounce products offers various colored filters as accessories that can be used to change the color of the light output for a special effect (see the gelled grids in the Advanced Lighting Chapter). If you want to experiment with colored gels and a small, battery powered flash unit, I suggest you get a filter swatch booklet so you have many more choices than the dome manufacturers offer. If the swatches are smaller than your flash's reflector, use some opaque tape to cover the edges of your reflector so only light that passes through the filter can escape. If you find a favorite color, you can buy a bigger sheet of that gel and use it over bigger flash unit's reflectors. *Caution:* If your bigger flash has a modeling light, even gels that are made for cinematography's continuous light sources will eventually catch fire and burn, so be careful!

corner bounce

The last type of bounce lighting is the one I find most beautiful; it is a combination of wall and ceiling bounce. It again requires a room with white or off-white walls and ceilings where you aim your light into the upper corner that is created where two walls and the ceiling meet. Just as when using a window, you can't move the corner of the room around so you must position the subject so the light hits the subject at a 45° angle. And, if you use your imagination, the shape formed by the junction of two walls and the ceiling can be roughly likened to the shape of an umbrella.

electronic flash vs. quartz light vs. fluorescent tubes

Throughout this book I refer to the use of flash or quartz video lights as light sources; however, to avoid any confusion, I will clarify and define these two light sources and even add a third type to your lighting arsenal.

Flash

As the name suggests, electronic flash units emit a short, intense burst of light. They have an approximate Kelvin temperature of 5600K and are a non-continuous, instantaneous light source. They also balance well with daylight. They are a perfect (and my preferred) light source for photographing people because they do not emit a lot of heat and their short duration is helpful in freezing any camera or subject motion. Even though the flash tube's envelope is usually made of quartz, they are never referred to as "quartz" lights.

AC (wall outlet) powered flash units often have built-in modeling lamps (or lights) to see the effect of the flash. Because these modeling lamps are often quartz-halogen bulbs, all the care in handling video lights listed below should be observed.

Video Lights

These are continuous quartz halogen lights, hot lights, and movie lights that have an approximate Kelvin temperature of 3200K. They do not balance with daylight (direct sunlight is an approximate Kelvin temperature of 5000K between 10 AM and 2 PM, depending on location) and either the daylight or the quartz halogen light must be filtered to work well with each other. They are often called hot lights because the bulb's envelope is made of quartz (instead of glass) which has a higher melting temperature (than glass), so the filament inside the bulb can be burned at a higher temperature, producing more light (measured in lumens).

Inexperienced photographers often prefer these lights to flash because they are continuous, so it's easy to see the light's effect and measure the output for proper exposure. But there are down sides. They put out a lot of heat that can cause light modifiers and diffusers to burn or catch fire and a subject to get uncomfortably warm or, even worse, perspire. Another downside is that quartz light bulbs draw a tremendous amount of power from a wall outlet (a 1000 watt quartz bulb draws 7.5 amps) and the only ways to change a quartz light's output is with diffusers (a fire hazard), changing the light's distance from the subject (sometimes impossible), or changing to a lower wattage bulb (often impractical). Finally, because they are continuous, they do not freeze camera or subject motion.

Quartz halogen lights operate at higher temperatures than regular glass bulbs and are basically a system always on the verge of a meltdown, so you must take extra precautions when using them. Be aware that the heat they produce can be a fire hazard—so don't use them near flammable surfaces and have a fire extinguisher handy just in case.

While you should never touch a quartz light that is operating (ouch!), you should never touch a cool quartz bulb with your fingers either because skin oil on your fingers will transfer to the bulb and trap heat against the bulb, which will cause the light to prematurely fail or even shatter when it's turned on. All quartz bulbs come with a plastic bag-type envelope or wrapped in a special tissue by which you hold the bulb when inserting it into the light fixture's socket to help avoid this problem. This protective coat must be removed before you turn on the light.

Because the bulb's quartz envelope might shatter when it's turned on, you should never turn on a quartz halogen light with the subject facing an unprotected bulb. Proper technique (used by video and cinema professionals) calls for either turning on the lights before the subject (often called "the talent") is on the set, or by turning the light on with the bulb facing away from the subject and, after the bulb gets up to operating temperature, turning the light back towards the subject.

When a quartz halogen is burning you shouldn't jar the bulb, the light fixture, or the light stand it is on. This can cause the bulb to fail prematurely or shatter. Always treat quartz halogen light bulbs with respect and care.

Fluorescent Lights

Also available today are fluorescent lights that are designed specifically for photography. They are a continuous light source, don't put out a lot of heat, draw very little current (comparatively speaking), and have a Kelvin temperature of 5000K. A grouping of these special fluorescent tubes can be arranged into a bank, and they are easy to balance to daylight. Like quartz halogen bulbs, they are not useful for freezing subject or camera motion. Personally, I don't use them because they often have a green tinge to them that I abhor because of its effect on flesh tones.

While quartz and fluorescent lights have their place, I prefer electronic flash for portrait photography. They balance well with daylight, don't barrage subjects with a lot of heat, and the short burst of light is great for freezing camera or subject motion.

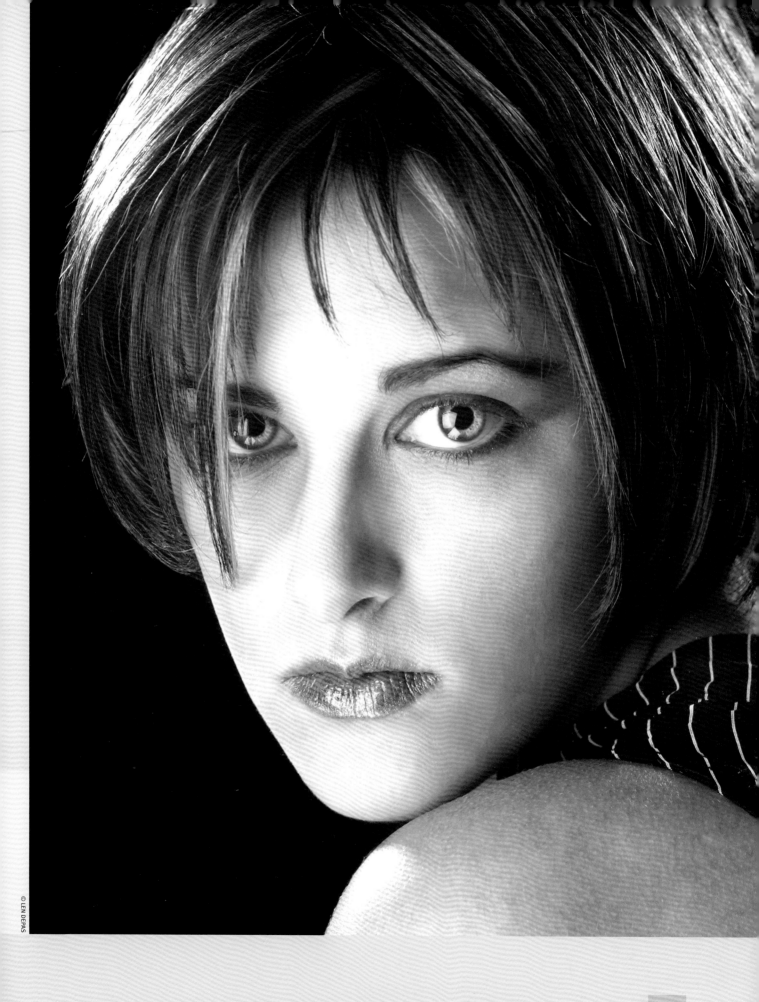

Umbrellas and bank lights are two distinctly different types of lights, so I have divided the sections covering them into two parts: Umbrellas first and bank lights (or soft boxes) next. But because both represent broad light sources, there are some similarities and differences that I will point out first. When you use an umbrella, there is no direct point source light hitting the subject because it is aimed towards the umbrella's surface. Conversely, a bank light is a light source aimed directly at the subject, but its light has been diffused by passing through the front surface of the bank. While both are considered broad sources, and therefore create the same small shadows described at the beginning of this chapter, the bank light creates shadows that are more distinct, with sharper, harder edges.

The biggest noticeable difference between the two types is dependent upon the size of the room in which the light is being used. When an umbrella is used in a small room, some of the light aimed into it spills over the edges and hits the walls and ceiling. This secondary light bouncing back at the subject can actually fill in the shadows created by the umbrella's primary light, thus making the shadows more "open" (less dark) than shadows created by a bank light. The dark, opaque sides of a bank light contain this spillover so it doesn't bounce back off nearby walls in small rooms and fill in the shadows. In large rooms there is less difference between the two. With a high or dark ceiling and a large room, the spillover from an umbrella's edges has less effect on the quality of the light, so the differences between bank lights and umbrellas become less noticeable. Although physically very different, bank lights and umbrellas produce very similar lighting in most situations. Ultimately, choosing between them is a matter of personal preference.

It's worth spending some time discussing the setup and use of these two types of broad lights in a portrait situation. While I wish it were within the limits of this book to describe concrete examples of things like how far away an umbrella or bank should be from the subject, how high they should be relative to the subject, or at what angle they should be to the camera's lens axis, this is unrealistic because there are far too many variables. These decisions depend on many factors, including the physical characteristics of your subject. Traits like their complexion, bone structure (how deep set their eyes are, for example), weight, and even how they are posed have to be considered, including what it is you want to say about them—are they lighthearted, serious, happy, peaceful? Also, the intended use of the final portrait (i.e., business, family heirloom, graduation photo) has to be considered, so a lot of decisions have to be made before you even think about where to place a broad light. But that's the fun part of portraiture and it shouldn't be dreaded! Taking a portrait is not a life threatening brain operation; no one will die if you don't get it perfect, and these types of decisions are part of the creativity you bring to the process. However, even though all of the variables play a huge role in lighting decisions, I can still offer some general advice.

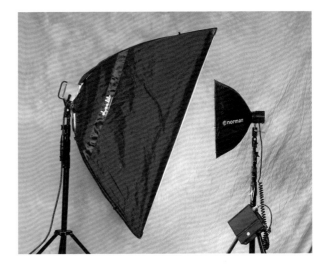

Bank lights (top photo) and umbrellas both produce a similar broad lighting effect. However, there things to consider when determining what to use when. These include room size, subject characteristics, and even the intended use of the photo.

Distance of a Broad Light from the Subject

Generally speaking, the closer a broad light is to your subject, the softer and smaller the shadows it creates become. Both of these things are beneficial, so don't be afraid to push your soft light (be it an umbrella, bank, or other types mentioned later) in as close as possible to your subject. Conversely, the farther away a soft light is from the subject, the less of a broad source it becomes until eventually it's no more effective at creating soft-edged shadows than a small source hard light, and it has the added disadvantage of being less powerful than the hard light when measured watt for watt. Even if you are using a large 60-inch (1.52 m) umbrella (or a 40 x 60-inch [1 x 1.52 m] bank light) and you find yourself in a situation where the light is more than approximately 20 feet (6.1 m) from the subject, my advice would be to forget about using the umbrella or bank altogether and consider using direct light instead.

Angle of the Broad Light from the Lens Axis

Generally speaking, most photographers place their main broad light at an angle of 45° to 60° away from the lens axis, but this is only a general rule and, as mentioned previously, many factors will affect your decision. Although most of this information will be covered in other forms later in this book, here are some of the basic factors affecting the placement of the light.

The farther the broad light is moved from the lens axis...

...the larger the shadows it creates will become.

...the more it will accentuate skin imperfections.

...the more three-dimensional your subject will look.

...the more you need some fill illumination on the shadow side of the face (remember the hatchet lighting example used when we discussed window light).

The closer the broad light is moved to the lens axis...

...the smaller the shadows it creates will become.

...the less it will accentuate skin imperfections.

...the less 3-dimensional your subject will look.

...the less you need some fill illumination on the shadow side of the face.

This photo was taken using a bank light for a broad light source on the left side of the baby's face, while a fill reflector was used to lessen shadows on the right side of the face.

Umbrellas are probably the fastest and least expensive way to turn a small flash or continuous light into a broad source. With what I can only describe as a pleasant and reassuring "foop" sound, they can be opened and ready for a photo shoot in seconds, and packing them away at the end of the shoot is just as fast.

There are also various surfaces available for the inside of the umbrella that range from shiny silver or gold to alternating panels of silver and white. I don't like any of the silver, gold, or alternating panel options because I find the light produced is too harsh and uneven (it feels more like a point source than a broad source). And while I only use translucent white ones, I prefer an umbrella that has a removable outer covering so that I can use it in the normal mode and in a diffuser mode (see "bank light impersonators" on page 77).

There are oddly shaped umbrella lights introduced from time to time. Sometimes they have a few longer ribs so they supposedly create their own fill light, or they are a shoot-through design where the light in the umbrella is turned around and bounces off a silvery surface to emulate a bank light, and the list goes on—let's just say the fertile imaginations of lighting designers are always at work. My advice is to use good, old-fashioned, plain white translucent umbrellas, though you might want to experiment a bit for yourself before settling on your favorite type.

Why carry a 46-inch (116 cm) umbrella if you are only using the center 24 inches (61 cm) of it? To get larger, more distinct shadows!

using all the umbrella you paid for

A common mistake photographers make when first using an umbrella is pushing the shaft too far into the mounting hole on the light source, bringing the light source and the reflecting surface of the umbrella closer together. This results in the light pattern not covering the entire surface of the umbrella. In effect, you are creating a smaller light source than you'd get if the umbrella's reflecting surface was farther from the light and the entire surface reflected the light back towards the subject. In specific instances, you might want a smaller source than the whole surface of a big umbrella because it creates larger shadows but, in general, why bother to carry a 55-inch (1.4 m) umbrella if you are only going to use the central 24 inches (61 cm) of it? If you are using a continuous light source (or a flash unit with a modeling lamp) aimed into your umbrella, there is an easy way to see if your light source is filling the umbrella. Look for a scalloped edge shadow

created by the umbrella that is cast on the ceiling or a nearby wall. If you don't see that scalloped edge shadow, chances are good your light source is not using the umbrella's entire surface.

However, a smaller umbrella used at the same distance as a larger umbrella will give you larger shadows, and sometimes a larger shadow will result in more dramatic lighting. So even if you're using a 60-inch (152.4 cm) umbrella, knowing that it can create shadows like a smaller umbrella if you sink the shaft further into its mounting hole is a trick worth remembering.

Let's imagine that because you like the portability, economy, and convenience of their quick setup and break down, you've decided that umbrellas are for you. You buy one and immediately discover that attaching your light to the light stand and the umbrella to the light might require an adapter of some sort. Although there are many options, two pro-grade, bulletproof

If you don't see this scalloped edge shadow on the ceiling or wall, you aren't filling all of the big umbrella you paid for with light. While it's easiest to see this with a continuous light source, if you practice you can see it when firing a test flash. It helps to squint when trying this.

The hole for the umbrella shaft must be on the upper half of the adapter for it to work as designed!

attachment adapters are made by Norman and Bogen/Manfrotto. The Norman adapter assumes your light has a 1/4"–20 thread hole in the bottom of it while the Bogen/Manfrotto unit relies on a stud system to join the pieces together. One point worth noting, however, is that the Bogen/ Manfrotto adapter should be mounted on the light stand with the hole for the umbrella shaft on top; otherwise, you'll be able to change the angle of the light but not the angle of the umbrella.

containing the spill

One way to stop the light from spilling off the edge of an umbrella, and thus lowering the contrast your light creates, is to use a lighting accessory called a barn door. A barn door attaches to the edge of a light's reflector and limits the width of the light's beam. Attaching barn doors to your light can be difficult, but a product made by Bogen/Manfrotto called the Multi-Clip can often do the job. A Multi-Clip is made up of two metal spring clips that are held together (and pivot on) a metal wire bent into the shape of a squared-off U. One of the clips is attached to your light's reflector and the other holds the barn door. If, like me, you use flash heads with round reflectors, you might bend the wings on one of the clips to better conform to your equipment. This little trick can be done easily with a pair of regular pliers.

There are metal barn doors available commercially, but I have also used pieces of mat board for years with nary a visit from the photo purity police. I use black-and-white ones (the white side always faces the light source) and, with a #1 Exacto knife and a #11 blade, I can custom tailor a barn door to suit my needs in seconds. Generally, I use 6 x 8-inch (15.2 x 20.3 cm) rectangles, which work well with my flash head's round reflectors.

Bending the wings on one clip of the Bogen Multi-Clip allows it to conform better to a round reflector.

arachnid catchlights

One downfall of umbrellas is the catchlight they create. This term refers to reflections in shiny or wet objects, such as people's eyes or glasses, that are created by a light. The reflection of the umbrella, with the back of the light source in its center and the ribs of the umbrella radiating from it, make the catchlight look like a spider. Although this is great for a horror movie, it is not the most flattering thing to appear in your subject's eyes. For most general portrait subjects, the reflection of the catchlight is fortunately not an issue because it is so small. But if you are shooting close-ups of your subject's eyes, let's just say the catchlight shape is a subject worth reflecting upon!

To combat the catchlight, some manufacturers have come up with translucent covers that can be attached to the front of their umbrellas that effectively hide the reflections of the ribs (the Photek Softlighter II is an example of this kind of accessory), while other manufacturers have designed their umbrellas so the ribs are hidden behind the umbrella's inner surface (the Photogenic Eclypse is an example of this solution). Still, neither of these addresses the black blob in the center of the catchlight that is the reflection of the back of the light source.

In many ways umbrellas are the perfect broad source light—compact, portable, fast, and easy to use. But if you work in small areas with light colored walls, or shoot highly reflective subjects, then you might want to consider a bank light instead.

In this bottle's reflective surface you can see two arachnid-shaped catchlights in all their glory.

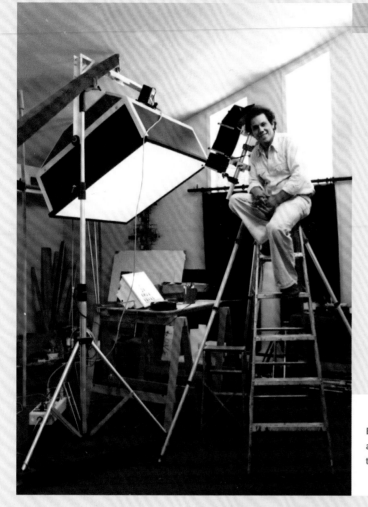

First off, some bank light basics. Unlike umbrellas, bank lights are bulky (even when collapsed), a pain to set up, and equally frustrating to break down. But if your studio is a small room (like that spare back bedroom) or your subject is highly reflective, they are in a class by themselves. They come in a huge variety of sizes that create beautiful, soft, directional light suitable for a huge variety of subjects. They are available as hard-sided light boxes, soft-sided collapsible units and, in the past, many photographers even made their own from aluminum frames and foam core board (shown at left). Big ones, small ones, rectangular, square, and even octagonal ones, they come in just about every size you might ever need.

Before manufactured bank lights were available, every pro figured out a way to make one.

Here is a 30 x 40-inch (76 x 101 cm) rectangular Chimera bank (this particular one is distributed by Dyna-Lite) and a 19-inch (48 cm) octagonal Norman bank. There are banks that are also larger, smaller, and somewhere in between these two examples. The Chimera is designed to work with AC powered flash units and the Norman fits on battery powered flash units with removable round reflectors, such as those made by Norman, Lumedyne, and Quantum.

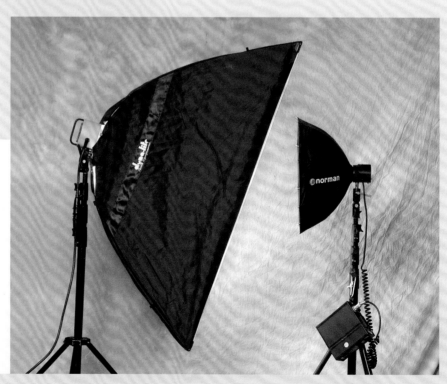

build a mini bank light

Although large lights often produce soft light because of their size, you might want to experiment with a smaller-sized bank light to create harder-edged shadows. Instead of buying one to experiment with, you can build your own with some common photographic and household accessories.

figure 1

list of materials:

1 **grid adapter**

2 **Bogen MultiClips**

2 **rectangular pieces of mat board**

1 **small piece of SetShop Tough Lux**

4 **clothespins or 4 two-inch (5.08 cm) pieces of strapping tape**

figure 2

construction:

- Put the grid adapter onto your lamp head **(figure 1)**. You can leave the grid adapter empty or put a grid in it.

- Attach the two MultiClips to the grid adapter, 180° apart from each other **(figure 2)**.

- Attach the two rectangular pieces of mat board to the MultiClips. In the example shown here, I used 11 x 7-inch (28 x 17.8 cm) pieces of mat board. Note that I put the white side of my black/white mat board towards the light **(figure 3)**.

- Attach a suitably-sized piece of Tough Lux to the mat boards with the wooden spring clothespins. In the example shown here, the Tough Lux piece measured 11 x 18 inches **(figures 4 and 5)**.

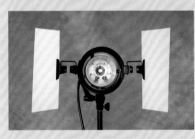
figure 3

figure 4

 While I don't usually find it necessary, if you want to further control the spill that can escape past the open sides of your new mini bank, you can add two more MultiClips and make a pair of mat board barndoors to close in the open sides of the minibank, or use a narrow angle grid in the grid adapter.

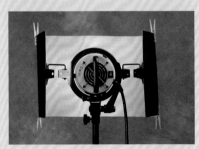
figure 5

adding panes to the "movable window"

In use, a photographer might consider a bank light to be like a north light window, the only difference being that it can be positioned wherever you want. One way I jazz things up a bit, and reinforce the feeling that the light is a window, is to put two pieces of black one-inch (2.5 cm) wide tape across the front surface of the bank. One runs top to bottom over the bank's vertical centerline and the other runs left to right across the horizontal centerline. The two pieces of tape look like window mullions in the bank's reflection as they divide the catchlight into four separate rectangles or squares.

An easy way to add interest to a rectangular bank's catchlight is to divide it into quarters with two pieces of opaque tape.

Here are two photos of a bottle. One was made with an umbrella and the other with a taped bank light. Which photograph do you find more appealing? Which photo looks more finished and professional? Also note the difference in the background tone between the two light sources: The photo on the left is a perfect example of the extra spill created when using umbrellas.

but is it even?

Unlike the umbrella's spider-shaped catchlight, most bank lights create simple, clean, rectangular or square catchlights that match the shape of the bank. However, with poorly designed banks, the central light located behind the bank's front diffusion panel often creates a hot spot. In using these banks, the beautiful, even, and rectangular catchlight can become a grayish rectangle with a white spot in the middle of it when seen in a reflection. This problem can become really noticeable when the portrait features the subject's eyes. To get the front panel of a bank evenly illuminated, many well-designed units have a second diffusion panel inside the bank halfway between the light source and the bank's front translucent surface. One way to discover if your bank light is even is to shoot a picture of the bank's front surface and underexpose it by two or three f/stops. The underexposed photo will reveal any hot spot that the bank may have. If you're shooting reflective subjects and want a smooth, evenly illuminated catchlight, you're better off using a bank light with a secondary, internal diffuser included in the design.

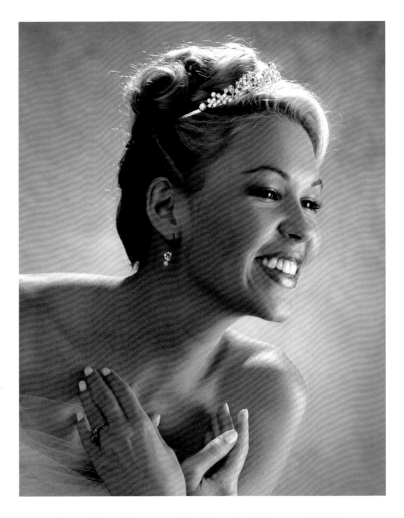

Even small catchlights are important to help define and give life to your subject's eyes.

Here is my Chimera bank with and without the secondary diffuser in place. Note how the diffuser smoothes out the hot spots and makes the bank's surface more even.

turn that hot spot to your advantage

Before you get overly hot and bothered by a hot spot in your bank, you should know that the unevenness a hot spot creates can be used to your advantage. I once assisted a photographer who used lights behind translucent acrylic sheets as his broad sources (in the days before readymade bank lights were available). Instead of centering the point source light behind his diffuser, he would move it off to one side of the panel and rotate the light left and right as he studied the reflections in his subject. By doing this, his catchlights would become a unique reflection that showed an interesting dark-to-light gradation. So, as always, feel free to experiment with different techniques—the resulting portrait may be beautiful, interesting, or both.

The preceding story about the photographer and his acrylic sheets is worth exploring further. For many less dollars than the cost of a readymade bank, you can use almost any diffusion material clamped to a light stand in front of a point source light to create the same look. It can be made into an even more realistic impersonation of a bank light if you use barn doors clipped to two or four sides of your light source to limit the point source's beam so it only hits the diffuser. For your diffuser, you can use a pre-made model or make a simple frame from four pieces of 1 x 2-inch (2.5 x 5.1 cm) lumber held together with inexpensive angles, over which the diffusion material can be stretched.

Because some diffusion materials come in rolls, you might even slip the roll on a boom arm, use spring clamps to secure it, and make a diffuser that works like a window shade. If you decide to experiment with this concept, you might find that a piece of 1 x 2-inch (2.5 x 5.1 cm) lumber spring-clamped to the bottom edge of your window shade will help keep the diffusion material taught. Often, hardware store spring clamps and wooden spring clothespins can be your best friends; they are like having a second (or third!) pair of hands. Because I often work on location, and the portability factor is important to me, my favorite substitute for a bank light is a Flexfill diffuser clipped to a light stand with a point source shining through it. Since I always have an extra light stand, two spring clips, and a Flexfill with me on location, I can simulate a bank any time I want one.

A Flexfill, a light stand, and two spring clamps can do a pretty good impersonation of bank light quality if the catchlight shape isn't your primary concern.

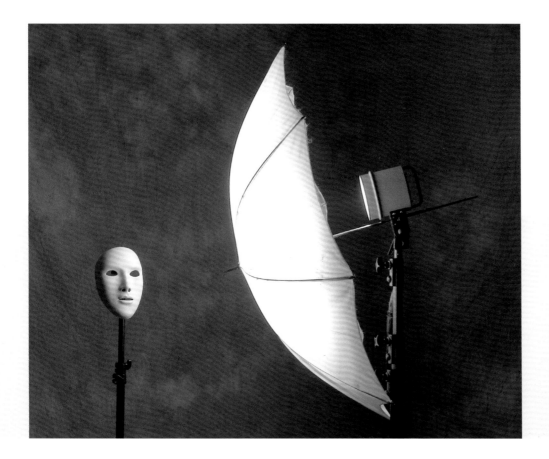

Ah, the old turn the umbrella around trick! If you use a translucent umbrella (or remove the black cover from a Photek model) it can be a pretty good impersonation of a bank light. But, as in this example, it only works in situations where the catchlight shape is not paramount.

the umbrella masquerading as a bank

To close the circle on this topic, it is only fitting to backtrack and point out that an umbrella can also be used to impersonate a bank light. Some well-designed umbrellas (Photek, as an example) are designed with an opaque cloth backing that is removable, and this feature has a special advantage. Once you remove the backing and turn the umbrella around from its normal position so that the light projects through it at the subject, you are, in effect, creating a bank light look. And, joy of joys, you're still getting the quick set-up and break down associated with using an umbrella.

There are some caveats here, however. First off, there can be a problem with the color of the light coming through the umbrella. As umbrellas age, the material yellows and, although a shift to the warm side is usually acceptable when photographing people, the results can be disconcerting when a technically exact color rendition is required. But this is a problem with almost all diffusers made from white material, so don't get overly hung up on it. Second, if you don't use some type of barn doors, spill from the edge of your umbrella can create lower contrast than when using an opaque-sided bank light.

Whether you use an umbrella or bank, there is one last point that is true about all broad light sources and worth repeating. To be most effective at creating tiny, soft-edged shadows, your broad light source should be placed as close as possible to your subject. Note that a 2 x 2-foot (61 x 61 cm) square bank light (or a two-foot diameter umbrella) placed 50 feet (15.24 m) from your subject will create the same type of large, inky black shadows that a point light source at closer distances would. To illustrate this, we need only look at the sun. Knowledgeable photographers treat direct sunlight as if it were a point light source when, in reality, our sun is almost a million miles in diameter. But because the sun is about 93 million miles away from the earth, it creates the same type of large, inky black shadows that a one-foot (30 cm) diameter light creates when placed 93 feet (28.3 m) from a subject. So, to paraphrase Al Pacino in *The Godfather Part II*, keep your friends close and your broad sources even closer!

figure 1

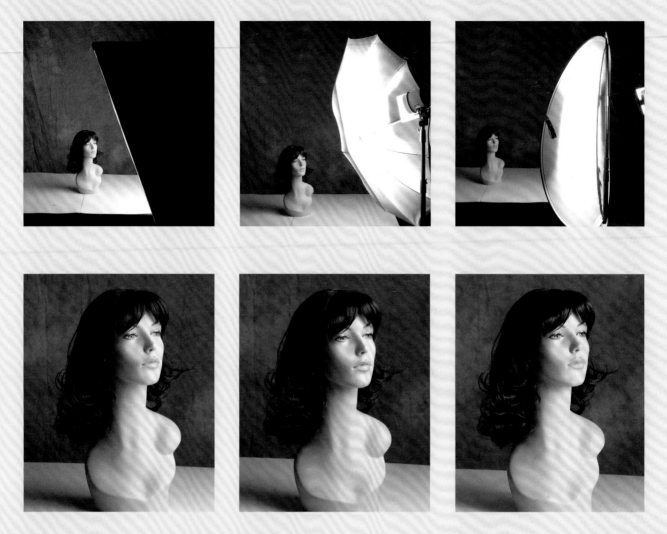

figure 2 figure 3 figure 4

ethel lit by four soft lights

Both photographers and photography equipment manufacturers are always proclaiming that their way of doing something is best, but don't you believe it. Sometimes it's true, but not always. In this series of pictures, I have lit my favorite mannequin, Ethel (named in fond remembrance of Fred and Ethel Mertz), with four different soft lights. The soft lights used are an umbrella (figure 1), a bank light (or softbox) (figure 2), a reversed umbrella used in the shoot-through mode (figure 3), and a Photoflex LightDisc with a hard (point) light source shining through it (figure 4). In each case, the hard light source used in conjunction with the light modifier is the same distance from the subject. Furthermore, I positioned Ethel on two cards butted together and intentionally left the joint line between the cards in the photographs to prove that Ethel didn't move. Below each setup photo is a close-up picture of Ethel that shows the resulting effect of the particular soft light source. Can you tell the difference between one soft light source and the next?

If your subject has a reflective surface (glassware, silverware, or anything shiny) then you are photographing the reflections in it (see the blue bottle in this chapter on page 75) and choosing a light source that creates a beautiful reflection is important. But, when it comes to portraits (especially those where the catchlight reflections in the subject's eyes are miniscule) I don't think the difference between types of soft light sources matters that much! Take a look, then decide for yourself.

© MICHAEL ZIDE

chapter four
advanced lighting

In the last chapter we started to lay a foundation upon which to build your lighting technique by learning the difference between soft and hard light. But, unlike a poured concrete foundation made up of one humungous lump, consider this foundation to be one made from individual stones that are carefully positioned one block at a time. This chapter is phase two of this construction analogy. In it we are going to cover the concept of fill lighting and exposure and why they're necessary, then we'll move on to different ways to use hard lights. We will end by covering the equipment you'll need to apply this knowledge and then, in the following chapter, we will build our house on top of the foundation with examples of real-world situations where these techniques are used. So let's continue laying stones!

What are gunfighter eyes, and what do they have to do with portrait lighting? Let's travel back in time to the days of the Wild West, when a gunfighter's trick that could save his life was to pull down the brim of his hat to shade his eyes and squint before he walked into the town saloon. Why? The light outside was much brighter than the dark interior of the dim saloon in the days before electricity. By shading his eyes with his hat brim and squinting before he walked into this possible hornet's nest, he forced his pupils to dilate which enabled him to see better once he entered the darkened saloon. Again, you might ask, what does this have to do with portrait lighting? Well, the human eye is an amazing and versatile tool, and its pupil, which can be equated to a camera's lens aperture, is constantly opening and closing as it adjusts to a scene's brightness. In fact, the eye actually scans a scene and the pupil reacts by opening as it looks at a dark area and closing as it looks at a light area.

While the pupil of the human eye is a marvel in the way it adapts to varying light intensities, you should pity the poor lens aperture because it is stuck at one mechanical opening. This often means that if we set the aperture to expose for the highlights in a scene, the shadows may be too underexposed to register; or if we set the aperture to expose for the shadows,

Digital cameras have a narrower latitude (dynamic range) than the human eye, causing shadow and highlight areas to hold less detail. You will have more versatility in deciding how to best manage the dynamic range in the image by shooting RAW.

then the highlights may be blown out. This is because the dynamic range that can be recorded by the camera sensor is less than what we see with our eyes. This problem is compounded when you shoot JPEGs because camera-applied image processing uses a curve that may clip highlight or shadow detail present in the RAW data captured by the sensor. Fortunately, there are a few ways around this problem.

One way to extend the latitude of a digital camera's image is to shoot RAW files instead of JPEGs. A RAW file is all the information captured by the chip within a digital camera to which little in-camera processing is applied. RAW files are much larger than JPEG files, and by shooting in RAW you are given a second chance at correcting mistakes that you may have made when you originally took the picture. After the photograph is taken you can make some adjustments to such things as contrast, exposure, and color balance (to name but a few). While it is always ideal to create the best possible image file, shooting RAW does give you versatility in correcting things after the fact, without degrading the image file.

One camera company, Fuji, has gone so far as to create a digital imaging chip that has both a small and a large pixel at each photosite. If the large pixel (which might be equated to a larger aperture because it has a larger surface area to accept the light rays) receives too much light, it defers to the smaller pixel, which hasn't been blown out because it has a smaller surface area and so receives fewer light rays. This switch happens automatically thanks to software. And while the latest Fuji chip on their newest pro D-SLR has 12 million pixels, it uses only 6 million of them to form the image by picking the information from either the large or the small pixel. This is such an important feature that many knowledgeable photographers choose Fuji cameras, with their lower megapixel chips, over other brands of cameras with a higher megapixel count.

and just who is this guy named Phil?

Although it's a poor play on words, there is an old photographer's joke that says a photographer's best friend is a guy named Phil—fill lighting, that is. The joke is based on the previously mentioned fact that the human eye has a constantly varying aperture while the camera is saddled with a fixed one. This means that what might appear to be an "open" shadow when seen by your eye often turns into an inky, black hole when it's seen by the camera's recording medium, be it a digital imaging chip or film.

Remember that there's no rule stating that you are limited to only one fill card. In this simple, one-light photo, I used two fill cards; one on top of the table on which the subject is leaning and another vertical one to the subject's right, opposite the single umbrella to the subject's left. There are no fill card police to tell you how many fill cards you're allowed to use.

the inverse square law

The inverse square law states that the intensity of light radiating from a source is inversely proportional to the square of the distance from that source. So, if you have two objects of equal size and one is twice as far from the light source as the other, the farther-away object receives only 1/4 of the light that the closer object gets in the same time period. In other words, when you double the distance between the light and the subject, the light reaching the subject is only 1/4 as strong as it was before, which means that the light's intensity is two stops less powerful. This means that if you move the light twice as far from your subject, you either have to open the lens aperture by two stops, use a shutter speed two stops longer, increase the ISO by two settings, or increase the output of the light four times. Each of these solutions would compensate for the two stops of light you lost in the move.

The inverse square law is a way to understand the diminishing intensity of light as a subject gets farther away from the light source.

Being aware of how the eye and a camera see things differently is both difficult to visualize and hard to remember. Knowing that whenever you light a subject you are often going to need a "fill" light or reflector to open up the shadows and bring both the highlight and the shadow intensity close enough together so that both register correctly is a very important lesson. Furthermore, it's one that you (and even I) will sometimes forget.

Basically there are two ways to create fill lighting; one uses a second light (the fill light) and the other uses a reflector to bounce some of the main light into the shadow side of the subject. Using a second light as a fill is fraught with peril. First off, it's hard to pre-visualize and you need fine control of its intensity in relation to the main light. If you can't control its intensity to a fine degree in relation to the main light, you risk the possibility of the fill light being too strong and creating an unnatural-looking second set of shadows. This extra care is usually not needed when using a reflector to bounce some of the main light into the shadow side of the subject. While a second light might be more powerful than the main light, a white reflector (either opaque or a translucent diffuser used as a reflector) can never be more powerful than the light it's reflecting, if it's at the same or a greater distance from the subject than the light. In part this is because the white reflector described above doesn't reflect 100 percent of the light that hits it, and the light from the main light that goes to the reflector and then bounces back at the subject has to travel a long distance before it hits the subject. Light decreases in intensity the farther it has to travel and the decrease happens rather drastically because it follows a formula called the inverse square law (see the sidebar above).

understanding exposure

A camera's aperture, or f/stop, refers to the size of the opening in the diaphragm that allows light to pass through the lens onto the sensor. While f/stops are a measuring system used to quantify and compare the various size options of this opening, the way f/stops work also applies to the way shutter speeds, ISOs, and light intensities work. Photographers generally refer to changes in aperture or shutter speed in terms of opening up or stopping down the amount of light coming into the camera; they talk about opening up or closing down a stop when referring to their lenses, and pumping up, cutting, or dropping a stop (or a fraction of a stop) when they adjust their lights.

The difference between any two sequential shutter speeds or aperture values is one stop. The entire universe of light in photographic terms—its intensity and reflectance, how it is measured, how it is used, how you adjust a camera to deal with differing amounts of light—can all be described in terms of stops. For this to be an earth-shattering revelation to you, as it was to me when I first learned it, you have to know that the difference in light between any two adjacent stops is the same. It's always the same, so let's start there.

Note: For years now, most newly manufactured cameras have allowed for intermediary aperture and shutter speed values in increments of 1/2 or 1/3 stop. You can refer to the chart below to see the traditional full stop increments between one aperture value or shutter speed and the next.

In examining the aperture of the lens, the difference between any two sequential f/stop values is that a given value allows either twice as much or half as much light through the lens as the next closest f/stop value, depending on whether you are stopping the lens up or down. For example, an aperture opening of f/4 is twice as wide as an aperture of f/5.6; conversely, f/5.6 is half as wide as f/4. (See the chart below for a visual guide to f/stop and shutter sequences.) This light relationship continues in either direction to a given lens' maximum and minimum aperture values.

Shutter speeds work in terms of stops too. The difference between any two sequential shutter speeds in terms of the amount of time that light is allowed to reach the sensor is twice as much or half as much as the next closest time value. For example, 1/60 second is twice as long as 1/125 second, while 1/125 second is half as long as 1/60 second.

Correct exposure can often be achieved through a whole range of shutter speed and f/stop combinations. Think of it as a hole (the f/stop) and how long you leave the hole open (the shutter speed). You can have a little hole left open for a long time or a big hole left open for a short time and both will pass the same amount of light through to the sensor. If the light were water filling a gallon jug (with a full jug representing correct exposure), you could have a strong stream of water fill the jug quickly or a trickle of water fill the jug slowly; in either case, the jug would get filled. To better understand this, look at the scale of f/stops and shutter speeds shown below.

Each f/stop and shutter speed pair in the chart gives the same exposure as all of the other pairs. A sports photographer might choose a combination of a short shutter speed and a large f/stop to freeze action, while an architectural photographer might choose a combination of a small f/stop and a long shutter speed for extended depth of field. A portrait photographer might go either way, choosing a wide aperture (low f/number) to throw the background out of focus, or a small aperture (high f/number) for greater depth of field; they might select a fast shutter speed to freeze the subject's motion or a slow shutter speed to allow for creative motion blur. It all depends on the effect you want to create.

f/stop	1.4	2	2.8	4	5.6	8	11	16	22
shutter speed	1/4000	1/2000	1/1000	1/500	1/250	1/125	1/60	1/30	1/15

What's a photographer to do with a subject in the shade against a background lit by bright sunlight? This situation is way outside the exposure range of the camera's chip. In this instance, without using a flash, photographers usually end up with a blown out, high-key background if they expose for the subject's face. Because flash exposure is unaffected by the choice of shutter speed, but is affected by distance between the flash and the subject, a knowledgeable photographer can light in the shade with the flash placed close to the subject. Doing this requires a smallish f/stop and a shutter speed that will not overexpose the background.

© LEN DEPAS

using an instantaneous light source

All of what you have just read refers to continuous light sources. An example of a continuous light source is the sun, but an electronic flash unit is not—it is an instantaneous light source, here for one split second and gone the next. Instantaneous light sources have very short duration; in practice, the camera's shutter opens, the flash fires and its duration is shorter than the shutter speed, and then the shutter closes. Because the duration of the flash is shorter than the shutter speed, the exposure for a photograph lit only by a flash (or multiple flashes) is controlled only by which f-stop you set your lens to. For a short duration flash to work in harmony with the camera's shutter, the two must be synchronized. In practice, this is often called being "in sync" and to truly understand it you have to understand how the focal plane shutter in your D-SLR works.

Focal plane shutters are comprised of two curtains, and when you push the shutter release button on your D-SLR, a series of actions occur. The lens stops down to the taking aperture (until this point, the lens is wide open for viewing and focusing), the mirror flips up out of the way, the first curtain opens (exposing the sensor to light), the second curtain closes (stopping the sensor's exposure to light), the lens reopens to full aperture, the mirror flips back down for viewing, and the shutter is re-cocked so the camera is ready to take another photograph. Let's focus on just the shutter curtains. At longish shutter speeds (up to approximately 1/250 second), the first curtain opens and fully exposes the camera's sensor, and then the second curtain closes. When the first curtain has fully opened, a flash unit, either in the camera's hot shoe or attached by a sync cord to a PC terminal on the camera, is fired and then the second curtain closes. At shorter shutter speeds (approximately 1/250 through 1/8000, or whatever the shortest shutter speed is), the second curtain starts closing before the first curtain has fully opened. When this happens, you end up with the entire sensor never being fully exposed and, instead a slit (made from the two shutter curtains moving simultaneously) travels across the image plane. If you try using flash at these shorter shutter speeds, the flash ends up lighting only a sliver of the full sensor. When that happens you are out of sync.

Crafty photographers will sometimes use a longish shutter speed while using their flash unit(s) to let some of the available (continuous) light have an effect on the picture or the background, and doing this is often called dragging the shutter. Be aware that this also creates the possibility that the ambient light, combined with the flash and just a touch of camera shake, might create a secondary ghost image that ruins most portraits. There are also cameras that can force their shoe-mounted unit to rapidly flash repeatedly, creating a stroboscopic, almost continuous light effect, which allows you to use a shorter shutter speed than the camera syncs at normally. But when using this technique, the flash's output is diminished drastically to allow it to recycle so quickly. Finally some D-SLRs will allow you to synchronize the flash either when the first shutter curtain fully opens or just before the second curtain closes (called rear curtain sync), but this feature is best reserved for subjects in which you want to introduce a blur created by the ambient light exposure combined with a sharp flash image. For general portraiture just regular sync works well, but the most important thing to remember is that you control flash exposure by changing only your lens' f-stop.

The concept of using stops to quantify light also extends to ISO. If you double your camera's ISO setting (i.e. go from ISO 200 to ISO 400), the difference between the two settings is one stop of light; if you change the ISO setting on your camera from 400 to 100, the difference between the two settings is two stops of light. The concept of using stops to quantify light exposure even extends to photographic lighting equipment. If a pro-type, AC powered flash unit can be set to 125 or 250 watt-seconds, the difference between the two settings is one stop. If your flash unit has a half power setting and a quarter power setting, the difference between the two settings is one stop. If you put a 1000-watt bulb into a video light, it will be twice as powerful as if you put a 500-watt bulb in it, and the difference between the two bulbs' power is one stop. This is as sure as the fact that night follows day, and once you truly understand and apply this concept, f/stops, shutter speeds, ISOs, flash units, and continuous light sources will all mesh together into one sublime, interlocked system.

seeing it in practice

Let's say you have a camera lens with an aperture range from f/1.4 to f/16 (seven stops—see the chart on page 85). Furthermore, the shutter on your camera has a range from 1 second to 1/1000 second (11 stops). Imagine you were in a lowlight portrait situation. You set the camera's ISO setting to 800 and take a meter reading of a portrait subject. Now, make believe the exposure suggested by your camera's meter is f/8 (a medium-small aperture opening) at 1/250 of a second. How can you adjust the camera settings while maintaining a correct exposure if you want to use an aperture of f/2 instead of the suggested f/8 so the background of your portrait will be thrown out of focus?

Well, to get from f/8 to f/2, you have to open the lens aperture four f/stops (from f /8 to f/5.6 to f/4 to f/2.8 to f/2). As the size of the aperture hole in the lens doubles with each f/stop, you must shorten the exposure time (the shutter speed) by cutting it in half four times to give you an equal exposure. That means that your shutter speed should be shortened from 1/250 to 1/4000 of a second (going from 1/250 to 1/500 to 1/1000 to 1/2000 to 1/4000). But hold on a minute; your camera doesn't have a 1/4000 of a second shutter speed; your camera's fastest shutter speed is only 1/1000 of a second. Using only the shutter speed to accomplish this, you'll find that you're two stops short and, if you try to use an exposure of f/2 at 1/1000 of a second, the resulting photograph would be two stops overexposed. Bummer!

Are we to believe that it just can't be done, that there is no way to make an adjustment to your camera's settings that would allow you to shoot at f/2? Remember that ISOs also work in stops! If you were to change the ISO setting from 800 to 200, that would mean a two-stop loss of sensitivity by your camera's sensor, meaning that your f/2 aperture and a shutter speed of 1/1000 second will give you a correct exposure.

What I just took so many words to explain is not alchemy, it is just based on knowing that everything about light intensity in relationship to photography and exposure is based on stops—a system where each step up or down means a corresponding value doubles or halves. When opening your lens a stop at a time, a one-stop difference means twice as much light, a two-stop difference means four times as much light, a three-stop difference means eight times as much light, a four-stop difference means 16 times as much light, a five-stop difference means 32 times as much light, a six-stop difference means 64 times as much light, and so on.

By changing the combination of your shutter speed and aperture, you can still achieve correct exposure and get interesting effects like the shallow depth of field seen here.

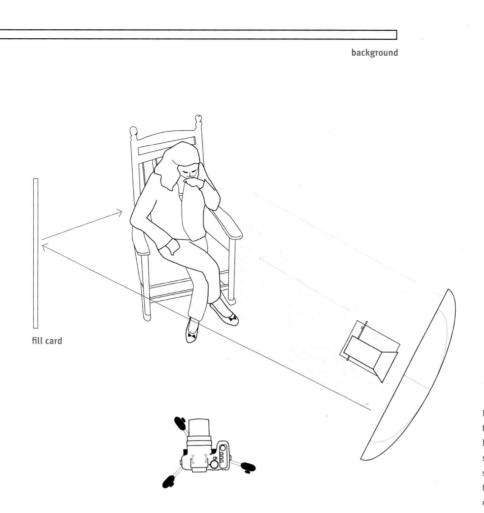

background

fill card

Notice the greater distance the light ray hitting the fill card has to travel before hitting the subject. Although this might seem like a small detail, it is the primary reason why a fill card is easier to control than a second light for beginners.

summary

Earlier I wrote about the reflector and how it can't reflect 100% of the light that hits it. Now that you know about stops and the inverse square law, it's time to revisit the fill card. Note that the light from the source travels to the umbrella, then bounces off it, reverses direction, passes the source on its return trip, and then travels on to the subject. The light travels two feet (61 cm) to the umbrella's surface, travels another two feet (61 cm) back to the light source, and then, after passing the source, travels a final two feet (61 cm) to the subject; this is a total of six feet. Next, note that the fill card is three feet (91 cm) from the side of the subject opposite the umbrella. The fill light, reflecting off the card, also starts its journey at the umbrella's light source. But, after traveling the same six feet (1.8 m) as the main light, it passes the subject,

travels three feet (91 cm) to the reflector and then, after hitting the fill card, travels three feet (91 cm) back to the subject. While the main light component of the total light travels only six feet (1.8 m) [2 + 2 + 2 = 6], the fill component of the total light travels 12 feet (3.7 m) [2 + 2 + 2 + 2 + 3 + 3 = 12]. As already explained, because of the inverse square law, the doubling of the distance lowers the light's intensity bouncing off the reflector (when measured at the subject) by two stops. Further, you'll probably lose another stop of light because the reflector card doesn't work at 100% efficiency.

This automatic loss of light intensity because of the less-than-100 percent efficiency of the fill card and the greater distance the fill light has to travel before hitting the subject is why fill cards are much easier to control than a second light source used as your fill light.

negative fill

While a white reflector will add fill light to the shadow side of a subject, a black reflector will subtract it. While it might seem that there is never a need to subtract fill lighting, which increases contrast between the highlights and the shadows, I can only say that by increasing contrast you can often add drama to a photograph. Furthermore, if you are using umbrellas in small, white-walled rooms, darkening the shadows is not only advisable, but often necessary to make the subject look more three dimensional. One of my favorite reflectors is a 30 x 40-inch (76.2 x 101.6 cm) matte white cardboard (often called a show card and available at art supply stores); when I shop for them, I choose ones that are white on one side and black on the other. That way one show card can double as both a positive and a negative reflector. The only problem with using big, rigid cards is that they are not easily portable, and one important consideration for location assignments is that your lights and lighting accessories are both easily portable and, if possible, collapsible for easier packing. To sidestep the show card problem for location shoots, I carry two 45 x 60-inch (114.3 x 152.4 cm) pieces of black satin folded up in one of my cases. This fabric can be used to cover a posing aid, or I can drape it over the Flexfill mentioned in the last chapter (see page 72) making it a negative reflector. While using a black reflector might seem counterintuitive, I can tell you that it is often necessary and might well be the answer you need in a tricky lighting situation.

Here's a subject lit by a single umbrella with a black, negative reflector (top) and a white, positive reflector (bottom). If you want to increase lighting contrast when shooting in a small or medium, light-colored room, a negative fill is the only way to do it.

the histogram

The histogram, which intimidates many neophytes, offers a great deal of information about how much light each of the pixels on the camera's imaging sensor is receiving. But before we get into how to understand and read one, let me make an important point: there is no such thing as a "bad" histogram!

One way to imagine a histogram is to think of a big jug in which you are collecting loose change. Once you fill the jug, you'll want to cash it in. To do this, you'd separate the change into stacks of each denomination of coin. Eventually, you'd be sitting at your kitchen table looking at stacks of coins.

A histogram does the same thing, except it makes stacks out of pixels. And instead of a few stacks of coins, a histogram makes 256 stacks of pixels. Each stack represents a tone in a range from pure black to pure white, with 254 shades of gray between them. On the right side of the histogram is the stack that represents white, and on the left side is the stack that represents black. A histogram is merely showing a graph of the tones that have been recorded that tells us a lot about our photo. That's why there's no such thing as a bad histogram!

If we were to drastically overexpose a photograph by mistake, the histogram would show very few pixels on its left side, with most of them bunched to the right side of the graph. But if you correctly photographed a fair skinned, blonde model dressed in white posed against a white background, you might well get a histogram that was approximately the same as the drastically overexposed mistake. An opposite histogram— one with the majority of the pixels on the left side of the graph—

Histograms are valuable tools if you remember that they are subject to interpretation. For example, the histogram for the well-exposed, high-key portrait (above) is very similar to the one for the overexposed picture (left). How you interpret the graph depends on the nature of the subject and the effect you want to achieve.

would represent either a drastically underexposed photograph, or one in which you had a dark haired model dressed in black posed against a black background. Finally, a subject dressed in gray with a medium-toned complexion posed against a gray background would result in a histogram that looked like it had a hump in the middle of the graph with few pixels recorded on the left and right sides. By learning to read a histogram, you can easily see over or underexposure, but better still, if you have a preconceived notion of the result you want, you can verify that you have achieved it. This is a very powerful tool in helping you know if your pre-visualization matches your results.

Again, the histogram for the underexposed photo to the right is very similar to the one for the low-key study of the male subject below. Both provide valuable information that can be used to determine if you are getting the result you desire.

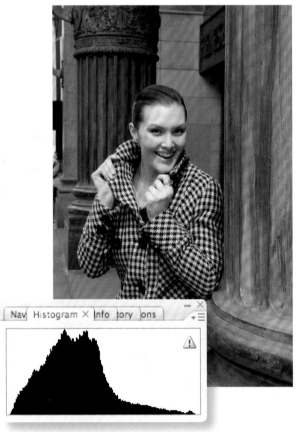

Usually, a histogram representing a correct exposure shows a fairly even distribution of light and dark tones. Compare the histogram for this correct exposure to the underexposed image above.

using kelvin color temperature

Before I start this section I thought I would share two emails I received from one of my students at the Maine Media Workshops:

Shortly after the workshop, I got this email: "Yesterday I shot my first wedding since taking your wedding workshop. I shot the ENTIRE event setting the color temperature myself! I can't thank you enough for teaching us that in class. I am beyond thrilled with the results! It's already obvious to me how much less color correcting I'll be doing in Camera RAW. Thank you, thank you, thank you!"

About a month later, I got this second email: "I have to sing your praises again! Color temperature has changed my life! I know I already mentioned this a month ago, but I have been shooting all of my children's sessions by dialing in the color temperature, and I did another full wedding doing the same. Honestly, my post-production time has been cut to at least 1/3 or 1/4 of what it was before. Thank you, thank you, thank you!"

My favorite method of setting the white balance on my camera is to use the Kelvin Temperature option because it is the only white balance selection that gives me a repeatable method, doesn't require that I reset a custom color balance each time I change lighting conditions, and can be adjusted easily in small increments to suit my taste. For those who don't know what Kelvin temperature is, let's start with a quick definition. All light is not the same! Household light bulbs put out a yellowish light compared to sunlight, and the light in open shade is bluish compared to sunlight. A scientific way of comparing and quantifying the color of light uses a metric called the Kelvin scale, measuring color temperature in degrees.

If you know the exact color temperature of your studio lighting, you can simply dial it in using the Kelvin temperature option in your camera's white balance menu field.

Setting the Kelvin temperature yourself gives you predictable results for getting accurate color in your photos.

The lower the Kelvin temperature, the warmer (yellowish) the light is. The higher the Kelvin temperature, the cooler (bluish) the light is. Here are a few specific Kelvin temperatures to help you picture the concept. Direct sunlight (defined as sunlight on a clear day between 10 AM and 2 PM in the northern hemisphere) is about 5000K. Quartz halogen bulbs (common video lights) are 3200K. Electronic flash is usually about 5600K. And open shade is usually somewhere between 5900K and 6500K.

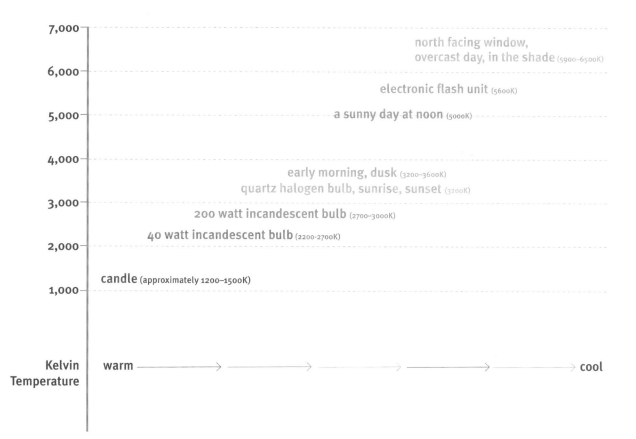

7,000 —		
		north facing window,
		overcast day, in the shade (5900–6500K)
6,000 —		
		electronic flash unit (5600K)
5,000 —		a sunny day at noon (5000K)
4,000 —		
		early morning, dusk (3200–3600K)
		quartz halogen bulb, sunrise, sunset (3200K)
3,000 —		200 watt incandescent bulb (2700–3000K)
		40 watt incandescent bulb (2200-2700K)
2,000 —		
		candle (approximately 1200–1500K)
1,000 —		

Kelvin Temperature warm ⟶ ⟶ ⟶ ⟶ ⟶ cool

Nearly all D-SLRs give you the option to select from a group of preset choices, called the white balance, such as Daylight, Cloudy, or Incandescent, which you can choose depending on the light in which you are photographing. Thankfully, more and more current D-SLRs are including the ability to go beyond these presets so you can set the white balance using a specific Kelvin temperature. Part of my reason for choosing Kelvin temperature white balance over all the others is because I'm against giving creative control to my camera in almost any situation where my personal input can offer better or more consistent results.

Using this method for your white balance offers consistency because Kelvin temperature is a measurable, scientific constant, and therefore it's repeatable, as are its results. Furthermore, there are really only a few Kelvin temperature settings to remember for portraiture with electronic flash, window light, or quartz halogen lighting. Above is a listing of color temperatures degrees in Kelvin for various light sources. However, it is important to note that you might not agree with what I find pleasing, so do some testing on your own.

A few notes on this information are in order. First off, the light produced by artificial sources turns warmer (more yellow/red/orange) as the lights or light modifiers age. To account for this, try lowering the Kelvin temperature by about 200K for a more technically correct rendition. When using the Kelvin temperatures

above, the color of the light emitted by a standard household bulb will be technically correct but it won't have the warm-toned look often associated with these types of light. To account for this, try a 200–600K higher Kelvin temperature to get the warm tone effect you see with your eyes.

As both a general rule of thumb and a starting point when using the Kelvin temperatures listed above, increase the Kelvin Temperature 200–600K if the pictures looks too blue, and decrease the Kelvin temperature by 200–600K if the picture looks too yellow. Lastly, when photographing people, almost any slight color balance shift is acceptable as long as it's towards the warm (yellow) side, while a shift to blue or green makes your subject look like a corpse!

adjustable iso

The advantages of this feature should be obvious. You can use the adjustable ISO feature on your D-SLR in both directions, up and down. Obviously, increasing the ISO setting will allow you to take portraits in lower light situations, but it can also mean that you are able to use smaller flash units to achieve a smaller f/stop. Using a lower ISO setting allows you to choose a larger f/stop, limiting your depth of field and creating a pleasingly out of focus background. Remember that if you choose to use a higher ISO, you'll have increased noise in your digital images.

There are some lights and lighting styles that have limited applications, but when used in specific situations result in absolutely killer portraits. While there are many more than the few mentioned here, those that I have included are all ones with which I am very familiar and use repeatedly. There are literally hundreds, if not thousands, of different banks, reflectors, and umbrellas, and all have unique sizes and features available for you to try. However, if you made it your life's work to experiment with all of them, you'd become hopelessly bogged down in equipment, bankrupt from buying and storing them, and end up being more of an experimenter than a photographer. I strongly believe that it's better to use and understand the subtleties of a few lights than to have many and be the master of none.

traditional reflectors

While shoe mounted flash units have built-in reflectors whose primary purpose is to magnify and direct the light, more powerful AC-powered flash units have enough power to use reflectors that will direct the light without necessarily having to magnify its power. These accessory reflectors are usually made of aluminum and clip or clamp onto pro-level flash heads. To understand this concept, consider three imaginary reflectors that are the same in most respects but differ in their interior surfaces. One has a mirrored interior, one has a dull aluminum interior, and the third is painted white. In use, each reflector, while having the same angle of coverage, will produce a different quality and quantity of light, with the mirrored one being the hardest and most powerful and the white one the softest and least powerful. The one with the dull aluminum interior will fall somewhere between the other two in both quality and quantity of light output. For the sports

This photo of an Adorama Flashpoint self-contained AC flash unit shows what a standard 60° reflector looks like.

photographer lighting a hockey rink or the industrial photographer lighting a huge industrial complex, the mirrored reflector might be the best bet. But the portrait photographer will probably find the other two less powerful alternatives more to his liking. There are literally dozens (if not hundreds) of different reflectors available and some photographers will swear by the exact same one other photographers will swear at. While searching for your perfect reflector can be a pleasant although unproductive diversion, don't get too hung up on it at the expense of taking photographs. In general, for portraiture, more specular ones (having the qualities of a mirror) are not as useful as ones that are less specular.

There are also traditional reflectors designed for more specific purposes, and one in particular is very noteworthy. Often called a background reflector, its primary use in portraiture is to flood the background with a puff of light while not allowing any spill to hit the subject. The readymade shown at left is made by Photogenic, but you can make a similar one yourself using an empty coffee can (the 1 pound size) and a pair of tin snips. This can be taped onto a flash head (*hint:* the adhesive on real gaffer tape doesn't melt and run when it gets hot like it does on the less expensive duct tape), but some studio portraitists actually cobble up a more permanent solution and dedicate a flash head to this specific purpose because it's that useful a reflector/light combination. In fact, many experienced photographers even call the whole genre "coffee can reflectors" for just this reason. If you decide on the do-it-yourself route, be very careful and remember to cover any sharp edges on your creation with two layers of gaffer tape!

A Photogenic background reflector is usually placed over a light that's positioned on the floor, and is designed to illuminate a canvas or muslin backdrop.

snoots and grids

There are times when you'll want to mix soft and hard light sources in the same portrait. An example of this might be when you want the subject's face lit by soft light but you want a hard light source to accent the subject's hair, or to skim across the background so that it "pops" and appears three-dimensional instead of flat. In these cases, you might not want any of the hard light's spill to hit the subject. Light modifiers give you the ability to control the hard light's pattern. Although there are homemade solutions that I will cover later, the two most common ones that are available over the camera store counter are called snoots and grids. A snoot is a metal tube that fits over the front of a hard light and limits its beam (or pattern). Obviously, the smaller the tube's diameter the smaller the resulting beam of light will be.

You can also shape custom snoots to fit a particular situation. Not only can these snoots be any diameter you need, the aperture at the end of the snoot can be any shape you want it to be! What kind of magic is this, you ask! How can you easily change the shape of a metal tube? The answer lies in a product made by Lee Filters called Black Foil. This material, used by the motion picture industry, is like super heavy-duty aluminum foil, only it's matte black on both sides instead of being shiny and dull silver like regular aluminum foil. It's also much thicker; regular aluminum foil (not the Heavy Duty type) is approximately one-thousandth of an inch thick (.025 mm) while Lee's Black Foil is almost four times thicker (.1 mm). It can be easily rolled and crimped around any hard light source to form any size snoot, and it's even heavy enough to be used as a barn door (see page 72) in a pinch. Although I have avoided citing specific stores in this book, in this case I must make an exception because Lee Black Foil is difficult to find. There's a place called The Set Shop in New York City (setshop.com) that specializes in everything you might possibly want or need on a photographic set that is not usually available from a traditional camera store. It's a place worth knowing about. Lee Black Foil is available in 50-foot by 12-inch (15.2 m x 30.5 cm) or 25-foot by 24-inch rolls (7.6 m x 30.5 cm), and both are currently listed on the Set Shop website.

Snoots and grids are light modifiers that can be used when you need to control the pattern of your light. Here, a moldable snoot is created by using heavy-duty foil.

This front side of a 20° grid shows what the honeycomb looks like.

Unlike bulky snoots, grids are flat discs that narrow the hard light's beam by having it pass through a honeycomb-like grid. By changing the size of the hexagonal holes in the grid, you can easily change the angle of the resulting light beam. The 5.5-inch (14 cm) diameter grids can be purchased one at a time or as a set of four in 10°, 20°, 30°, and 40° angles. I can tell you that after using a grid system for over 20 years I couldn't do what I do without one. I use the 20° grid 90% of the time! If you want to get into using grids you will need a relatively bulky grid holder that clips onto the front of your light, but that is the only downside to this system. *Hint:* Some manufacturers sell a set of four for 1/4 to 1/2 the price of buying one or two individually, so shop wisely by checking out the cost on a few brands.

Look at these two photos showing a typical background. In the first example (top), the wall is lit by a frontal flash while the second example has a slightly more powerful light with a grid slicing across it in addition to the frontal flash. In the grid example, the exposure is adjusted so that the grid becomes the primary light source and the frontal flash is a less powerful fill light (bottom).

10° grid

20° grid

30° grid

40° grid

These four photos will give you an idea of the differences between 10°, 20°, 30°, and 40° grids. The mannequin head is just for scale, and there is a red gel over the grids just to jazz things up.

the condenser spot

One thing that I know in my gut is that photographic styles (and many other things) run in cycles. If photojournalistic style portraiture becomes all the rage and every photographer is doing it and every subject wants it, then I am willing to bet that more carefully posed, formal portraiture will eventually become the style d'jour once again! A photographic example of this phenomenon is color wedding photography. In the late 60s and early 70s, when color photography was just coming of age, there came a time that you couldn't give away black-and-white wedding pictures. Today, 30 years later, more and more brides and grooms are asking for—you guessed it—black-and-white photography. There are myriad other examples of this; men's ties and lapels get thin, then wide, only to get thin again while women's hemlines go up, then down, then up once again. By now you might be asking what this has to do with condenser spotlights? Well, like lapels and hemlines, lighting has styles too. And although the style of hard light that a condenser spot produces is out of vogue now when used as a main light, it's safe to assume that the dramatic light that hard-edged spots create will be back in style before too long, so leaving them out of this book would show a real lack of foresight.

© LEN DEPAS

In the 1940s during the golden age of Hollywood, there was a photographer who specialized in glamorous, dramatically-lit portraits of Hollywood movie stars. His name was George Hurrell (www.hurrellphotography.com) and he worked in a time before there were bank lights. Without ever having been on one of his sets, I can tell from looking at his portraits that they are lit with multiple, carefully placed and controlled hard lights. But the edge of the pattern created by a hard light is not always as smooth and even as a photographer might like. Enter the condenser spotlight. By placing one or two condenser lenses in front of a point source light, all the rays of light passing through the condenser lens become parallel with one another. These parallel rays create a beam with a sharply defined edge—just the thing you need for a dramatic portrait light. To further sweeten the condenser spot pie (so to speak), sometimes the condenser lens or lenses can be moved or mounted in conjunction with a movable lens, and therefore the spot's beam can be focused so the light can produce a sharp-edged pattern at any distance from the subject.

Because the light rays produced by a condenser spotlight are parallel, this type of light, when fitted with a

focusing system, can also be used to project a pattern in the same manner that an old-fashioned slide projector shows slides. By inserting a thin metal sheet with a pattern cut into it in front of the light's beam, a condenser spot can project that pattern on a subject or the background. The metal sheet with the pattern cut into it is known as a cookie (or, alternatively, a cukaloris, kukaloris, or even a cuke). Think of a background with what looks like hard sunlight coming through a vertically or horizontally slatted window blind and you'll get one idea of a possible use. Some might think that you could accomplish this with a regular flash unit shot through a normal window blind, but if you try it you'll find it doesn't work well because light rays from both edges of the flash tube cast multiple patterns of the blind slats, which are confusing compared to the single shadow produced from the parallel rays of a condenser spot.

the ring light

Let me start off by saying that although I've experimented with ring lights, I generally don't like them for portraits. They are occasionally useful for edgy fashion shoots, and they do have a place in other types of technical close-up photography. But you never know when something may become stylish, so I'm including it and saying its use is covered with caveats. A ring light is a circular flash tube that surrounds the camera lens. It produces light that creates no shadows and at one time this was all the rage for fashion photography. The lack of shadows really flattens the subject so that they almost look like a paper cutout pasted over the background. On the plus side, it just about eliminates any shadows created by wrinkles, or skin imperfections and that feature alone makes it worth remembering. But the flattening is the antithesis of what I usually try to create with my lighting (a three-dimensional feel), so although it might be useful for a very different looking portrait, and the uniqueness of its light quality makes it noteworthy, it is something that I would use very infrequently. Finally, I should mention that if you decide to experiment with a ring light for portraiture, be prepared to use your photo-editing program to remove the redeye from your subjects—unless you decide to work in black and white and want the weird cat-eyes-in-a-darkened-room look.

filtering individual flashes

While I find it worthwhile to adjust the overall color balance of my portraits in Photoshop, I sometimes want different flashes lighting the same set to have different color casts, or I want the flash lighting the subject to emulate a background lit by a warmer light. For example, I might want the overall color of a portrait to be neutral, but I want a hair light to appear more golden in tone. Another example might be a subject standing in front of a sunset-lit (warm tone) landscape, and I want to light them with a matching warm light because, although the background is lit by the setting sun, the subject is in the shade and therefore cooler than the background. The answer to these lighting dilemmas is to filter the flash unit with sheets of either salmon colored (for warmer tones) or blue colored (for cooler tones) heat-resistant polymer filter material.

I first learned about this trick while working on the set of a TV commercial shoot. The set was a kitchen and the model was supposedly enjoying a cup of coffee during a quiet moment (must have been after the kids and her husband went off to school and work!) as rays of warm, golden sunlight streamed in through a kitchen window in the background. The kitchen window was mounted in nothing more than a scenery flat; a spotlight

representing the sun and hidden from the camera's view shone through it. On a break, as I wandered around the set, soaking in every detail I could, I noticed that the spotlight acting as the sun, shining through the window had an orangey (I later found out the color was called *salmon*) filter in front of it. I asked the key grip about the filter and he told me it was to "warm up" the light. That was over 30 years ago and it was when I learned that you could change the Kelvin temperature of one light on a set to create an effect of warmth or, if the situation demanded it, coolness.

You can do the same thing yourself by experimenting with and learning how to use lighting filters that are a mainstay of the film industry. Both Lee and Rosco make filters that are sold in 20 x 24-inch (50.8 x 61 cm) sheets as well as rolls (of the most used ones), and there are literally hundreds of different colors available. Warming ones are called CTOs (Color Temperature Orange) and are available in varying strengths. Likewise, CTBs (Color Temperature Blue) do the opposite by making lights cooler. But there are also hundreds of other colors available that can be very useful in adding a creative punch to your portraits.

So, consider how a red, seamless background might look if it was lit by a red filtered grid. You'd get a red background with an even more intensely red center. If you want to experiment with this idea, both Lee Filters and Rosco offer swatch books of their filters (the Rosco line is called Cinegel) and the swatches can be cut with a pair of scissors to cover the reflector of smaller flash units. As always, there are caveats to consider. Even though the filters are heat-resistant, taping one over a flash head that has a quartz-modeling lamp is an invitation for a disastrous fire hazard.

When I'm faced with wanting to use a "gelled" flash head in such a situation, I turn that head's modeling lamp on for a *few seconds* to see the effect of my creativity and then immediately turn it off for the actual shoot. Although you have to be careful with a lot of lighting gear because they often get hot or carry a lot of electricity, that doesn't mean you should avoid using them. Just remember that there is always the potential for a serious accident and be ready for the unexpected by keeping your wits about you, and having a fire extinguisher for electrical fires close at hand!

A red gel was used over a hair light to achieve the red background color seen in this image.

Because photographers are such equipment freaks, I thought I'd share with you a list of all the lighting equipment I bring with me on a location photography session. If I know of or have seen the location beforehand, I might modify my list slightly, such as leaving the bank light at my studio and only bringing my umbrellas. Or, if my assignment is an outdoor portrait session, I might bring my battery-powered flash units and reflectors and ditch the AC powered units altogether. I use a technique called stand-alone packing that makes all this equipment manageable.

stand-alone packing

All of my equipment fits into four cases and one bag that go into the trunk of my car. There is a case for all the battery powered flash units. Another case has one AC powered flash generator and two heads in it, including all the accessories needed to use that flash unit. That means, with the flash pack and the two heads, there is also a power cable, a 25-foot (7.6 m) extension cord, two Bogen Multi-Clips, two barn doors, and a radio slave receiver. The third case is similar to the second, except it has two packs and two heads plus *two* power cables, *two* 25-foot (7.6 m)

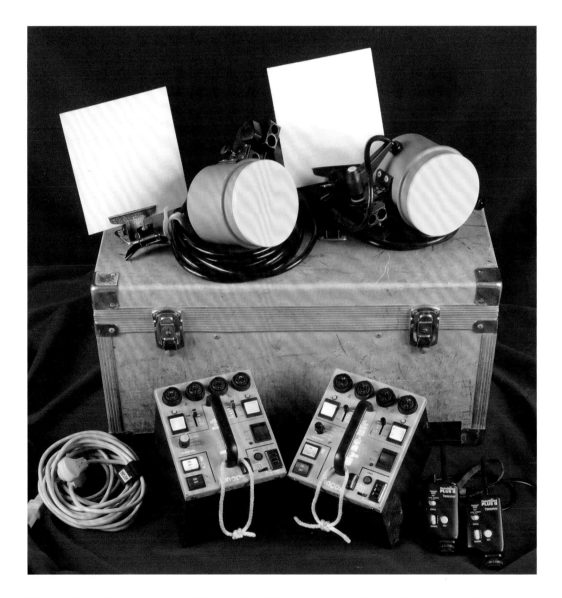

This two-pack case is an example of stand-alone packing. All the accessories needed to make this equipment work are included in the case from packs, to heads, to cables for the heads, to pack connections, to barndoors, to radio slaves. If I need two packs and I grab this case, I'm good to go!

extension cords, two Multi-Clips, two barn doors, and *two* radio slave receivers. The fourth case carries spare parts, grids and grid adapters, extra extension cables, various AC plug adapters, and a fourth pack and head if I include them in my kit. Lastly, I carry a pole bag for light poles and umbrellas. The advantage of this organizational scheme for packing is twofold. If I'm working out of a car trunk I can take out only the case or cases I need for a particular assignment. The concept of stand-alone packing means that if I grab one case, I don't have to go fishing through others to find accessories needed to make the equipment from the first case usable.

A long time ago, before I settled on the concept of stand-alone packing, I organized my cases so each held one type of equipment...silly me! Case number one held all my AC flash packs, case two was filled with flash heads, and the third carried all my cables. The idiocy of that system was brought home to me when I did an eight-day, 11-flight assignment for a major US corporation. On the first leg of that journey, my pack and cable cases made it to our destination, but the case with my flash heads took a detour at Chicago's O'Hare airport. For the next seven days the case containing my flash heads always caught up to me right *after* I had left for my next destination. I got around the situation by having a New York rental house ship me a case of flash heads, but if that hadn't worked out I would have been dragging two cases of useless equipment with me from location to location! I learned two things: (1) Use a stand-alone packing system, and (2) You are in this for the long haul, so it pays to cultivate friendships with your suppliers.

equipment list

Some of you may read this list and get very depressed because you don't have all the equipment and think you can't possibly make great portraits without it. That, by the way, is *not true*—but it's a great excuse to put yourself into a state of inaction. Others will think that they need to have *exactly* the same equipment as me. My equipment is beat-up and old; some of it is held together with gaffer tape! So to those who absolutely must have the exact same equipment as me, I say, "I will sell you mine and, for the right price, I'll even throw in the roll of gaffer tape!" Some photographers may think that a specific flash unit, battery, or light stand is going to see the picture *and* push the button for them. These photographers are in for a rude surprise! While everything on my list has proven its worth to me, it might not fit into your shooting requirements or style, and other brands are just as worthy of your consideration. Still others may think that they should go out and buy this equipment even if they decided to get into portrait photography yesterday. Remember that it is much more important to know how to use the equipment you have then it is to have a ton of equipment you don't know how to use. Now, without further ado, here is a complete list of the equipment I carry on almost every assignment.

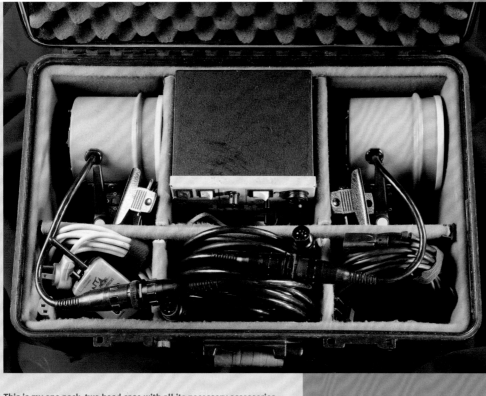

This is my one pack, two head case with all its necessary accessories. It's another example of stand-alone packing.

All my AC and battery packs have short rope loops attached to them. This allows me to hang a pack from a light stand, which provides two advantages: (1) The weight of the pack helps stabilize the stand, making it harder to tip over, and (2) It gets the power pack off the floor so I don't have to crouch down to change its power switches. I use 1/4 inch nylon rope that is rated for more than the weight of my packs. I melt the ends of the nylon rope with a match so they won't fray (use care, melted nylon burns skin easily), and I soak the knot in super glue so it won't come undone.

Battery Powered Flash Units

2 Top-of-the-line Nikon speedlight flash units

2 Sunpak Auto Pro 120J flash units

1 Stroboframe Quick Flip 350 Bracket, customized to suit my preferences

2 Lumedyne 065X flash units (2 packs, 2 heads)

4 Special order Lumedyne extreme wide-angle reflectors for the Sunpaks and the Lumedyne flash heads

1 Lumedyne Ultramegacycler HV (high voltage) battery

2 Lumedyne Microcycler HV batteries

6 Quantum cables to use the Lumedyne Cycler batteries with the Nikon (3 total, 2 to use plus 1 spare) and Sunpak flashes (3 total, 2 to use plus 1 spare)

4 Bogen/Manfrotto light pole/umbrella adapters with mounting studs to accommodate all six flash units

AC Powered Flash Units

3-4 Dyna-Lite 1000 watt-second packs

3-4 Dyna-Lite 2000 watt-second, fan cooled Dyna-Lite flash heads with 14-foot (4.3 m) cables for each

4 Dyna-Lite 15-foot (4.6 m) power cables

4 25-foot (7.6 m) extension cables

2 Dyna-Lite grid adapters

5 Grids, 1 each of 10°, 30°, and 40° grids, two 20° grids

4 Bogen Multi-Clips (modified as per the picture in the previous chapter on page 72)

4 Black/white 6 x 8-inch (15.2 x 20.3 cm) mat board barn doors

3-4 Non-grounded to grounded AC adapter plugs and a few multi-outlet adapter plugs

© LEN DEPAS

Battery Powered Flash Units

2 Top-of-the-line Nikon speedlight flash units

2 Sunpak Auto Pro 120J flash units

1 Stroboframe Quick Flip 350 Bracket, customized to suit my preferences

2 Lumedyne 065X flash units (2 packs, 2 heads)

4 Special order Lumedyne extreme wide-angle reflectors for the Sunpaks and the Lumedyne flash heads

1 Lumedyne Ultramegacycler HV (high voltage) battery

2 Lumedyne Microcycler HV batteries

6 Quantum cables to use the Lumedyne Cycler batteries with the Nikon (3 total, 2 to use plus 1 spare) and Sunpak flashes (3 total, 2 to use plus 1 spare)

4 Bogen/Manfrotto light pole/umbrella adapters with mounting studs to accommodate all six flash units

All my AC and battery packs have short rope loops attached to them. This allows me to hang a pack from a light stand, which provides two advantages: (1) The weight of the pack helps stabilize the stand, making it harder to tip over, and (2) It gets the power pack off the floor so I don't have to crouch down to change its power switches. I use 1/4 inch nylon rope that is rated for more than the weight of my packs. I melt the ends of the nylon rope with a match so they won't fray (use care, melted nylon burns skin easily), and I soak the knot in super glue so it won't come undone.

AC Powered Flash Units

3-4 Dyna-Lite 1000 watt-second packs

3-4 Dyna-Lite 2000 watt-second, fan cooled Dyna-Lite flash heads with 14-foot (4.3 m) cables for each

4 Dyna-Lite 15-foot (4.6 m) power cables

4 25-foot (7.6 m) extension cables

2 Dyna-Lite grid adapters

5 Grids, 1 each of 10°, 30°, and 40° grids, two 20° grids

4 Bogen Multi-Clips (modified as per the picture in the previous chapter on page 72)

4 Black/white 6 x 8-inch (15.2 x 20.3 cm) mat board barn doors

3-4 Non-grounded to grounded AC adapter plugs and a few multi-outlet adapter plugs

light stands and light modifiers

4 tall light stands: 3 Bogen 13-foot (4 m) light stands and 1 Bogen 13-foot (4 m) stand that incorporates a built in boom arm

3 short light stands: 2 Lightweight Pic 7-foot (2.1 m) light stands and 1 short backlight stand

4 Photek Softlighter II SL 5000 46-inch (1.2 m) umbrellas with the Softlighter stuff thrown away

1 Photek Softlighter II SL 6000 60-inch (1.5 m) umbrella with the Softlighter stuff thrown away

1 Photek Sunbuster-84 Plus 84-inch (2.1 m) umbrella

1 30 x 40-inch (.76 x 1 m) Chimera bank light that is distributed by Dyna-Lite

1 52-inch (1.3 m) PhotoFlex Flexfill white translucent reflector

1 Bogen Lastolite TriGrip white translucent reflector

2 45 x 60-inch (1.1 x 1.5 m) pieces of opaque black cloth

If you have a collection of similar equipment, get into the habit of numbering each piece of the group. This includes packs, heads, batteries, and anything else that you have multiples of. By doing this, when a part breaks, all you have to do is make a mental note of its number so when it's time to send that piece in for repair, it will be easy to find.

meters, slaves, spares, and extras

1 Sekonic L-358 light meter equipped with a Pocket Wizard radio slave transmitter module

1 Minolta Flash Meter IV

11 Pocket Wizard radio slaves with sync cords: 2 transmitters, 6 receivers, and 3 transceivers (that can be used either as a transmitter or a receiver)

2 Three-light actuated slaves from various manufacturers

3 Wein TeleFlash monitors

 A few 18 x 24-inch (45.7 x 61 cm) pieces of Set Shop Tough Lux and various Rosco (or Lee) sheets of color filters

 About a dozen spare sync and radio slave PC cords

 Replacement batteries for the radio slaves and the flash meters (Lithium AAs for the radio slaves and Minolta Flashmeter IV and CR123As for the Sekonic meter)

 Pens, markers, a small roll of Gaffer tape, jeweler's screwdrivers, and a Leatherman Wave tool

where to begin

Feeling overwhelmed by the list above? Don't be! It's the result of over thirty years of experience and millions of photographs. There's no way anyone should use that much gear until they've got the need for it and the knowledge to use it. You should all know that way back when, in prehistoric PD (pre-digital) days, I started off with a couple of small, inexpensive aluminum reflectors into which I screwed standard light bulbs. These lights were cheaply made and they came equipped with a spring clamp so I could clip them to a light stand, door edge, or anything else that was handy. I eventually graduated to a few quartz halogen video lights that were slightly more professional, but they put out a lot of heat (they're not called hot lights for nothing!), and required my subject to hold still because longish shutter speeds were required when using the best low ISO films of that era. Frankly, I was scared silly about using flash primarily because I couldn't see the effect of my lighting. A mentor forced me into using flash and, as I cried, moaned, and gnashed my teeth,

I scraped together my pennies and bought a single battery-powered flash unit, although it was a manual one with a round reflector that had a soft-edged pattern.

My next purchase was a second flash (the same brand and kind as the first) and a single light stand. Next I added a single umbrella and used a piece of white cardboard as a reflector. There was even a time when I was crumbling up huge pieces of aluminum foil and then spreading them back out and gluing them to my fill card (even by trying both sides of the foil—dull or shiny—I got mediocre, inconsistent results). So, I've both been there and done that. As I mentioned earlier, I started off small—with just one light! The point is, I didn't use banks, or grids, or the list of equipment that I just shared with you until I knew how to use what I already had. It's important to build your "photographic lighting" house on a firm foundation, so forget about using four lights until you've really mastered one. Simply put, you don't need custom made, Olympic-quality running shoes when you're just starting to walk, even if they do look cool.

© LEN DEPAS

After reading the two preceding chapters, you should have a foundation of lighting knowledge to build upon. So far, we've covered how light works, the difference between hard and soft lighting, what specific kinds of lights do, and even which lights I personally use, but we haven't always covered how to apply this knowledge directly. Now that you know about lights, it's important that we look at how they work together to illuminate your subject, and how to best measure the lights to get consistent and correct results. We'll then look at various applications that tie everything together that we've learned so far about lighting. Essentially, we'll finish building our house atop the foundation, so your understanding of portrait lighting will be complete. First, we'll start with two important pieces of the framework, short lighting and Rembrandt triangles.

chapter five

using lights

short lighting: the two faces of fred

What if I told you that you can make many subjects look heavier or thinner depending upon which side of their face you lit? Well, it's true. The technique is called "short lighting" and here is how it works. In many portrait situations, you only see one ear of your subject. Some may think that if the subject only has one ear showing, then the subject's face must be a profile. Although short lighting can work with subjects in full profile, if the subject is looking at the camera face on (with both ears showing), it only takes a tiny turn of the subject's face to block the camera's view of one of their ears. I would hardly call a 1° or 2° turn off dead center, a subject in profile. Regardless, once you have a subject showing just one ear, if you drew a vertical line through the subject's nose you will find that the width of their face's two sides are very different. On the broad side of the face you will see an ear, a cheek, and a jowl, while you will see none of that on the short side of their face.

But allow me to be the monkey with the wrench for a moment—before you add some form of fill light or reflector to open up the shadow side of a face (in this case, the broad side that is in the shadows), you can use some of the main light illuminating the short side of the face to help define the side in shadow. Allow me to introduce you to Mr. Rembrandt's triangle.

rembrandt's triangle

A long time ago in Egypt, artists couldn't figure out how to draw a subject's face to show that the nose protruded from the surrounding facial area. While they could do it when working in a three-dimensional medium such as a sculpture, translating it to just two dimensions on a piece of papyrus left them scratching their heads in dismay. Their solution was to draw everybody in full profile. Thousands of years later, along came the Dutch painter, Rembrandt, who realized that he could fool a viewer into seeing that a portrait subject's nose protruded from their face by painting in a shadow caused by the nose. This shadow implied the shape had depth and was three-dimensional. By placing his subject so window light hit them at a 45°–60° angle, the subject's protruding nose cast a shadow onto the subject's cheek. If this shadow of the nose hit the shadow on the side of the face away from the light and was further defined by a horizontal shadow line caused by the subject's brow, he ended up with a very pleasing triangular-shaped highlight on the shadow side of the subject's face.

A Rembrandt triangle helps define the shadow side of many subjects' faces. Let's consider what determines its shape. In a nutshell, it depends upon how high the light that creates the triangle is in relation to the subject's face.

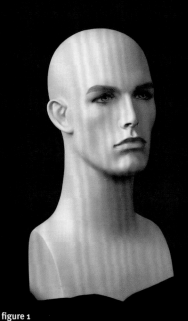

figure 1

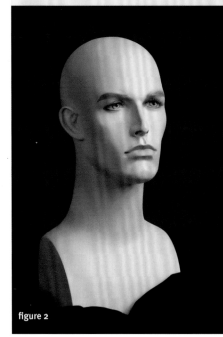

figure 2

If we place the main light so that it illuminates the broad side (figure 1), we are lighting the subject's ear, cheek, and jowl; that will make the subject's face appear both wider and heavier. Conversely, if you light the short side of their face, the ear, the cheek, and jowl seen on the broad side will be in the shadows and your subject will look thinner (figure 2).

If the light is low, the line caused by the shadow of the nose runs horizontally (instead of at a downward angle), and the highlight that you want to be in the shape of a triangle becomes more rectangular. The low light also crosses over the subject's upper lip and accentuates the crease between the lip and the subject's cheek—not a pretty sight!

If the light is too high, the top line of the triangle (created by the subject's brow) moves downward and puts the subject's eye sockets (and eyes) in shadow.

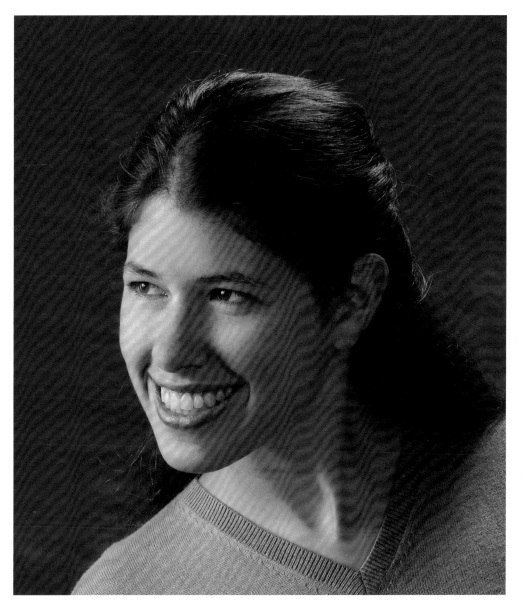

This is an example of a Rembrandt triangle. Note that it helps define the shadow side of the face and makes the face look more three dimensional.

Here are a few hints for making perfect triangles, but please remember that it's a just-for-fun exercise, because the real idea is not perfect triangles but perfect portraits. When shooting a close-up with the subject lit by either an umbrella or a bank, I try to make sure that the bottom 1/8 to 1/4 of my umbrella or bank is lower than my subject's eye sockets. Another point that's easy to remember is that as a subject tilts their chin down, the light has to move down accordingly. As the subject tilts their head up, the light has to rise accordingly to keep pace.

Considering that the height of the light can be adjusted and the tilt of the subject's head is changeable, you might think that getting the perfect Rembrandt triangle to light the subject's face at the exact moment the exposure is made would be easy, but in reality the exact opposite is true. Things happen quickly in a portrait session (much faster than the deliberate way a painter works), and slight movements of the subject's face can affect the lighting on it drastically. To make things even more frustrating, many subjects move their faces as they emote the perfect expression. The problems double if you try to pull off Rembrandt triangles on two subjects simultaneously. Trying to accomplish the feat with three or more subjects, with all their heads at differing heights and all moving as they emote the perfect expression simultaneously, is almost an exercise in futility. This doesn't mean you shouldn't try it, but accept the difficulties involved and be satisfied with results that are less than perfect.

I'd like to revisit something I covered in the last chapter; namely, just how much fill should be used, with either a light or a reflector. As always, the answer is that it depends, on both your taste and what you are trying to accomplish. But the heavier your subject is, and the fuller their cheeks, jowls, and earlobes are, the steeper the ratio between the highlight and shadow intensities should be to help slim the look of your subject. Some of you may now be confused because I used the word "steeper" in the last sentence. Steeper and flatter is how I've come to describe ratios, which, as a term used in photographic lighting, expresses a comparison between the relative intensities of two lights.

Some photography authorities will tell you about a 2:1, 3:1, or 4:1 ratio which they equate to mean the main light is one, two, or three stops more powerful than the fill light. Other photography authorities will say that the 2:1, 3:1, and 4:1 ratios refer to the main light being twice, three times, or four times more powerful than the fill light. Sadly, a difference of one, two, or three stops isn't equal to the main light being twice, three, or four times as powerful as the fill light. If only it were that simple! But stops work in multiples of two, so a three-stop difference between lights is equivalent to having eight times (2^3) more light from the main light than the fill light! While a one-stop difference represents two times as much light, a two-stop difference represents four times as much light (as opposed to three times as much light), and, as just mentioned, a three- stop difference represents eight times as much light (as opposed to four times as much light).

There is a second issue with ratios that can also be confusing. The same people who talk about a ratio between the main and fill lights often suggest that the fill light should be placed as close to the camera's lens axis as possible (so it doesn't create a second set of shadows), while the main light is placed at a 45°– 60° angle off the camera's lens axis. They will also state that if we make the main light one stop hotter (twice as powerful) as the fill light, then the lighting ratio is 2:1. In other words, what some people are saying is this: If the fill light represents one unit of light, then the main light must represent two units of light (remember, it's twice as powerful). While this seems simple and easy to understand, I think there is a major fallacy in their reasoning.

Here's the rub that drives me nuts: If the fill light is close to the camera's lens axis, then it actually hits both sides of the subject's face. However, the main light only hits the highlight side of the subject's face. Therefore, the highlight side of the face gets three units of light (two from the main and one from the fill) while the shadow side of the face only gets one unit of light (from the fill) because the main light never hits it. If there are three units of light hitting the highlight side of the face, and only one unit of light hitting the shadow side, then it would seem to me that the ratio between the highlight and shadow illumination is 3:1. But, because the main light is twice as powerful as the fill light, a zillion photographers will tell you the lighting ratio is 2:1.

To take this one step further, if both lights are of equal power and distance from the subject, this supposedly represents a 1:1 ratio because the two lights are equal in output. But, once again, because the main light only hits the highlight side of the subject while the fill light hits both sides of the subject's face, then there would still be two units of light hitting the highlight side of the subject and only one unit of light hitting the shadow side of the subject—seemingly a 2:1 ratio! All of this is enough to make anyone want to stand in a corner, scream at the wall, and pull their hair out. Surely there's got to be a more sane way of thinking about ratios, right? Luckily, there is.

After reading about, thinking about, talking with other photographers about, and experimenting with ratios for almost 40 years, I finally gave up on all the ratio punditry because it got in the way of taking pictures. I now think of the ratio between my main and fill lights as either steep or flat, and I don't bother to use numbers and punctuation colons to describe them. For portraits of individuals and two subjects, I often go for a steeper ratio (meaning a greater difference between the highlight and shadow areas) if I want the lighting to be dramatic or I want to hide a few extra pounds on my subject. For larger groups or portraits where I don't want to make a dramatic statement with my lighting, I go for a flatter ratio (meaning a smaller difference between the highlight and shadow areas). There's another reason I use flatter ratios for groups of more than two subjects; if you use a steep ratio on four subjects (as an example) the subject closest to the main light is always lighter than the next subject in the line, who is lighter than the next subject, and so on. Steep ratio group portraits end up being light on one side and dark on the other, which emphasizes the subject closest to the main light and makes the subjects farther away from it darker and seemingly less important.

This series of pictures shows a one, two, three, and four-stop difference between the ratios on the highlight and the shadow sides of the subject's face. It starts with a flat, one stop difference, proceeds through a two and three stop difference, and ends with a steep, four stop difference. Which ratio is correct? All of them. Which one should you use? That's up to you.

Everything I just wrote does not mean that I have no idea what the specific differences are between my main and fill lights. Instead, it means that I will often go by feeling that is based on a lot of experience and the way I power my lights. With practice, you'll be able to do the same thing. Here is one easy technique that will help you get the "feel" of your lights more quickly: Use equal light settings to eliminate a variable.

Most flash generators can power two (or more) flash heads. Usually, how the power is distributed to the flash heads can be arranged in two different ways. If the total amount of power available (usually measured in watt seconds) is split between the two (or more) flash heads equally, this is called a symmetrical distribution. If the power distribution is arranged in such a way that each flash head can be set to differing amounts of power, this is called asymmetrical distribution.

If we have two flash heads, each fitted with the same reflector and/or light modifier (umbrella, soft box, etc.), there are two things that determine how much light that flash head produces when measured at the subject. One is its power (usually measured in watt seconds) and the other is its distance from the subject. Even if we were working with two continuous light sources, it still boils down to the light's power and how far it is from the subject. In fact, all things being equal between two (or more) flash heads, flash units, or continuous sources, light intensity at the subject always boils down to power and distance.

Distance is both an easy concept to understand and see. In a two-umbrella light setup, you can see that one umbrella is farther away from the subject than the other umbrella. But problems arise, especially when using flash, as you try to pre-visualize your light's effect while trying to keep track of the light's differing power outputs if you are using an asymmetrical power distribution. Lighting would be much easier to pre-visualize and understand if we made each light equal in intensity and only had to worry about how far each one is from the subject. So, at least in the beginning, that's what I'm going to suggest you do.

If you were always to set up your two lights (the main and the fill) so they were equally powerful, then the only governing factor in determining the light's effect would be how far it is from the subject. By using a symmetrical distribution for your light's power, regardless of what types of lights you use, you have eliminated one of the two variables from your mental calculations, and this will result in making your whole lighting technique much easier to pre-visualize and apply.

Dyna-Lite 1000 watt-second pack

This is a Dyna-Lite 1000 watt-second pack. While each brand of electronic flash unit has a different control layout and different placement of their switches, all of them work similarly. Note that across the top of the pack there are four sockets into which you can plug four flash heads. The 4 sockets are divided into two separate banks: A and B. We'll get back to the separate banks in a minute. Next note that below the two banks there are two white rocker switches that can set the output of each bank to 125, 250, or 500 watt-seconds. Above each white rocker switch there is a tri-color LED that glows red for 500 watt-seconds, orange for 250 watt-seconds, and green for 125 watt-seconds. The way the white power switches are set, if this flash unit were set to asymmetrical power distribution the "A" bank of sockets would receive 500 watt-seconds of power (a single flash head would receive 500 watt-seconds of power or two flash heads would get 250 watt-seconds each) and a flash head in the "B" bank would get 125 watt-seconds of power (or if two flash heads were mounted, they'd get 62.5 watt-seconds each). But, if you notice

Electronic flash units like the Dyna-Lite 1000 watt-second pack can be set for symmetrical or asymmetrical power distribution.

the black rocker switch and red LED (at the 4 o'clock position), you'll see that there are two choices for power distribution: A:B and A+B, which determines if the pack is set up for asymmetrical (A:B) or symmetrical (A+B). Since this pack is set to symmetrical (A+B) distribution, each head would receive 312.5 watt-seconds (500+125/2) if two heads were plugged into it, 208 watt-seconds if three heads were plugged into it, and 156 watt-seconds if four heads were plugged into it. This type of symmetrical power distribution is much easier to control because the only difference between multiple heads (if they are all fitted with similar reflectors or light modifiers) will be their distance from the subject. After you become very comfortable with using only the distance a light is from the subject to determine the ratio between multiple lights, you can experiment with asymmetrical power distribution for special situations. However, I can tell you from hard-earned experience that symmetrical power distribution is more easily controlled, more easily pre-visualized, and perfectly usable for the majority of the situations you'll find yourself in.

For pros having to shoot creative portraits according to their client's schedule, working in the studio is often easier than working with natural daylight. While natural light is beautiful, it changes with the season and time of day. It's hard to run a profitable business if the prime ingredient (light) is as fickle as the weather.

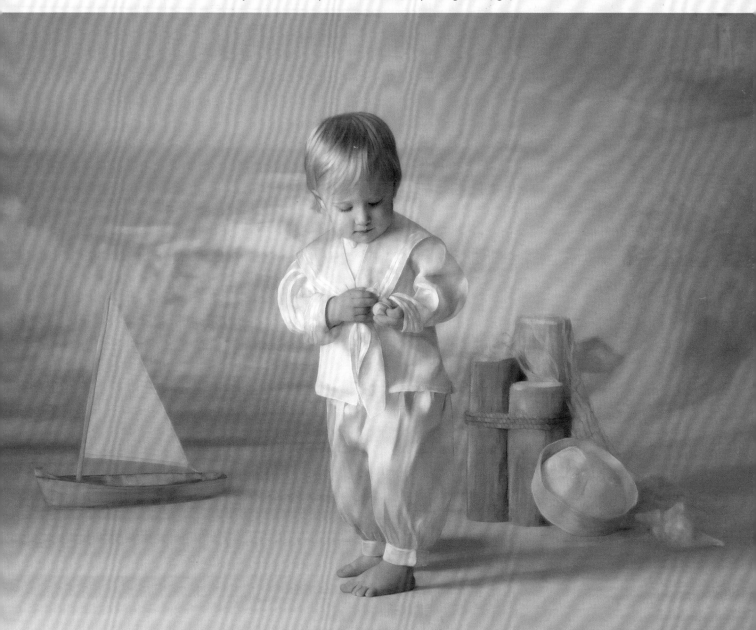

© LOUISE BOTTICELLI

When I first started in photography, my exposure was all over the ballpark. There was as much chance of my exposures being consistent from frame to frame as there was of me getting hit by lightning twice! While my exposure inconsistency translated into hours of drudgery in the darkroom fixing my mistakes, today's inexperienced photographer will spend hours in front of their monitor doing the same thing. And it can all be avoided. My inconsistency was due to the fact that I had no understanding of how a light meter worked. So if your goal is taking pictures rather than fixing them, continue reading for a light meter primer.

reflected light meters

Light meters are dumb. They don't have a brain, and for them to work they have to have some sort of standard against which to measure. This standard is called a middle gray, and regardless of whether you use your camera's TTL (Through The Lens) meter or a handheld one, a reflected light meter will suggest an exposure that will render whatever it's pointed at as that middle gray.

Point a reflected light meter at a bride in a snowy field or at a kid in a white sheet pretending to be a ghost on Halloween and a reflected light meter (including the one in your camera) will suggest an exposure that will reduce your stark white subject to a dingy gray. Point a reflected light meter at a black gorilla that fills your frame or at the proverbial black cat in a coal bin and a reflected light meter will suggest an exposure that will reduce your dark, mysterious subject to a dingy gray. It is important to realize that the light meter is not doing anything wrong when this happens—remember that it doesn't have a brain and thinks you (the one with a brain) are pointing it at a middle gray.

However, reflected light meters will almost always give you a correct exposure suggestion if you point them at an object within the scene that is indeed a middle gray. The problem is the world is in color! So the question then becomes just what color is a middle gray? Red? Yellow? Blue? Tough call, huh? Some photographers suggest taking a reading off a Caucasian subject's face, but is a Caucasian's skin tone a middle gray? It's not (it's one stop lighter), but wait a minute—even if it were, is the Caucasian being measured pale toned or tanned? As you can see, consistent exposure, or even choosing the proper thing to read with a reflected light meter, can be a real headache.

Speaking of headaches, here's another one. If you don't use your D-SLR manufacturer's dedicated flash units, there's almost no chance of figuring out single or multiple flash exposure correctly without, quite literally, years of experience. Since no one can get years of experience without spending years working at it, there must be an easier way, right? Enter the incident light meter.

© LOUISE BOTTICELLI

Even though your scene may have a lot of grays in it, it's hard to decide exactly where to point your reflected light meter to get a middle gray. Using an incident light meter will take the guess work out of the equation.

incident light meters

Almost every professional still photographer and every professional cinematographer understands the problems that reflected light meters can cause and bypass them altogether. Their reasoning behind this is simple: Too much money and effort goes into setting up the shot to risk it all on the vagueness of guessing what in the scene is a middle gray. Also, most professionals don't limit themselves to manufacturer-dedicated flash units, but they still produce the correct exposure, and they can do it with any brand of flash unit. How do they do this? Is there a special light meter that only professionals know about? Well, yes, there is. What if I told you that you can measure the light before it hits the subject and reflects back off of it? What if I told you that by measuring light this way it was no longer necessary to first decide what part of your subject was a middle gray? When it comes to light meters, there are two ways to classify light. One is reflected light that measures the light after it has hit the subject and is reflected back at the camera; obviously, this is called reflected light. The second way is to measure the light before it hits the subject, before it can go through the altering state of being reflected, and this is called incident light.

To get a repeatable technique for figuring out the relative power of each of my lights, I turned to the movie industry and learned about their standard, the incident light meter. Every incident meter has a white translucent dome that acts as a stand-in for the subject's face. In use, the dome is pointed towards the camera's lens and placed where the face is. The dome collects and measures the light falling on the face and gives you an exposure based upon this light as opposed to the light reflecting off it. When you use an incident meter, at the moment when the dome is pointed towards the camera, a few very important things change. No longer is it important if the subject is white, yellow, black, red, green, blue, or any other color. No longer is it important if the subject is sunburned or pale. No longer is it important if the face is surrounded by a shock of curly brunette hair or framed by blonde tresses. It no longer matters if the subject's outfit is white, red, black, green, blue, yellow, or any other color. And it doesn't even matter if the subject is against a white, black, or multi-colored background. In fact, the reflective qualities of different colors or different materials don't matter anymore! In one fell swoop you have achieved exposure consistency for your subject's color and reflectance. But this doesn't mean you can turn off the brain in your head when using an incident meter because getting a consistent exposure reading is not always the same as getting the exposure correct. I can't emphasize enough that the words "consistent" and "correct" are not interchangeable!

I have three incident light meters, each calibrated to the other two. Two travel with me, and the first thing I do on an assigment is make sure they match each other. The third stays at home in my studio and is used to check the other two for consistency.

A white, high-key background can result in exciting portraits, but it's also an exposure situation that is hard to get right with reflected light meters. Using an incident light meter will yield more professional results.

This overhead view of a photographer using an incident meter reveals a few important details about consistent metering technique. Note the photographer holding the meter has positioned himself on the fill light side of the scene so if, by chance, his body obstructs some of the light hitting the meter's dome it is blocking the less intense fill light instead of the more powerful main light. Even so, he has carefully positioned his body so that there is little chance of blocking any of the light hitting the dome. Although the meter's dome was intentionally drawn oversized for clarity, note that it is "feathered" so as to point along an imaginary line between the lens axis and the center of the main light.

incident light meter consistency

I have discovered that using my incident meter in sunlight consistently (there's that word again) suggests an exposure that results in a JPEG between one and two stops overexposed. The amount of overexposure always depends upon how intense the backlighting is in the scene. For subjects that are lit from the front, the meter's suggestion always results in a one stop overexposed JPEG. In strong backlight, the JPEG is always two stops overexposed. In both instances, I adjust my camera's exposure setting to decrease my exposure by one or two stops respectively. I have also found that if the subject is standing in a field of snow, on a sandy beach, on a large patch of light-colored cement, or next to a white-washed wall, the meter's suggestion also results in one stop overexposure. In these situations, I also adjust my camera's exposure settings by decreasing one stop. This means that when using my incident meter's exposure recommendation, I'll close my lens down two stops (or use a two stop shorter shutter speed) if my subject is on the snow, sand, or cement, and if my subject is lit by strong backlighting and also on snow, sand, or cement, I'll close my lens aperture or shorten my shutter speed by a total of three stops. Regardless of whether you find this to be true or not when you use an incident light meter, the important thing to understand is that because your metering technique is consistent and your meter reads consistently, it is easy for you to dial in a correction that you find necessary. As long as any exposure correction required is consistent, it is easy to make; it's when exposure corrections that are inconsistent pop up that you'll find yourself all over the ballpark.

An incident light meter will give an accurate reading of the light falling on the subject. Unlike a reflected light meter, its analysis won't be changed if the subject is wearing light or dark clothing.

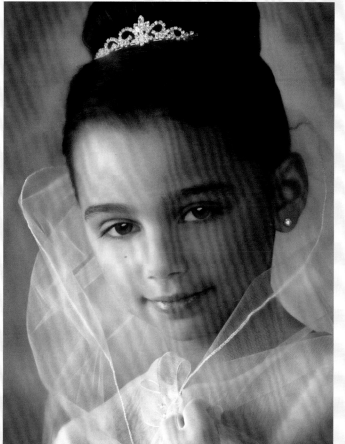

© JAN PRESS PHOTOMEDIA, LIVINGSTON NJ

Kenko meters (formerly Minolta meters) have a higher contrast LCD display, are lighter in weight, balance better in your hand, and use an easier to find AA battery when compared to the Sekonic L-358 meter (which uses a more expensive and harder to find CR123A battery). However, Sekonic's L-358 features a killer advantage if you use the Pocket Wizard radio slave system. The Sekonic RT Module-32 fits inside the Sekonic meter and allows you to fire any Pocket Wizard-equipped flash unit by pushing a button on the meter. This feature makes taking flash meter readings so convenient that photographers who use the Pocket Wizard Radio slave consider a Sekonic meter equipped with a RT Module-32 a must have accessory!

The technique required when using an incident meter to read flash or hot (quartz) lights is also tricky and can benefit from consistency in your technique. Part of this has to do with both where we place the dome and where we point it. Let's say, for example, we have a subject lit by two broad light sources (the main and the fill), with the main light 45° – 60° away from the lens axis. The fill light is on the opposite side of the lens axis from the main light, closer to the lens axis than the main light, and farther away from the subject than the main light (see figure, opposite page). If we place the dome on the fill light side of the face, we will get a different reading than if we place the dome on the main light side of the face, even though the difference between the two positions is only about six to eight inches. We will also get a different reading if we have the axis of the dome pointed directly at the camera lens or angled towards the main light instead. If you were to ask

me which position is best, I would answer that it doesn't matter as long as you do it the same way every time. If you do this, you will have eliminated another variable in your technique. As long as your technique is consistent, you can figure out the correction required by looking at the histogram from a single photograph.

Let's continue along this path of eliminating variables. Not only do you have to consider where you place the dome, but you also have to be sure that *your* position, when you take the reading, doesn't affect the amount of light hitting the dome. Many inexperienced photographers will walk up to the subject and, as they stand directly on the axis between the lens and the subject, place the dome in front of the subject's nose and take a light reading. This might be okay except for the fact that your standing along the lens/subject axis means that your body might be blocking some of the light from hitting the dome.

Let's look at another example. Say you are working in a flash-lit scenario and you were using a grid spot that acts as a hair light. Once again, if you were to stand on the axis between the camera's lens and the subject, placing yourself directly in front of your subject, the exposure setting your meter suggests would be affected by whether you were wearing a black or white shirt. When wearing the black shirt, you would be acting as a negative fill reflector; when wearing the white shirt, you would be acting as a positive fill reflector. I can promise you that each exposure reading would give you an exposure suggestion that would be wildly different!

To eliminate both of the variables mentioned in the last two paragraphs, I always stand to the side of my subjects and never in front of them. If I'm working with electrically powered lights (flash or quartz hot lights), I always stand on the fill light side of my subject. I choose to stand on this side of my subject because, by definition, the fill light is always less powerful than the main light, so it is a smaller component of the total light hitting the subject. This means that if I block it slightly with my body as I take a meter reading, the reading will be less affected because the fill light is less powerful. Likewise, I always extend the meter into the scene and place the dome at my subject's chest height or under their chin. This meter position doesn't offer as accurate a reading as when the dome is placed in the middle of the subject's face at their nose tip, but I prefer not placing it right in their face because I think it is a big intrusion on my subject's space and hurts our rapport. Because of this I have to remember to adjust my reading accordingly because the subject's chest height is usually farther away from the light source than their eyes.

Because my incident meters read flash (as well as ambient light), I know what my flash units are doing and I can therefore control them. And regardless of how accurate or how much you want to use automatic flash, dedicated D-SLR flash units are always less powerful and otherwise more limited than the vast majority of AC powered flash units available on the market. While there are times when a hot shoe mounted flash is all you need, there are many other times when you just need more choices to create different and exciting portraits.

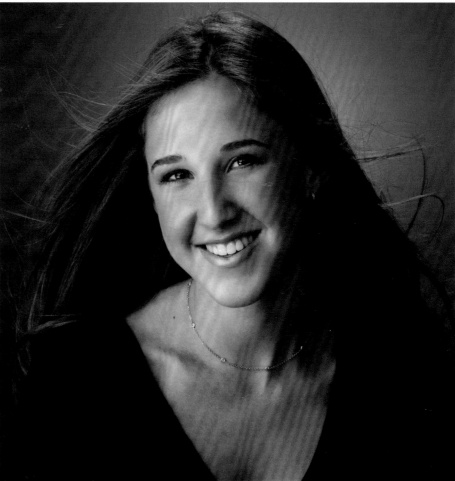

Some photographers like the look of a strong hair light, while others prefer one that provides just a hint of light on the back of the subject's head (as seen here). Regardless of your preference, if you are wearing a white shirt while standing directly in front of your subject while using an incident meter, the reading will be affected by the hair light's spill bouncing off your white shirt and hitting the meter's dome.

reading lights individually

While every incident light meter has a translucent half dome that is supposed to represent a three-dimensional subject (such as a face), many still photographers and cinematographers use a flat, translucent receptor instead of the rounded dome. The reason behind this is simple: The flat receptor allows them to aim and read each light individually, with less chance of another light on the set affecting the reading on the meter. Some incident meters have a separate flat receptor available as an accessory, while others have a dome that is retractable so it becomes a flat type of receptor.

Although I have incident meters with either accessory flat receptors or retractable domes, I really don't use either of these features. Instead, I use the regular (or fully extended) dome. When I want to read the intensity of a single light, I use my free hand or my body to block the other lights from hitting the dome.

In the end, I can only say that if you look at almost any portrait, in any high-end magazine, annual report, or hanging on the wall in a fine living room, I am willing to guarantee that hardly any of those images were taken with a single automatic flash unit mounted in the D-SLR's hot shoe. While the paparazzi photos of stars and starlets may have been grabbed by a D-SLR with a flash unit set to auto mounted in the camera's hot shoe, their value is based primarily on the subject's notoriety and not on any great photographic quality. If you produce those kinds of portraits of regular people, you probably won't be in business for long. While it's not the only factor, generally speaking, the lighting quality you bring to a portrait session is what will help generate high-end fees, and controlling that lighting is what incident meters are all about.

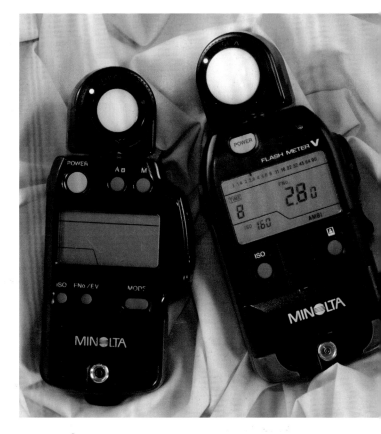

Minolta meters, now sold under the Kenko name, require the use of a separate flat receptor accessory if you want to read an individual light's intensity.

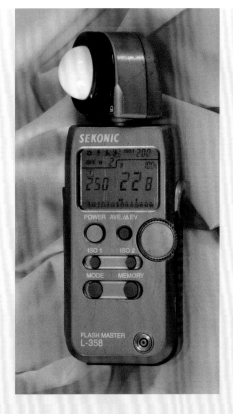

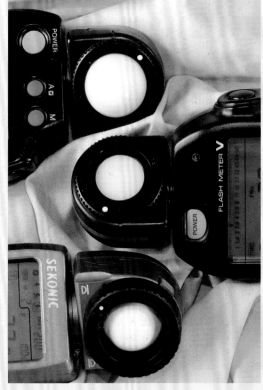

Some Sekonic meters feature a retractable dome (their L-358 is an example). This allows you to retract the dome when you want to read the intensities of individual lights.

Okay, it's now time to stop discussing theory and to start applying it. The examples that follow are done in a studio setting using flash, but the techniques used can be applied just as easily on a location portrait shoot and possibly even in natural light situations. These examples can also be accomplished with quartz halogen ("hot") lights instead of flash units.

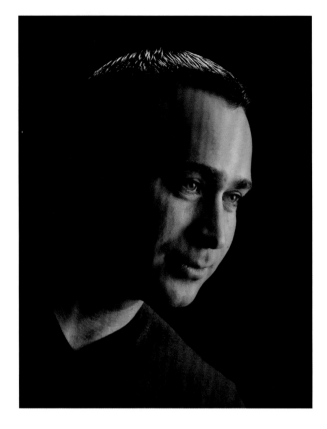

high-key and low-key portraits

High-key and low-key portraits can be very eye catching. High-key portraits usually have a light and airy feeling with a majority of light or white tones, while low-key portraits are more dramatic and mysterious with a lot of dark or black tones. Because the majority of the tones are on the light side, high-key portraits are relatively low in contrast, while low-key portraits have much more contrast because a light-toned face floats in a sea of darker tones. In practice, I think of high-key portraits as one in which the subject's face is the darkest part of the portrait while low-key portraits make the subject's face the lightest part of the portrait.

If you're doing a high-key portrait, it is important to remember that if you overexpose a white background, you eventually get to the point where the background flares and this can creep around the edges of the subject, which can look either ethereal or just plain soft and distracting. So, while you want a light background in a high-key portrait, don't go so far that you end up making it hopelessly overexposed. For low-key portraits, be aware that a dark-haired subject's head will merge with the dark background. It is important to use a hair light to create a rimming effect on a dark-haired subject to keep the subject's head and the background separated.

If you want to do a low-key portrait of a subject with dark hair, one important consideration is to use a hair light so the top of the subject's head doesn't merge into the backdrop. You can use a snoot or a grid, but make sure the hair light's spill doesn't hit the background, which would ruin the low-key effect.

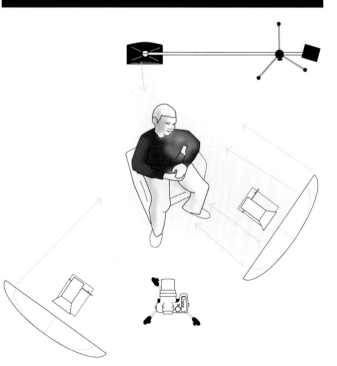

Many photographers only use high-key portraits for little kids or blondes, but I find they can be equally effective with a dark-haired subject. The difficult part about all high-key portraits is to overexpose the background, but not so much that it starts to flare.

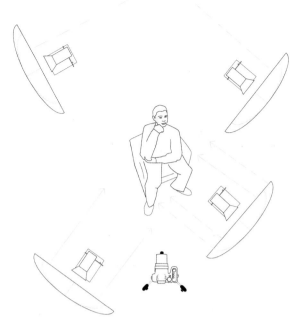

the beauty light

The beauty light is designed to minimize facial wrinkles on your subject and make them look, beautiful! In practice, the primary light is a very large, soft source (I usually use two umbrellas) that is over the lens and extends left and right past both sides of the subject's face. This light totally minimizes *vertical* creases and wrinkles in the subject's face. The second part of this lighting technique is a *large* white fill reflector placed horizontally 14 to 24 inches (35.6 to 60.9 cm) beneath the subject's face. Imagine the subject sitting at a desk or table with the reflector placed on the desk or table's top surface and you'll get the idea. This reflector totally minimizes *horizontal* creases and wrinkles in the subject's face, in addition to opening up the subject's eye sockets and filling in the shadows under the subject's chin. It is also worth noting that you can achieve the same effect by using a white seamless paper background that extends onto the floor beneath the subject and have the subject sit down on it. This can be especially useful for a relaxed family portrait or a group of kids.

This lighting technique is important because almost any home has a table that can be covered by the reflector, or even a white tablecloth or a large white towel, which can be equally effective. This technique does not work if you use a light blue or green tablecloth, but a light pink, salmon, or yellow one will yield terrific results. Adding to the ease of creating this type of lighting, a shoe-mounted flash that can swivel 180° (so it's facing backwards) and can be bounced off a reflector held directly behind the photographer's head to achieve results similar to using more powerful AC-powered flash units.

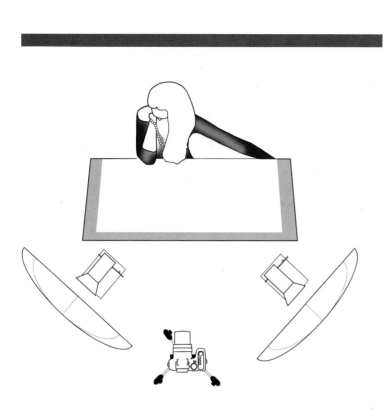

Although this diagram calls for two umbrellas, you can accomplish a similar effect with a large 30 x 40-inch (75 x 100 cm) bank light placed directly over the lens in a horizontal position.

Four photos, four different fill reflectors. Shown here, top to bottom, are a white reflector, a black (negative) reflector, a pink reflector, and a green reflector. My choice is almost always a white reflector, but on some occasions I'll use a pink or salmon colored one. When my goal is a "beauty light," I never use a black (negative) reflector and I avoid green reflectors like the plague!

A classical portrait lighting arrangement uses three or four different light sources: the main light, the fill light (or a fill reflector), a hair light, and a background light. Before we continue, a few caveats are in order. Sometimes, if you are after a more dramatic effect, you might decide against using a fill light or fill reflector at all. Also, there are muslin and canvas portrait backgrounds available (such as those from Adorama's Belle Drape Line or Denny Manufacturing's Old Masters line) that have a lighter area painted onto the center of them, and by using one of these you might be able to eliminate using a real background light altogether. In fact, the two samples I'm using in this section use only three lights each. On one, I eliminated the background light because I used a painted muslin that had a light spot painted on it; in the other, I didn't use a fill light because I wanted inky black shadows to make the portrait more dramatic. In any event, the specific type of lighting equipment used is not as important as how the lights all work together. Each light has a specific job to do, and the way each light is set up is usually fairly consistent from shoot to shoot.

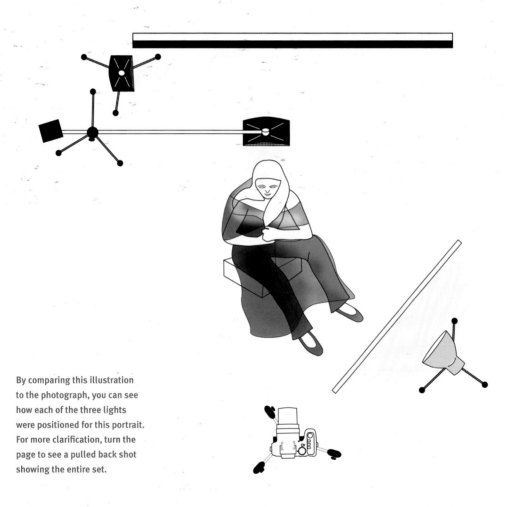

By comparing this illustration to the photograph, you can see how each of the three lights were positioned for this portrait. For more clarification, turn the page to see a pulled back shot showing the entire set.

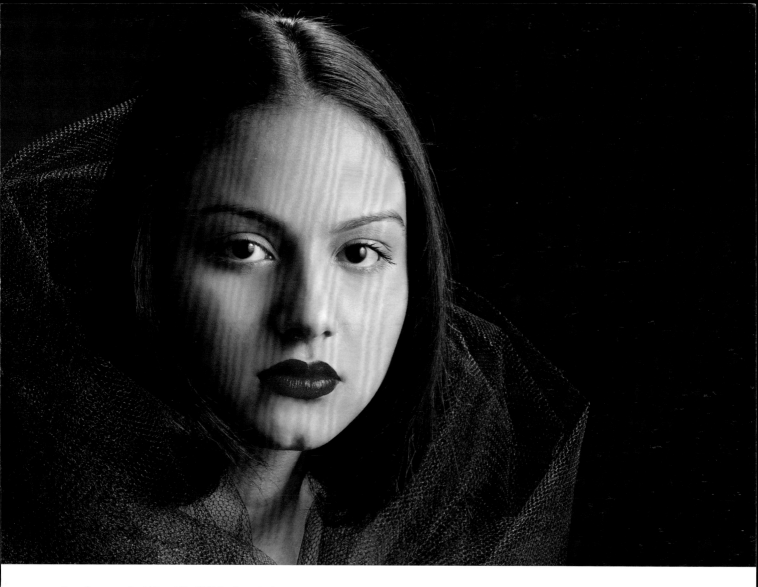

Sometimes you should forget the fill light altogether!

1. The main light, as the name implies, is the primary light source illuminating the subject. Usually it is a broad source, set at a 45°–60° angle from the lens axis that lights the short side of the subject's face, thus creating a triangular highlight on the broad side of the subject's face.

2. The fill light lessens the shadows caused by the main light, and its intensity in relation to the main light determines how deep or open the shadow side of the face appears. The fill can be a second light source (usually another broad source), or a reflector of some sort, but these are usually positioned differently from each other because of how they work. If the fill light is another light source of equal power (as suggested on page 114), it is should always be farther away from the subject than the main light and usually positioned close to the lens axis, but on the opposite side of the lens axis from the main light. It is always farther from the subject than the main light so that its effect is reduced. Both its distance and position are chosen so that the fill light doesn't create a distracting second set of shadows on the subject's face. If a reflector is used for the fill, and it is placed an equal or greater distance from the subject than the main light, then it is always less powerful than the main light. A reflector is usually positioned opposite the main light, as opposed to closer to the lens axis, because that position allows it to more efficiently catch and reflect the main light's beam back toward the subject.

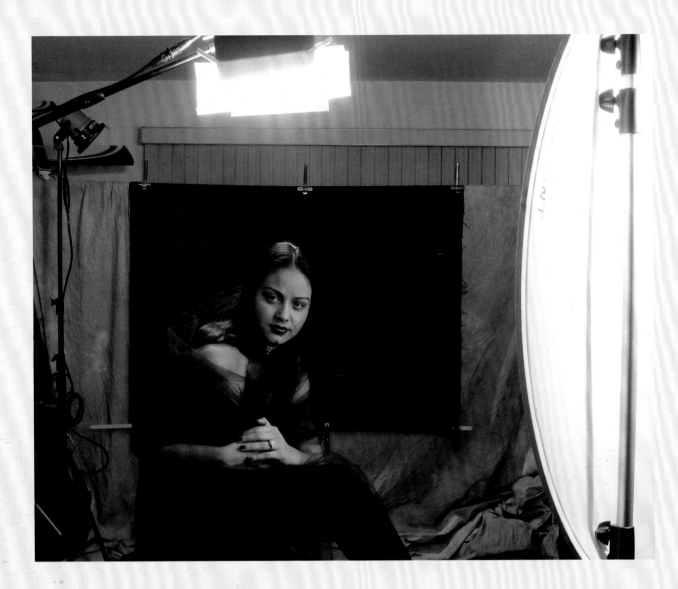

3. The hair light has two assignments: It illuminates the subject's hair, making it sparkle, and it separates the subject from the background. It is usually fitted with a light modifier that limits the width of its beam so as not to create lens flare. A hair light is *usually* mounted on a boom arm so it can be centered over and behind the subject's head, or it can be placed behind the background, peaking over so its support stand is hidden. It is *usually* 1/2 to 1-1/2 stops more powerful than the main light depending upon the subject's hair color.

4. The background light, as the name implies, illuminates the background but, unlike the other three light sources, it has the least consistency in how it is used. It can be placed high and to the side of the background with a light modifier narrowing its beam so that it slices across the background. It can be fitted with a light modifier to narrow its beam and be placed low and centered or off to a side to illuminate the lower half of the background. It can even be a broad source depending upon the background's size, or it may even be two or more lights combining broad and hard sources to illuminate the background and spotlight details within it. Background lights are usually 1/2 to 1-1/2 stops less powerful than the main light, depending upon the background's color and how you want it to appear.

Note how often "usually" is used in the descriptions of the four light sources. While I can guarantee that using the suggestions cited will almost always produce a stopper portrait, there are literally millions of other ways to create beautiful portraits—but you should at least understand and try these suggestions. Also note that "always" is rarely mentioned above. These absolutes are etched in stone because they refer to the definitions of what the lights do. If you are working with two lights of equal power, and move the fill light in closer than the main light so that it becomes more powerful, it is no longer the fill light because it has, by definition, become the main light. If you were to do this, then the main light automatically becomes the fill light. The point here is that by mentally assigning each light a title, and understanding the definition of that title, it is easier to understand how to position them.

Like almost everything we've covered in this book, the techniques described here, and how to achieve them, don't always have to be followed to the letter. Photography is a creative pursuit, and bending and breaking the rules is one of the best ways to get exciting new photographs. But you've got to start here, building your simple house, before you can tear it down and start over on your masterpiece. Also, there will be days when you'll find yourself shooting a portrait while you are juiced up on a cold medication and you're blurry eyed from a 102° fever. When one of these days happens (and if you become a pro, it will happen), you can wrap yourself in the warm blanket of basic technique and experience and still get the assignment done.

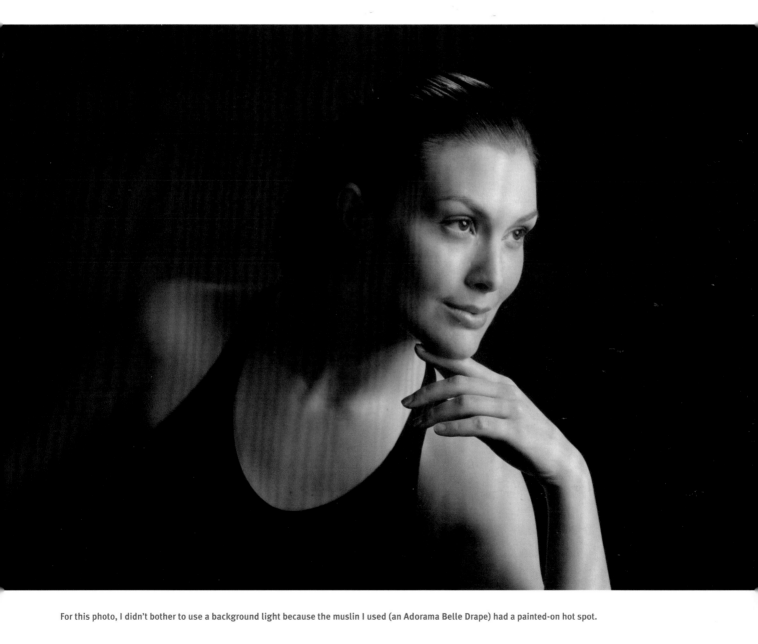

For this photo, I didn't bother to use a background light because the muslin I used (an Adorama Belle Drape) had a painted-on hot spot.

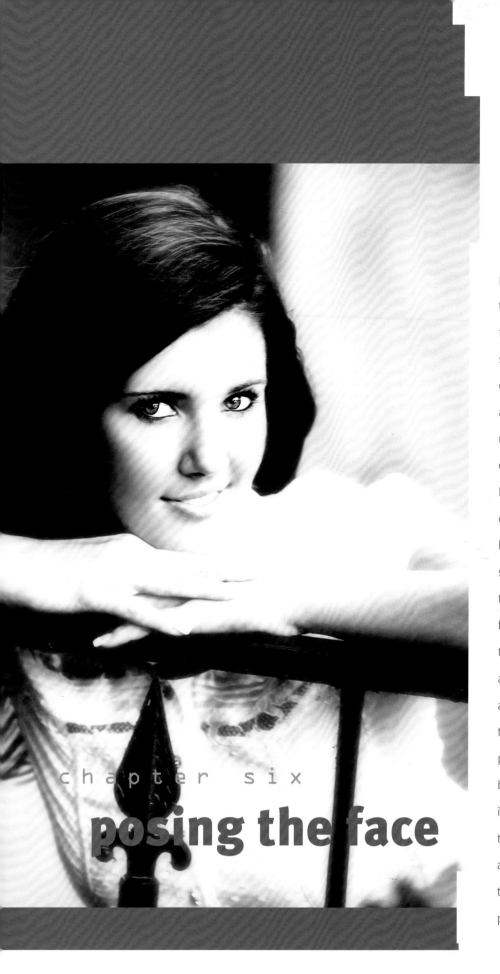

chapter six
posing the face

I firmly believe that perfect posing results in portraits that don't look posed. The idea that a photographer's best work should not be seen is a difficult concept for many photographers to accept because of the competitive nature of a profession where everyone wants to stand out. Imagine the consternation we egocentric photographers feel knowing that our goal is not to be seen? Regardless of our desire to shout about our competence from every hilltop and steeple, or the necessity for proving talent and creativity in competing for assignments, I still come back to the truism that the very best posing is invisible. The whole idea behind great portraiture is that it's not about the photographer's technical virtuosity, but instead about the subject and his, her, or their message. So let's talk about posing: the invisible art form.

Many artistic techniques in portrait photography are best when they don't call attention to themselves. If the viewer is distracted by any photographic technique, it obscures the subject who should be the focus of the portrait. There's a phrase that magazine and book publishers use to describe a great editing job: The perfect editor never leaves footprints. The editor's job is to make the words organized and easily understandable so the message comes through without losing the author's unique voice and, in a way, that's a good description of the portrait photographer's job, too. If a portrait photographer's posing technique looks stilted, uncomfortable, or unnatural, then the photographer is leaving footprints, and those very footprints can doom the portrait to mediocrity, or worse still, a cliché.

Even though posing is an invisible art form, when done carefully and with a plan, it can do wonders for a less than perfect face. In reality, there are very few "perfect faces" to begin with, so posing is an invaluable technique. Shortening noses, accentuating eyes, hiding lazy or different-sized eyes, strengthening weak chins, and a host of other common "problems" can easily be dispatched by posing. Like the magician's sleight of hand,

much of this visual trickery is based on controlling what the viewer can see, and probably more importantly, what they can't. While you can accentuate something by lighting it, or minimize it by hiding it, or placing it in the shadows, another way to do this is by carefully choosing your point of view. What this boils down to is your camera's position in relation to the face, and while it may not seem to be connected to posing, it can be considered as a block in the foundation you're building to support everything else you're going to do. That being the case, let's start there.

two planes floating in space

In your mind's eye, imagine two planes floating in space; one represents the subject's face (the facial plane) and the other represents either the digital chip or the piece of film within your camera (the imaging plane). Do you have a mental picture of this? Good. While these two planes are not physically connected, moving either of them affects how the facial plane is shown on the imaging plane. Not only does moving either plane left, right, up, or down change how the subject's face is portrayed on the imaging plane, but depending upon whether the planes are parallel or not also affects how the face is portrayed. If the two planes are parallel and centered on one another, then the imaging plane will record an "accurate" rendition of the facial plane. But if they're offset or not parallel, then things start to get interesting.

When I talk about centering the lens (or lens axis) on the subject, you should imagine a straight line that passes through the exact center of the front element of the lens and hits both the imaging and subject planes at a right (90°) angle. While centering the lens can be exact, the center of a subject's face is not as easily defined. If we were to center the face on the lens axis, it is likely that the centered lens axis line would hit the average subject somewhere between the bridge and the tip of their nose. However, when we get a mental image of a face the first thing we usually see in our mind is the subject's eyes. This means that there are two centers of the face; one is the physical center (somewhere approximately on the nose), while the other is the center of interest (usually the eyes). If I'm doing a bust-length portrait, I usually start with the camera centered on the physical center of the face. But if I'm doing a close-up portrait, which is primarily the subject's face, I start off with my camera centered on the center of interest—the eyes.

Full-lengths are a bit easier because the subject's eyes, while still important, are a much smaller part of the whole. I was taught that the approximate starting off point for a full-length portrait is to center the camera on the subject's belly button. In general, I find the least amount of subject distortion happens when my camera's imaging plane is approximately parallel to the subject plane, be it their face or their body. Remember though, that like all rules in this book, this rule is ripe for breaking, too.

Depending on what kind of portrait you are composing, you'll want to consider the camera height in relation to the subject's face. For bust-length poses (top), center your lens on the subject's nose. For close-ups, center your lens on the subject's eyes (bottom).

working with planes and distances

Let's talk about the changes that take place when you start to move out of parallel in the imaging and subject planes. If you're shooting a subject and the imaging plane is centered on the eyes (and thus slightly higher than the face's center), and you tilt the camera downwards to reframe and center the face, you have accomplished a few things, some good, some bad. Because the imaging plane is now higher and tilted downward toward the face's physical center, the subject's eyes are closer to the imaging plane while their chin is farther away. This is almost always a good thing. At the same time, the higher point of view and the downward tilt of the imaging plane makes the subject's nose look longer. This is not always a good thing! The higher viewpoint will also minimize the subject's nostrils and weaken a strong chin (or even worse, weaken an already weak chin). Often, you'll find that trying to accentuate or minimize one feature of a subject's face results in the accentuating or minimizing of another feature at the same time. That's because all of a subject's facial parts are connected and, sadly, you can't remove your subject's nose and move it a quarter of an inch up or down and then reconnect it! So whenever you adjust the camera angle to better portray one feature, be prepared for resulting changes in other features.

As you consider this point, remember that the facial plane is not fixed—it's also free to move and tilt, which will also change the results you'll see. For example, if you center your lens on the subject's eyes or even higher, which is slightly higher than the physical center of the face, and then have your subject tilt their head up slightly to bring the face's plane back into parallel with the imaging plane, then the folds of a double chin are stretched open and start to disappear. Without a doubt, 99.9 percent of your double-chinned subjects will applaud this change. As an additional bonus, any double chin still remaining will be hidden and minimized because the high point of view puts it under the primary chin. But remember to look for those resulting changes to other features and weigh their effect on the portrait; in this case, you will end up with a longer-nosed subject who has a weaker chin. I find it very interesting that even slight alterations in camera height usually create simultaneous positive and negative changes, and having to constantly evaluate these changes and make compromises is one of the reasons I'm still not bored with portraiture after all these years.

For changing the distance between camera and subject planes, small increments are usually best. If you were to draw a horizontal line through the center of most subjects' faces (the nose) and another horizontal line through their eyes, you'd find that the distance between the lines on most faces is only about two inches. So when raising the camera as in the example above, I would consider a "high" camera position to be one in which the center of the imaging plane is no more than approximately 4–6 inches (10.2–15.2 cm) above the center of the subject's face. Go much higher (like a foot or two) and the camera's height starts to leave a signature. What is a signature, you might ask? Any time you choose a point of view that is so radical that it detracts from the subject by calling more attention to itself, that point of view is leaving its signature on the photograph. I think very high and very low viewpoints trigger associations about the subject in the mind of the person viewing the photograph.

It's important to consider what the height of your camera says about your subject. A high camera position can make them seem small or young, while a low position can make them seem overbearing or larger than life.

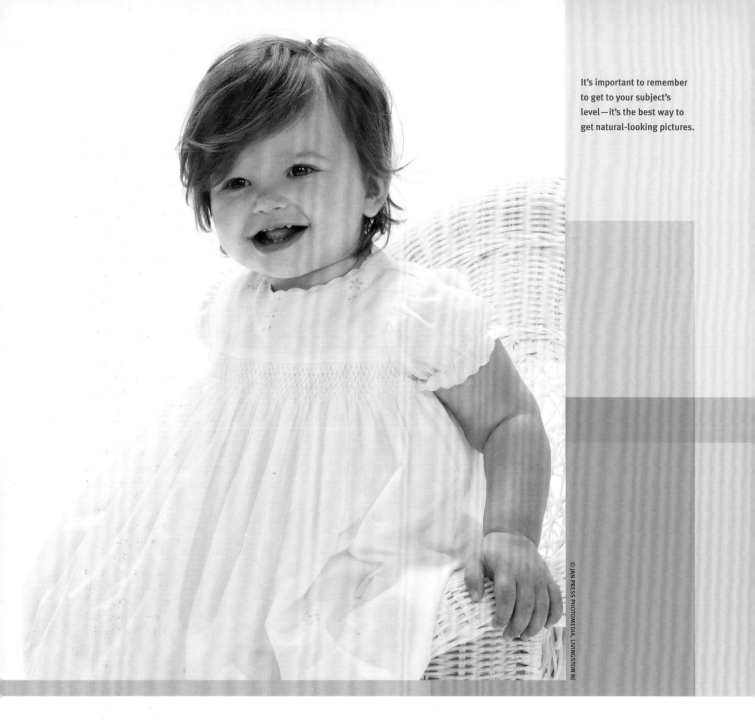

It's important to remember to get to your subject's level—it's the best way to get natural-looking pictures.

I believe everyone naturally makes assumptions about things they see that are based, in part, on past experiences, and camera height as interpreted by a viewer can be a prime example of this concept. If you start to bring up mental images of children you know, you might realize that in the vast majority of these instances, you are looking down at them because kids are smaller than adults. I believe that when we look at a portrait of a single subject done from a radically high viewpoint, it triggers our mental associations about children and makes us feel that the subject is young. If you accept this, then when we look at a portrait of a single subject from a radically low viewpoint, the opposite occurs—the subject looks heroic, powerful, and larger than life because of their dominant, overbearing position in relation to the camera.

While this may seem like a logical concept, I can't tell you how many photographers I've encountered who give no thought to how the camera's height in relation to the subject changes things. Worse still, these photographers often choose a camera height based on their own comfort or convenience, rather than the best choice for the portrait. This is similar to my observation in the Framing chapter that some photographers choose a horizontal over a vertical composition because the camera is easier to hold that way. I've seen very tall photographers doing portraits of small kids with the camera held at their own eye level. I find this unbelievable because they are giving up a useful tool without even considering how their camera's height might be used to their benefit in portraiture.

© JAN PRESS PHOTOMEDIA, LIVINGSTON NJ

One way to simplify the portrait process is to keep your camera parallel to the subjects. This will allow you to focus on posing the faces with less variables to consider on the camera's end.

Before we get into the specific details and tricks for posing the face that are covered in the next section, let's think about the big picture first. Just as reviewing how camera angles and distances can affect a portrait is important, we have to consider all the elements that make up our portrait in order to get a great shot, and posing is just one of these. Over the years, various mentors have given me useful advice. The first is that you are responsible for everything within your frame. Edge to edge, top to bottom—everything!

The bottom line is that the responsibility for a good final product is the photographer's. Just as you are responsible for finding a suitable pose for your subject, you must make sure that everything else in the scene—lighting, background, wardrobe, etc—is working well before you begin posing and finally push the shutter button. If you decide to do high-end portraiture with high fees and even higher expectations by your subjects, this same responsibility will be yours. Fortunately, there are steps you can take to be aware of and carefully correct for the various elements in your frame.

using the scientific testing principle of eliminating variables

When I first started to do still life photography, I would arrange and light my subject and then shoot a Polaroid. Often unhappy with the result, I would make a slew of changes and then shoot another Polaroid. Some of my changes would work and some wouldn't, but because I had lumped so many changes together, it was often difficult to tell which ones were successful and which ones weren't. Likewise, when I started to learn how to make black-and-white prints in a traditional darkroom, I would make a guesstimated test print; often, I was unhappy with the results. I would then change the enlarger lens' f/stop, my exposure time, my development time, and make another test print, often with equally unpleasing results.

Luckily, at the time I was working for a pro who set me straight. In one fell swoop he had me make only one change from Polaroid to Polaroid and, when I was using his darkroom, he demanded that I never change the enlarger lens' f/stop and always develop my prints for two minutes. Although the single-change-per-Polaroid rule undoubtedly improved Polaroid's price on the stock exchange, and although I was forced to stare at numerous black-and-white prints that were either too dark or too light, I soon understood the point being made. I had eliminated as many variables from my technique as possible and this reduced the confusion that often accompanies complication.

At this point, you might want to know what this has to do with portrait photography and posing. Two important points come to mind.

The first is using the scientific testing principle of eliminating variables to make changes to your subjects or scene during a shoot. Just as I had to learn to change just one aspect of a still life, you should take small steps in altering elements such as lighting or posing in a portrait as well. This is especially true when first starting out. Move just one or two elements at a time or change one aspect of the lighting, and then revaluate. Fortunately, in these days of digital cameras, you won't spend a fortune or a lot of time on Polaroids—simply review the new results on your LCD monitor. If you rush and try to fix all the elements of a scene or a subject's pose at once, it'll be harder to know which parts were working and which were flawed, and you'll usually end up wasting more time than if you had taken an organized approach.

The second way to simplify is to reconsider the two planes floating in space we looked at earlier. Try removing a huge variable set from the equation—lock one of the planes down! At the beginning of your journey as a portraitist, always set up your camera so that the imaging plane is parallel to the subject plane. It doesn't have to be perfectly parallel, but try to get it as close as possible. Next, don't tilt the camera forward or backward to adjust your framing: instead raise or lower your camera position while still keeping the imaging plane parallel to the subject plane by having the subject tilt their face up or down. Expend your energy on adjusting the facial plane only while keeping the imaging plane static. To be honest, you'll be giving up an important tool by doing this, but most of what you can accomplish by having both planes adjustable can be achieved with just one plane floating, with the benefit of having half as many things to think about. And because there's less to think about, you'll have an easier time being aware of and controlling the elements in your frame—from edge to edge and top to bottom.

© LEN DEPAS

Sometimes it helps to simplify your technique when shooting complicated situations like this one. Try changing just one aspect of the lighting or posing at a time and preview the results before moving ahead.

Let's assume that you have, in fact, locked down your imaging plane and only the facial plane is allowed to move. Now you're ready to start focusing on posing your subject's face. To simplify things further, let's only deal with what happens when the subject will only be tilting their head forward and backward. By now, you realize that a simple forward or backward tilt will affect multiple facial features at the same time, forcing you to constantly evaluate and balance what is working and what's not. Here are some results you can expect to see in facial features when your subject tilts their head.

If the subject tilts their head forward by lowering their chin, then:

1. Their eyes become bigger because they are closer to the camera's imaging plane (a very important point).

2. The height of their forehead (hairline to eyebrows) is magnified.

3. Their nose appears longer, the subject's nostrils are minimized, and the distance between the tip of their nose and the upper lip is shortened.

4. Their chin is weakened and double chins are accentuated.

If the subject tilts their head backward by raising their chin, then:

1. Their eyes become smaller because they are further away from the camera's imaging plane.

2. The height of their forehead (hairline to eyebrows) is shortened.

3. Their nose appears shorter, the subject's nostrils are accentuated, and the distance between the tip of their nose and the upper lip is lengthened.

4. Their chin is strengthened and double chins are minimized.

It is important to realize that a subject's eyes don't magically grow larger when they lower their chin. And while some may consider these changes in the size of their eyes and the relationship of other facial features an optical illusion, these changes are the result of a simple rule: As objects move closer to a camera's imaging plane they appear larger, and as they move away from the camera's imaging plane they appear smaller. Knowing this, we can move on to specific ways to adjust for various features.

These two photos have the same model, the same lighting, and the same basic pose. But concentrate on the subtle differences. In the top photograph, the subject has lowered her chin and all the attributes described regarding this pose are evident when you compare it to the bottom photograph in which the model has raised her chin.

specific fixes

Hiding and Minimizing Double Chins
Let's face it: If you ask the vast majority of Americans if they would like to look thinner, the answer would be a resounding "Yes!" The most obvious visual clue to a subject's avoirdupois has to be a double chin. Aside from a rooster or a turkey, very few subjects want to crow about the waddle hanging under their chin. This being the case, the question then becomes, "What can we do to minimize it?" Generally speaking, the solutions all boil down to three techniques (with more than three ways to apply them): Tightening the skin covering the double chins through posing, and hiding them by either placing them in shadow or blocking them from view.

figure 1

1. If you're willing to forgo a smiling subject, then ask them to press their tongue against the roof of their mouth. While this eliminates the ability to smile, it does tighten the muscles under a subject's chin, and this actually pulls the waddles tighter and makes a noticeable difference. Don't believe me? Try it on yourself in front of a mirror. And just for fun, try smiling while your tongue is pressed against the roof of your mouth. Tough, huh?

2. Ask the subject to push their chin ever so slightly forward. Like the tongue on the roof of the mouth trick, this stretches the skin under the chin and makes it appear more taut. Imagine a turtle with their head pulled in versus the same turtle craning its neck for a better view of things and you'll get a visual clue to the result.

3. If the subject tilts their face upward, this will also make the folds of skin under the chin more taut, but as a downside it will also make their eyes smaller, forehead shorter, nose shorter, nostrils more prominent, and their chin stronger. Instead, if you pose the subject tilting slightly forward from the waist, this makes their head tilt slightly downward and, when they raise their chin, that cancels out the waist

tilt and eliminates the downsides listed, while still stretching and tightening the folds under their neck.

4. By going to a higher camera position and then having the subject raise their chin so that the plane of their face is once again parallel to the imaging plane, the face is portrayed accurately but the skin under the subject's neck is stretched tighter. An extra advantage of choosing a slightly higher camera position is that the subject's double chins are more easily hidden under their primary chin. (figure 1)

5. By choosing a pose that stretches the subject's torso along a diagonal line (as opposed to a vertical one), the skin under their neck is stretched and becomes tighter. (figure 2)

6. Choose a pose in which the subject's hands are positioned under their chin; this blocks the view of the double chin area. (figure 3)

7. If you go with solutions 4, 5, or 6, consider using a steeper ratio (see page 112) between your main and fill lights so the subject's double chins are hidden in an area of deeper shadow.

figure 2

figure 3

Reigning in a Roman Nose

Aside from double chins, if you asked me what facial feature most subjects would like to minimize most, without hesitation I'd say it was their nose.

A Roman nose can be construed as a sign of character but, in reality, many people hate their profiles (even if they don't have extremely large noses). Why is this? I have given it a lot of thought—more than any sane, normal, non-portrait photographer would ever do—and while I haven't come up with a total understanding of the "why" of it, I have learned a "how" for minimizing it.

But first, an idea on the "why." No one can ever see their full profile in a mirror, so they're not used to it. Considering all the little jokes that nature plays on 99.9% of faces, constantly seeing our face in the mirror over a long period of time makes us acclimatized to what we consider our faults. But a profile picture, without the insulation of familiarity, can be filled with things we don't want to see. And in the case of a large nose, it can look alien and even larger when seen from a different perspective in a photograph.

Obviously then, the easiest way to minimize a subject's nose is to photograph the face straight on, and while this solution always works, it does limit your posing options drastically. So what do you do if you want to shoot the subject in a semi-profile and still minimize the apparent size of their nose?

There is one technique I have used that actually makes a nose look smaller. Here's the trick: The easiest and maybe most effective way to corral a large nose is by containing it within the line formed by the subject's far cheek. While you can't get a full profile this way, if the tip of the nose doesn't pass the subject's far cheek line it looks smaller, and the instant the tip of the subject's nose breaks the cheek line it looks bigger. Look at figure 1 and figure 2 as examples. If you want to accentuate a subject's nose, feel free to let it break their far cheek line, but that might be counterproductive because I have found very few subjects who want to magnify the size of their noses.

Beware the Evil Eye

If you decide to control the size of your subject's nose by containing it within the line formed by the their far cheek, there is a major pitfall to be aware of. Often, when shooting a three-quarter profile, the outline of your subject includes the pupil of their far eye. When this happens, the black pupil looks like a black hole that extends into your subject's face. I find this particularly distracting. You can avoid this distraction by making sure that some flesh separates the pupil from the subject's outline. Consider shooting a portrait both ways and seeing if you agree with me…I think you will!

figure 1

figure 2

In figure 1 the subject's nose doesn't break her far cheek line, while in figure 2, the nose just creeps past it. Doesn't the subject's nose look bigger in figure 2? Which one do you think the subject would like better?

The Subject's Nose Curves Left or Right

Sometimes a subject's nose curves to the left or right. If you shoot this type of subject straight on, their whole face looks out of joint. But there is an easy fix for this type of problem. If you think about it, a curved nose has a concave and a convex side (the inside and the outside of the curve, respectively). You'll find that you can almost completely eliminate this problem by posing the subject in a three-quarter profile and shooting into the concave (inside) curve of their nose. This way, the tip of their nose curves towards the camera and the resulting picture makes their nose look straight. Shoot into the convex (outside) curve, and the tip of their nose points away from the camera, accentuating the bend. So remember that shooting into the concave side of the curve hides the problem. I know it sounds weird, but it works!

Asymmetrical Faces and Different Sized Eyes

First off, an absolute truth: Faces are *not* symmetrical. If you were to draw a vertical line down the center of any subject's face and compare the left side to the right side, you would find that the opposite sides are wildly different. While there's not much that can be done about this, it is also the basis of why some subjects will say they have a "good side." Oddly, although no one ever mentions it, having a good side means the face also has a bad side. Whenever a subject tells me they prefer one side of their face over the other, I follow their lead to the letter. After all,

Imagine the penny and nickel are a subject's eyes. (Using a penny and a nickel helps accentuate the size difference for this example.) In the first picture, the difference in size is obvious, but by turning the mannequin's head so the nickel is farther from the camera, it appears smaller.

they've lived with their face for a long time, and whatever the reason for their preference, who am I to disagree with them? Besides, if I ignore their preference, no matter how great the portrait looks to me, the subject will never be totally pleased with the result because I didn't accentuate their good side, so by default I have accentuated the side they think is bad.

Sometimes the subject will tell me that one of their eyes is larger than the other and ask if there is anything I can do about it. The answer to that question is absolutely! You too can get both eyes to appear the same size by using the technique employed to enlarge a subject's eyes. To apply it, instead of using the raise/lower movement of the face in relation to the camera, use a slight left/right turn. If you pose the subject with their face turned slightly to the side, the plane of the face is offset from being parallel to the camera. When this happens, one of the subject's eye is closer to the camera. By having the subject turn so the smaller eye is closer to the camera, it appears larger. At the same time, the larger eye is on the side of the face farther away from the camera, thus making it appear smaller. Wow—magic! It's all in a day's work if you're aware of what your goal is and how to devise a solution.

using misdirection and distance

A few decades ago there was a famous child photographer in New York City who photographed gorgeous babies for national advertisements. Another part of his successful business was to photograph baby portraits for parents. His favorite portrait background for these clients was a very expensive oriental rug that featured an intricate pattern. The rug was hung like a roll of seamless paper and was both the base and backdrop of his portraits. A friend of mine worked for a while as his assistant, and we often shared "war" stories over beers. One day my friend excitedly rushed into the bar we met at and, within seconds, told me that his boss had shared a tremendous secret with him that afternoon. The photographer had told him that the homelier the baby he was photographing, the more he brought the rug's intricate pattern into focus, and the more beautiful the baby, the further he threw the rug's pattern out of focus. I thought about this for a long time (or at least a few more beers) and decided it was an important trick, one well worth remembering.

Throughout this book I have talked about hiding a subject's imperfections, how everyone has an inner beauty and grace, and how you can make anyone look great. Sadly, that's not completely true. Instead, it may be more accurate to say that you can make everyone look the best they can. In the Psychology chapter, I talk about always having compassion for my subjects, but I am also a realist, and an observant one at that. The reality is, that while I'll come in for a very tight close-up of a subject with a porcelain complexion, there are certain subjects that I choose to stay far away from because there's no way I can overcome the physical limitations they present. So, not only will I shoot a full-length portrait that minimizes the subject's face, I'll even back up further to include more of the background in an effort to distract and misdirect the viewer's attention. And while I might throw a background totally out of focus for the porcelain-skinned beauty, I will sharpen the background considerably for a much less attractive subject.

These two photographs illustrate masculine and feminine posing and the difference between a subject turning and tilting their head. Note how the tilt of the subject's head in the second photograph makes her look softer and more feminine. A subject can turn their head and still be posed in the masculine style, but the moment they tilt their head off the 90° axis, whether the subject is male or female, the pose becomes more feminine.

necks, shoulders, and hands

Now that we've covered a lot of the specifics on how to pose the face, let's move on to other parts of the body that play important individual roles that collectively add up to make a winning pose. Although not really part of the face proper, these parts of the body often share some of the frame with the face during a portrait session and should be discussed in relation to it.

neck

Let's start with the neck, because it's right below the subject's face, and then we'll continue working down from there. While a person's head can't spin around like the possessed girl's in *The Exorsist*, a person's neck is one of the most articulated joints in the human body. The head, perched on top of the neck, can turn left or right, tilt in four different directions, or make just about any combination of a twisting and tilting movement. Try to do that with your knee or elbow and you'll end up in a plaster cast or a brace! For the portraitist posing a subject, this fabulous ability can be used to make a statement.

Although I hate the terminology (which was coined in pre-politically correct times), there is such a thing as masculine and feminine posing. It might be better to term it today as hard and soft posing, because a male subject can be posed in a feminine way and a female subject can be posed in a masculine way. Regardless of the name you use, these poses are based on an imaginary vertical line that runs through your subject's face (top to bottom) and the angle at which that line hits a second imaginary line running horizontally across your subject's shoulders.

Here's the way it works: If the vertical line through the face meets the horizontal line across the shoulders at a right (90°) angle, the subject's head rests squarely on their shoulders and gives the viewer an impression of stability and strength. Conversely, if the line through the face meets the line through the shoulders at any angle other than 90°, it imparts a feeling of flowing movement and softness to the subject. If you want to see for yourself, put down this book, find a mirror, and try both ways. As with everything about posing, *slight* changes to the angle between the two lines are all that is required to switch from a masculine to a feminine pose. Remember that too much posing almost always looks stilted and unnatural. This technique only refers to the tilt of the subject's head in relationship to their shoulders and has nothing to do with their ability to turn their head from left to right.

As an aside, some subjects don't understand the difference between turning and tilting their heads, so I save my verbal cues for these directions until I'm back at my camera position. I do this so that my subject won't "lose it" (their position) while I move from them back to my camera. And because of the subject's confusion over turning versus tilting, and the fact that I'm not up close and personal as I ask them to do it, I have found that a visual aid is helpful. If they turn their head instead of tilting it, I often point to my own head and say something like, "No, not this (as I turn my head left and right), but this instead" (as I tilt the top of my head left and right towards my shoulders). I also often use

my free hand with my fingers straight and the pinky side of my hand facing the subject as I turn or tilt my hand at the wrist joint. Good posing is not only about knowing what you want, but also about getting your subject to clearly understand your directions.

shoulders

Many portraitists start by positioning their subjects' bodies at a 45° angle to the camera so that their body appears narrower in comparison to the width of their face (for more on this topic, see page 150). If the subject does this, one of their shoulders is nearer to the camera and the other is farther away. If you have the subject lower their near shoulder (in effect, raising their rear shoulder and tilting the line between shoulders downward towards the near shoulder), they will look more engaging and involved. Conversely, if they lower their far shoulder (in effect raising their near shoulder and tilting the line between their shoulders downward towards the far shoulder), they will appear more aloof and standoffish in the final portrait. In most situations, having the subject lower their near shoulder is a good thing to do, while having them lower their far shoulder is not. Remember, as in almost everything about posing, in either case we are talking about a minimum amount of shoulder tilting. In many cases, simply keeping the line between the shoulder tops level results in a neutral look that is often pleasing. Choosing straight or tilted shoulders will depend upon the subject and the desired feel you want to give the portrait.

The front shoulder lowered vs. the front shoulder raised. Doesn't the subject seem more engaged with her front shoulder lowered? Doesn't the subject with her front shoulder raised seem more aloof? In truth, other aspects of these two photographs are used to cement my point. In the lowered front shoulder example, her smile makes the image warmer, while the crossed arms and the subject's stern expression in the other example reinforce her aloofness. It is often the sum of many small details that reinforces the entire portrait's message.

If your posing is going to include hands, there are a variety of creative poses that can be used. Here are some examples of what you can do with a subject's hands. This is hardly a definitive list; use it as a springboard for your own ideas.

hands

Surprisingly, hands are one of the toughest things to pose gracefully. Both the palm or the back of the hand, when presented to the camera in a full, flat position, are almost as big as your subject's face. If a hand appears as just described with a face in the composition, you end up with a pictorial element that has a lot of visual weight, but many negative attributes. Hands can easily give away the subject's age because of liver spots or other blemishes, they are often scarred, many have less than perfect fingernails and cuticles, or, worse still, they may have crooked fingers. All of these can detract from the message in your subject's face and eyes. So it's obvious that something must be done to present hands in a pleasing way. See the sidebar on the following page for some suggestions.

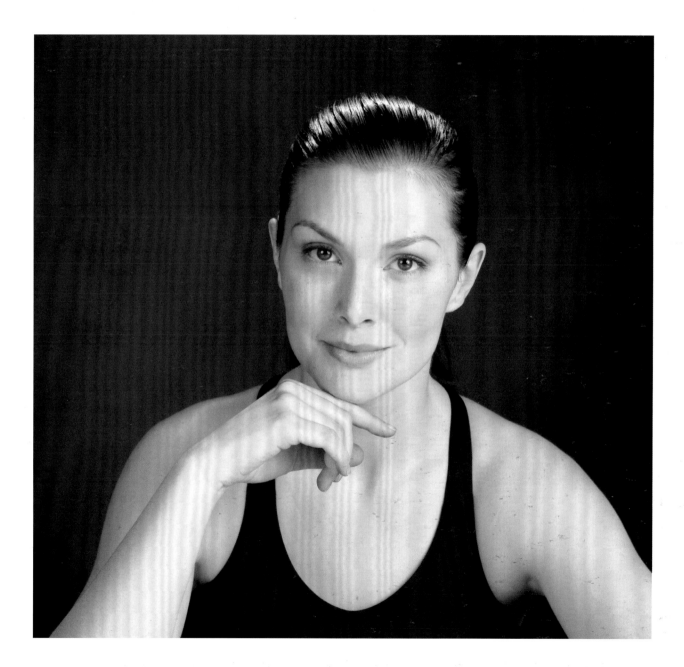

Interlocking fingers are very confusing and call a lot of attention to themselves. Generally speaking, this pulls the viewer's attention away from the subject's face, which is almost always a bad thing. Try another hand position that unlocks the subject's fingers.

figure 1

figure 2

figure 3

Some suggestions for posing hands:

1. Try to present the edge of the subject's hand instead of its broader back or palm. (figure 1)

2. Repeating patterns are a classical way to show elements in a pleasing way (think of roadside telephone poles or the pickets of a fence); your subject's fingers can be treated the same way. When the fingers are displayed with each successive finger bent slightly more than the preceding one, you have a pleasing repetitious pattern. To see examples, find a book or look on the Internet for a picture of God's outstretched hand in Michelangelo's Sistine Chapel painting for proof of this point. (figure 2)

3. If you can combine the edge of the hand, repetitious finger positions, and a slight backwards tilt at the subject's wrist, you will create a graceful "S" curve instead of a hand that looks like a lobster claw. But this technique is fraught with peril when used on a male subject, because if the backward tilted hand is not resting on something in a natural way it looks very feminine. However, if you have one subject's hand resting on a second subject's shoulder or horizontal forearm, the slight upward tilt at the wrist will make it look better.

4. At all costs, if you are showing both of the subject's hands, avoid letting them interlock their fingers. Interlocking fingers often make your subject's hands look like they belong to an eight-to ten-fingered mutant. Instead, have them make a loose fist with one hand while laying the other hand over it, slightly cupped. If the subject extends the thumb of the inner hand (the one shaped into a fist) towards their chin, the thumb can become a great chin rest and both hands together can easily hide a weak or double chin.

5. Avoid bad wrist lumps. Sometimes the bend of the subject's wrist becomes an overbearing white hump that I find distracting. Check out figure 3 and see if you agree. If you do, avoid it!

6. Here's an idea that avoids the pitfalls involved in posing a subject's hands—don't even show them! That way there's no need to pose the little rascals at all.

7. One last thing about hands: If you ask many men to "stand over there for a picture," they will do so and immediately clasp their two hands together and position them directly over their crotch. I'm sure there are deep-seated psychological or primitive reasons for this, but photographers affectionately call it "the fig leaf pose." Regardless of the reasons, it is something you should be aware of and try to avoid.

Now that we've addressed the subject's face, neck, shoulders, and hands, let's move on to some general information about bust- and full-length posing. It has been said that a natural-looking, full-length pose is also a natural-looking, bust-length pose, with the difference being primarily how it's cropped. Knowing this, I have merged the two for simplicity's sake as we discuss posing the body. We'll review posing for the single subject first as a foundation, followed by two subjects, which are really just two well-posed single subjects put together. Eventually we'll put it all together to figure out groupings.

chapter seven
posing the body

the famous 45° angle

Although some photographers will flatly state that the subject's body and shoulders must be at a 45° angle to the camera, I am not personally that rigid. However, it is important to remember that posing is an art and not a science, so differences between myself and other practitioners of the art can both be right. What is more important is why the 45° angle is so popular for portraits. The camera is monocular, as opposed to binocular like our eyes, so it has a hard time seeing depth. This means that by turning the subject to a 45° angle you are, in effect, making your subject appear narrower (and thus thinner) from the camera's point of view. Now you understand why so many photographers automatically turn the subject's body to a 45° angle.

This angle is not always as flattering as some believe it to be, however. Since the camera has a hard time seeing depth, the outline of your subject defines their shape; if your subject has even a bit of a belly, it becomes more noticeable as the subject turns away from the camera at an angle. This is because the belly's protrusion becomes part of the outline as opposed to being contained within the outline.

This general technique is important because it has many applications. In fact, we already touched on this same principle when I explained how to minimize a large nose by containing it within the line created by the subject's far cheek. So while I'll almost always turn a thin subject's body to a 45° angle, I'll often photograph a subject with even a slightly protruding belly straight on to help hide their weight.

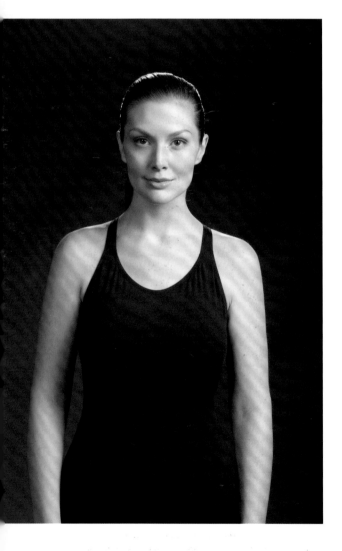
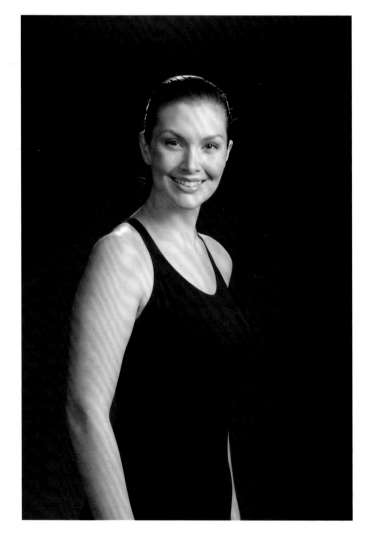

By turning a subject to a 45° angle, you can make him or her appear slimmer.

Although I didn't show the subject's face in these two photos, I can testify to the fact that this subject is nowhere near obese. However, by turning his body to a 45° angle, his stomach becomes part of his outline and that accentuates his belly. Note that the same situation is illustrated in the two photographs shown on the opposite page, except in that case the outline of the subject accentuates her bust. In instances like this, I find it better to break the 45° rule and just shoot the subject almost straight on.

the painless diet & other tricks

As long as we're talking about overweight subjects and their outlines, there are a few things you can do to give your subject a quick and painless diet. If your subject stands with their elbows against their sides, they'll look as wide as their elbows in photographs. To get around this, I try to use poses that allow the subject to get their elbows off their sides. For example, men can put a hand or hands in their pants pockets or hook a thumb over their belt. Women can use pants or jacket pockets, or even place a hand on their hip. All of these examples force the subject into bending their arm at the elbow and that creates a little bit of daylight between their elbow and waist which, in turn, makes their bodies look thinner.

The second painless diet is for executive types and is centered on the fact that many professionals carry a wallet or Blackberry in an inside breast pocket of their coat or have a cell phone clipped to their waistband beneath their jackets. As I'm posing an executive, I usually run my hand over their coat to smooth the material and if I feel any of these modern day accessories. I say something like, "I can save you five pounds," as I ask the them to remove the gadgets during their portrait session. Pens, pagers, eyeglasses, and eyeglass cases get the same treatment. After the offending items are removed, I smile and say, "Wow! I just saved you five pounds! Painlessly!" which is almost always appreciated.

As a side note before we move on: An executive's coat collar sometimes separates from their shirt collar, creating a gap between the two that can

Top to bottom: a cell phone lump, stuffed breast pockets, emptied inside breast pockets, and a potpourri of things men carry in their suit's breast pockets.

Pulling up on a jacket collar at the nape of the subject's neck so it lays neatly against the shirt collar beneath it will prevent your subject from having an uncomfortable-looking neckline. But don't do it without first telling your subject *what* you're going to do and *why* you're going to do it! I usually say something like, "Your jacket collar isn't lying smoothly against your shirt collar, do you mind if I become your valet for a moment?" I have never had a subject tell me no!

add weight to the subject. You can fix this by playing the role of a tailor and lifting their jacket collar at the nape of their neck so it lies smoothly against their shirt collar.

Although not connected to painless diets, here are a couple of other points worth mentioning. There should be about a quarter inch of shirt cuffs showing at the base of male subject's jacket sleeves; it makes both the jacket cuff and the executive look more finished.

Finally, make sure their tie knot is tight (no collar button should be showing) and that the tie and knot are centered. While these types of details might seem unimportant, I can promise you that someone else will notice it in the final portrait, and once it's pointed out to the subject, that will be his or her primary recollection of the photograph—even if he or she loved the picture (and you) when they saw it for the first time!

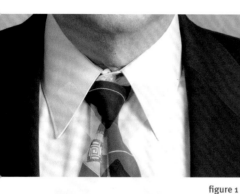

figure 1

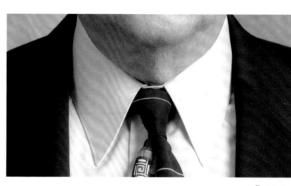

figure 2

There's an old saying that the devil is in the details; when it comes to executive portraiture, I find this to be true. Left to right we have photographs of a loose tie knot (figure 1), a correctly tightened tie knot (figure 2), shirt sleeve cuffs not showing (figure 3), and shirt sleeve cuffs showing (figure 4). In both instances the second example makes your executive look more finished.

figure 3

figure 4

Paying close attention to the details in your business portraits will pay off. Don't be afraid to straighten ties, cuffs, and shirt collars to make sure you get the right shot. Make sure lapel pins are upright (they can easily rotate out of position) and remember that businesswomen have both similar and different wardrobe attention needs.

form a base

If a subject presents themselves to the camera with their feet together, you will notice that their shoulders are wider than their feet. If we were to draw a straight line across the subject's shoulders and then draw two straight lines from the edges of their shoulders down to their feet, we'd find that the geometric shape is a long, thin triangle with its pointed end at the bottom of the composition. While I like triangles and use them whenever I can, I prefer to make one of their sides into the base of my composition. I find that triangles create tension when they are resting on one of their points. The easiest way to correct for this is to have your subject separate their feet a bit and then turn one foot slightly outward from the centerline of their body. When you do this, you are widening the base of the triangle, and this increase of width is usually enough to relieve some of the visual tension created by the subject's feet being too close together.

Forming a wide base is equally applicable to bust-length posing, but instead of working with the subject's feet, you can use their arms and forearms to construct the sides of the triangle. One of my favorite props for posing a bust-length portrait is a desk or a tabletop. By splaying the subject's elbows outward, their upper arms become the triangle's sides and their forearms become the base. This brings us to two more points worth addressing. First, when a man or a woman in a suit jacket splays their elbows outward, it often stresses the neckline of their suit, so be aware of this possible pitfall; the root cause is often from the subject's elbows being too far apart. Secondly, be aware that the desk or tabletop is a surface that your lighting can bounce off of, and you can use this to your advantage (see page 124 for more illumination on this point).

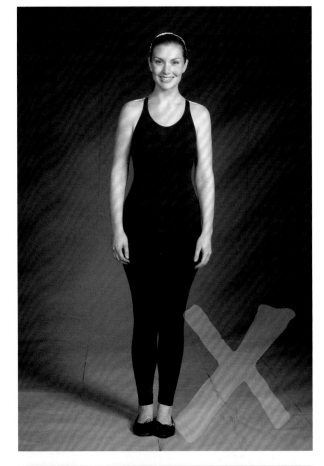

Having the subject put her hand on her hip makes her appear narrower because it shows off her waistline. When her arms are at her sides, the viewer misses the cut in at her waist and mentally assumes she's as wide as her elbows.

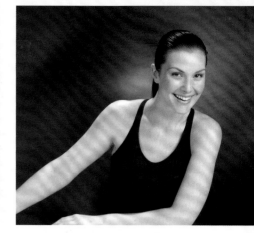

(Above) In the first photo, the subject's arms form a triangle that creates a strong base to support her face. In the second photo, the subject's left arm creates a feeling of tension because it's a hard vertical line. Also, note that the composition ends very abruptly. In the third photo, the subject's left arm has been positioned well past vertical until it's almost parallel to her right arm, making it appear as if she is about to topple over. While this may be a terrible posing technique for a single subject, if you add a second subject to the mix in a mirror image position of the first, their left arm can become the second leg of the supporting triangle that forms a base for both subjects. In the picture of the two girls (at right), their legs form a nice, solid base.

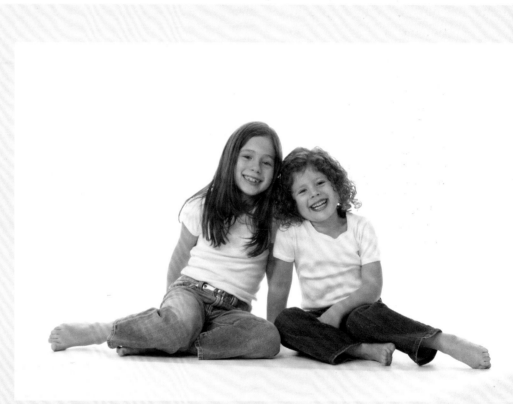

© JAN PRESS PHOTOMEDIA, LIVINGSTON NJ

now shift their hips

When I ask my subject to move his or her foot slightly outward, I ask them to lift the foot and place it back down. While this may seem like a strange request, it is because I have an ulterior motive. When a subject lifts one of their feet off the ground, it forces them to put all their weight on one foot. When they do this, they have to shift their hips slightly to move their center of gravity; otherwise, they'd topple over. While I certainly don't want to topple a subject, I do want them to shift their hips. For women, this hip shifting makes them look curvier (but not heavier!), and for men it makes their body look more relaxed and less rigid. Look at the full-length photos of the female subject on the opposite page to see this hip shifting movement in action.

do try this at home

As a previsualization aid, I find using a full-length mirror and myself as a model to be very helpful; you might want to try the same thing. Also, to better understand what the camera sees, do it with one eye closed. Try this: Push your belly out in an exaggerated way and look at yourself straight on, then turn yourself to an angle so that your distended belly is visible as part of your outline. This sobering view should guarantee that you never shoot a subject's portrait this way. Next up, try moving a foot slightly out to the side and see how it looks compared to when your feet are together. Finally, as you lift your foot to move it slightly, feel what happens to your hips and compare how you look with hips shifted slightly versus hips squared and straight.

shooting "two-up"

Posing two subjects in a full-length portrait is something I usually avoid; all too often the end result looks like nothing more than a prom picture. While it's okay in the harried world of the photographer shooting 200 prom portraits in an hour, it doesn't result in stopper portraits. Think of prom pictures more as record shots than art. If you end up doing it for a high-end portrait, know that shooting two full-length figures creates acres of dead space within the composition. The most expressive part of any subject is their face, and a full-length two-up (my slang for a two people portrait) makes their faces relatively tiny within the composition. One might even ask, "If full-length framing minimizes your subject's faces so much, why bother to do it at all?" There are a couple of good reasons.

One time you might want to shoot a full length, two-up portrait is if you are photographing heads of state or military personnel in formal dress or military regalia. Their uniforms are an important part of their message and should be shown in all their pomp and circumstance. Also, when an everyday couple is in formal attire, they'll often want a portrait that shows it all off. Even if these examples aren't common for your clients, you may still find yourself photographing two people dressed up in Halloween costumes or period clothing one day, and this might qualify for the two-up, full-length treatment because their message includes their outfits.

On a related note, there are times when the scene behind the subject is so grand, splendid, or overwhelming, that to throw it out of focus because the subjects are perfect is almost a sin. For these portraits I'll often use a wide-angle lens even though conventional wisdom calls for using a short telephoto lens for portraiture. While it might not happen often, it's worth remembering that shooting a full-length, two-up portrait might be just the ticket if the background deserves it.

Even considering the above exceptions, my preference is still for seating one of the subjects (usually the taller one) in a two-up, full-length portrait because it spreads the centers of interest (the faces) over a larger area of the composition. Doing this means I have to consider camera height in relation to a standing subject. Generally speaking, full-length photographs should be shot with the camera lens at the subject's belly button height to get an accurate rendition of the subject. If you shoot a full-length portrait with your camera's lens at the subject's eye level or higher, it will play havoc with how both subjects look, with the seated subject getting the worst of it. So, before we continue, look at the photographs on pages 157–159. One can see that having a seated subject look both natural and graceful is not an easy job. That being the case, let's look at how to skillfully pose a person seated in a chair.

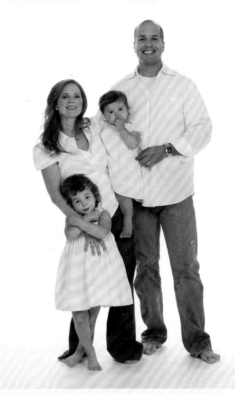

While shooting full-length portraits minimizes the face, there are sometimes reasons for shooting this way. In this case, showing the full body allows the viewer to see the family's bare feet, which, along with the choice of clothing, help set a casual tone.

The portrait on the left was shot with the camera lens at the approximate height of the subject's belly button, while the portrait on the right was shot with the lens about six inches (15.2 cm) above subject's eye level. Look at how much bigger the subject's head appears in the right photograph compared to the left one. Look at how the right photograph, with its high camera position, makes the subject's legs appear shorter. This in turn makes the subject's torso seem abnormally long.

One of the most important details about photographing a seated subject is the choice of the chair. There is just no way you're going to pull off the look and feel of a high-end portrait if your subject is sitting on a dime store folding chair. The "perfect chair" is not necessarily a throne (although chair arms are a useful feature), but you should choose a chair that fits the situation or personality of the subject seamlessly. When any chair is highly visible in the photograph it makes a statement about your subject. In fact, when I mentioned that I have a preference for seating one subject in a two-up, I must point out that actually doing this is based on whether or not I have a fitting chair available. But let's say you have wisely chosen the perfect, drop-dead chair—let's now find out about how to seat the subject in it.

posing the subject in a chair

It's not pretty language, I admit, but a long time ago I was taught that the most important thing to avoid when photographing a seated subject is having them look like they are on a toilet. Strong words, but they're true, and it's unfortunately a common problem in many seated portrait photographs. Knowing this, our goal is to seat a subject both gracefully and beautifully while avoiding this common mistake. Following the steps below will lead to the smooth and natural posing of a seated subject.

If you're trying to convey intimacy by posing the subjects' faces close together, seating the taller subject can help even out height differences.

Something to avoid: The "sitting-on-the-toilet" pose. By turning the chair, much better compositions can be achieved.

Turn the Chair

It's never a good idea to photograph someone straight on when they are sitting in a chair. I always turn the chair to a 45° angle before I ask the subject to sit down. By placing the chair at an angle, it allows the subject's front leg to help cover their pelvic area so that it doesn't become a center of attention in the photograph. I can tell you from experience that many subjects will turn the chair back to dead-on before they sit down. That's okay; I just smile and say something like, "Let's try that again." I ask the subject to stand up, I reset the chair, and then ask them to sit down again. Once they see what I'm doing, they usually understand and sit down the second time without first rearranging the chair.

figure 1

figure 2

Straighten Up and Fly Right

Ask the subject to sit up instead of slouch. Many people allow themselves luxuries with their posture when sitting that they would never accept of themselves while standing. Young men push their bottoms forward to the front edge of the seat and then lean against the chair back as if they were reclining. They then throw an arm over the back of the chair, which distorts the look of their shoulders and distends their stomachs, while they're under the mistaken assumption that the results look cool and laid back. Young women, often taught to be more "ladylike," don't push their bottoms forward because it accentuates their pelvic area; but once they're seated, their lower back and abdominal muscles mysteriously jellify. The result is a young or middle-aged woman who looks like she has the curved spine of a much older person.

This being the case, my first goal is to get my subject to sit up straight. A note of caution here: You want your subject to sit up straight, but not to be ramrod stiff. To get to this relaxed yet controlled place, I often chide my subjects playfully ("Aw, c'mon you look like an old man!"); I cajole them ("Aw, c'mon, you can do it!"); I even joke with them about it ("Make believe I'm your grandma telling you to sit up straight."). On a more concrete level, I ask them to push their bottom all the way back in the chair, and then to not let the small of their back touch the back of the chair. When they do this, keep an eye on their shoulders because some subjects seem to think that the only way to straighten their back is to pull their shoulders up to their ears. When subjects lift their shoulders, it almost always makes them look tense (or very cold). Some photographers notice this and don't know how to correct it. Here's a hint; tell your subjects to relax their shoulders!

Figure 1 represents how young men often sit in a chair. Figure 2 represents the posture I always see from teenage girls. Both positions can and should be corrected with coaching. Also, note the subject's leg position in the image on the right—her legs are crossed above the knee. If she were wearing a miniskirt, the results would draw undesirable attention to this area.

A portrait photographer must supply the direction; the subject can't magically make corrections without knowing what to change. Your subject is not looking in a mirror, so they can't see what's wrong—but you are looking right at them, so you can. Therefore, it's your responsibility to be specific in your directions. If the photographer is too general, it can often create a feeling of anxiety in subjects that is the antithesis of the end goal: a subject who is relaxed and comfortable. There is no way a tense, anxious subject is going to look their best! After you get them to relax their shoulders into a normal position, you're ready to focus on hands and feet.

This seated pose is typical to use for a male subject; it shows a nice, casual posture without being sloppy. It can be used with female subjects wearing knee or full length skirts and gowns as well.

Flying Feet and Flailing Hands

We're getting close to finishing the posing of a person sitting in a chair. In fact, there are only four loose ends to tie up: two hands and two feet. For men, one foot stays flat on the floor but is moved slightly forward while the other foot is moved slightly backward and under the chair. This other foot can no longer be flat on the ground in that position, so it usually ends up with its heel slightly raised. By moving the one foot slightly forward, you are also causing the subject's shin to be on a diagonal line that creates two positive effects: It expands the subject's base, and it looks more human and relaxed than a vertical shin does. Think back to the framing section and our discussion about horizontal, vertical, and diagonal lines to reinforce this point.

If your subject is a woman in a full-length dress, you might take the same approach because the dress material will fall along the diagonal shin and look nice for the same reasons. If the woman is wearing a dress or skirt with a shorter hemline, I find the most pleasing way to position her feet is to have her cross them at the ankles and tuck them slightly under the chair. By doing this, the whole body becomes a slightly angular "S" curve, up from the feet, along the shins, bending at the knees, along the thighs, bending at the hips, along the torso, and ending at the shoulders and face. Be careful if a seated woman crosses her legs at the thighs, however, especially when she is wearing a miniskirt, or even a skirt with a high hemline; this may result in a bad case of "overexposure" that cannot be fixed by changing the exposure settings on your camera! It will also deflect attention away from your subject's face.

The subject's hands are our last two loose ends to deal with, and they are more difficult to pose than the subject's feet. I believe one reason for this is because the subject's hands show a lot of exposed flesh (which can be distracting), while shoes and socks often cover the feet. If the chair has arms, that's the first place you might decide to rest your subject's hands. Although I think this is a good idea, there are two caveats worth mentioning. First, don't let your subject grip the arms of the chair in a white-knuckled, dying-in-the-dentist's-chair manner. Second, try to avoid letting your subject's hands droop at the wrists. Let their hands rest on the arms of the chair naturally. If the chair is armless, I like suggesting that a woman rest her hands in her lap, one atop the other. If the portrait includes a second, standing subject, the seated person can hold one of their hands. For men, I avoid the hands in the lap solution because it often looks like the "fig leaf" pose; instead, I suggest that they rest their hands on their thighs. Sadly, I've found that when I suggest this,

This is a good, traditional pose for a seated female subject. Unlike the typical pose for a man, which can be used for women in some cases, this posing does not lend itself well to men.

the end result is often the man grasping his knees in the same white-knuckled manner that happens when they grasp the arm of a chair. As a general rule, anytime the subject tenses or locks any of their muscles, the pose won't look natural or relaxed.

Finally, ask the subject to turn their face towards the camera. Remember the chair and their body are still at a 45° angle to the camera. Asking the subject to turn towards you finishes the look of the portrait nicely. Now, the only thing left for you to do is work on their expression and then push the shutter button.

Try Something Different: Turn the Chair Around

For a totally different look, don't forget that you can turn the chair around and have the subject straddle it with their legs splayed around the chair back. Obviously this only works with an armless chair, but many a fine portrait has been posed this way. Start with the chair back at a 45° angle to the camera before asking the subject to straddle it. Consider placing your main light on the side of the subject that the rear of the seat back is facing. If the seat back is the right height, you can have the subject fold their arms and rest them on the chair back. Your subject can also raise one hand to support their head while leaving their elbow on the chair back. This type of pose can be framed as a full-length, bust-length, or close-up portrait, but it rarely works if your subject is wearing a skirt or dress.

Sitting with Small Children

In the framing chapter, I pointed out that you could sit a small child on the lap of a seated subject. You can apply the 45° angle of the chair and body to these situations as well, but be aware of some issues. If the child straddles the adult's legs, you run the risk of having the child look like they have only one leg since the other is hidden from view. Also, if the child straddles the adult's legs, the kid may partially or entirely block out your view of the adult subject's face. If the child is seated in a sidesaddle manner, they don't block the view of the person they're sitting on, making this the best position for this kind of shot. We all know that children wiggle and wriggle, so if you can only get the kid to be happy when they're straddling the adult's legs, so be it. If that's the case, ask the adult to lean a bit right or left so the child in their lap doesn't obscure their face.

Many great portraits have been taken with a subject seated in a chair that has been turned around.

© JAN PRESS PHOTOMEDIA, LIVINGSTON NJ

posing small groups with stairs and chairs

Posing small groups such as families or executives is basically a rehash of how to pose individuals because, up to a certain point, it is just a bunch of individuals. The soundest piece of advice I can give is to try to avoid lineups. If all your subjects are approximately the same height, the worst (or at least the most boring) arrangement is a line of heads at about the same height running across the frame. While the easiest way for creating differing heights between your subjects is to use chairs or stairs, sometimes, especially when photographing family groups with adults and children, the differing subjects' heights can create all the variety you need. Although it's covered in detail in the framing chapter, try to arrange your subjects so there are diagonal lines connecting the faces. One mental trick I use is to imagine that the center of each face is a dot and the entire frame is like a piece of graph paper. Chairs and stairs can be used to help you arrange the dots in an interesting way on the graph.

Avoid boring arrangements for groups by playing off differences in height. It adds visual variety to an image if faces are seen at multiple levels.

© JAN PRESS PHOTOMEDIA, LIVINGSTON NJ

Next, consider overlapping your subjects to get the group tighter. This is a perfect way to cover spreading waistlines as well as showing a close relationship between the subjects. But, because every rule is begging to be broken, a family portrait can often be equally effective by spreading the subjects out.

Overlapping the subjects usually helps to get the group tighter. But that doesn't mean that a portrait with "air" between the subjects can't be a success, as seen here.

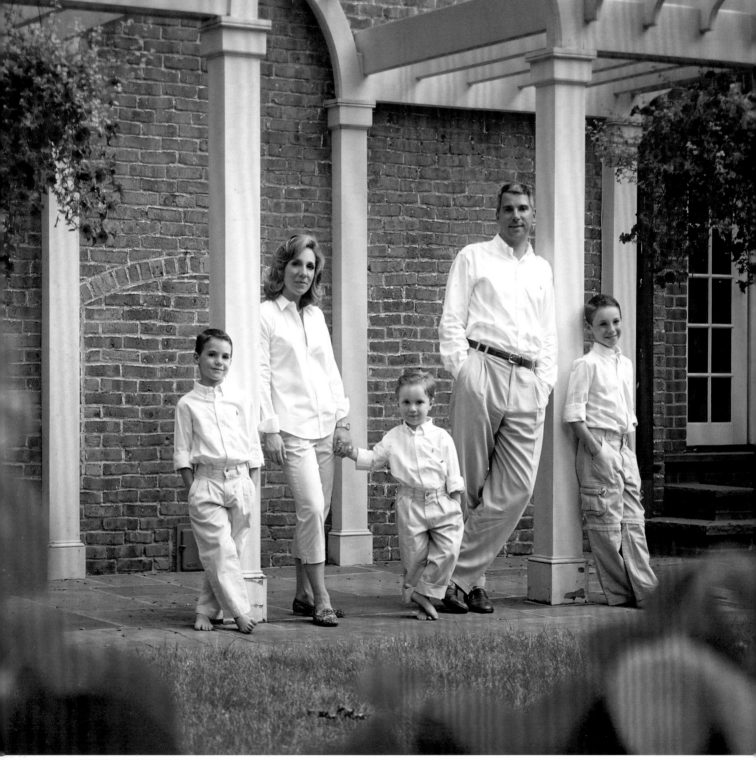

posing large groups

Professional photographers are often called upon to photograph large groups, which can be very lucrative. Multi-generational families, companies, public, private, or political organizations, teams, and clubs, to name but a few, are plums because they usually result in multiple print orders. Oddly though, because of the amount of subjects involved, most of this book's suggestions on posing, lighting, and relating to the subject no longer apply; the group as a whole is the subject instead of the individuals within it. Instead, what you are trying to accomplish can be broken down into just three simple rules. And the greater the number of subjects in the portrait, the more important these rules become. After years of handling 50 or more subjects in hundreds of single photographs, I have found the following to be true:

1. **You have to be sure the camera is able to see all the subjects' faces.**

2. **All the subjects' faces must be evenly lit.**

3. **Get all the subjects to look at the camera .**

Let's look at each of the above suggestions, and I'll offer some tips on how to accomplish each one.

Posing large groups looks best when the subjects aren't posed in a straight line. Also note the use of the planned wardrobe of white and black in this shot. This helps portray a sense of unity that ties the subjects together.

Seeing all the faces:

If you line up 60 subjects standing shoulder to shoulder, you'll end up with a composition that is very long in the horizontal dimension and very short in the vertical dimension. To get around this problem, you have to find a way to shorten the horizontal dimension and extend the vertical dimension, which usually means breaking the group down into smaller rows and arranging them on different levels. There are a few ways to pull this off.

1. **Find a wide staircase and place subjects in rows on the stairs.**

2. **Use risers that you can either buy (an expensive proposition unless you do this often), or rent and transport them to the assignment's location (a real hassle).**

3. **Use bleacher seats at a school or gymnasium, if possible.**

4. **Find a high vantage point and shoot down on your subjects (this is an interesting and worthwhile alternative if you are presented with the right conditions).**

5. **Create a makeshift set of risers from a bunch of chairs.**

This 100-subject group shot was done from a high vantage point. For more details, see page 210.

Let's expand on the fifth concept. By arranging two rows of chairs, one behind the other, with approximately 1.5–2 feet (45.7 cm–61 cm) between the backs of the front row chairs and the front edge of the seats in the next row, you can cut the horizontal length of the single line down to a third or a quarter of its original size. You can seat a third of the subjects on the front row of chairs, a third can stand behind the front row of chairs, and the last third can stand on the chairs in the rear row. If the group includes little kids, you can seat them on the floor in front of the first row of chairs. If there are a bunch of eight to ten year olds, they can be sprinkled in front of the middle row of standing adults. But be sure to place them so their faces are between the front row of seated adults so that they are seen. The middle, standing row of subjects can contain more than the seated front row by having the standing subjects turn towards the center and move closer together. You will find that a person turned to a 45° angle is only about two-thirds as wide as a seated one, so you can fit two standing people behind each seated one. Be aware that you can sometime squeeze 12 subjects' bottoms onto only 10 chairs if everyone squishes together a bit. You'll need 18 to 20 chairs for a four-row group of approximately 60 people that includes children, but you'll need 24 to 30 chairs for a three-row group of approximately 60 adults.

While a far cry from carefully posed studio portraiture, this photo does show how using rows of chairs can help build vertical space in a picture. If everyone pictured here was seated or standing side-by-side, the photograph would have to be taken from far away to include everyone in the shot, which would minimize their faces. Always be careful when posing subjects on chairs.

Youth in Group Shots

Here are two ways to sit youngsters on the floor. The top example, sitting cross-legged, is great for little kids. Once seated this way they think they're in school and stop squirming around, you don't end up seeing a lot of shoe soles, and they can't kick the kid next to them (believe me, it happens all the time!). The pose illustrated in the lower example is great for young teenage girls because it's flattering and they seem to fall into this pose naturally. If you try it for more than a few subjects at once, try to get the teens on the right side of the photo's centerline to point their feet to the right (out of the picture) and do the opposite for teens on the left side of the photo's centerline.

Safety Issues

There are a few important safety issues that must be addressed before you ask subjects to stand on chairs.

1. Only try this with substantial chairs. Using lightweight wood, plastic, or even tubular metal folding chairs is an invitation to disaster. They are weak, difficult, and dangerous to stand on, so if that's the only kind of chair available on location, don't even think about trying this.

2. It's important that your subjects are also aware of this danger, so tell them to be careful—more than once.

3. Only allow physically able, younger adults to stand on the rear row of chairs; they are spryer than older subjects.

4. Even using substantial chairs, high heels and standing on chairs do not mix; require that female subjects remove their high heels before standing on a chair.

5. Make sure you have liability insurance before you try this for a group photograph.

6. Make sure you have liability insurance before you try this for a group photograph. Yes, I typed it twice!

7. You can never be too careful in situations like this. So pay close attention to your subjects.

8. You must take all these caveats very seriously. It may sound like the tone of this list is overbearing, but the last thing you want personally and professionally is for a subject or many subjects to be injured under your direction.

Evenly lighting the faces:

Forget about ratios between the main and the fill lights, triangles, hair lights, and everything else covered in the lighting chapters— just make sure to get all the faces evenly lit. You might consider an old axiom that compares cinematographers to still photographers: Still photographers light the subject while cinematographers light an area within which the subject can move about. In these cases, you should concern yourself with lighting the area. I use two to four lights for mammoth groups, one or two on each side of the group in a basic copy lighting setup. This setup is made up of two lights of equal intensity placed at an equal distance from the subjects. The lights are set to the right and left of the camera lens, with each placed at a 45° angle away from the lens axis. I also often add a strong frontal fill light just over my camera's lens; the last thing you want is for all the eight to ten year olds in front of the second row to be lost in the shadows behind the heads of the seated subjects in the front row because the lighting was set up poorly.

Large families often contain multiple, smaller families and this can help you arrange them in an interesting, airy, way.

Getting subjects to look at the camera:

Don't worry too much about expressions, because no matter what you do, a few in the group will be scowling, a few in the group will be blinking, a few in the group will be talking as you push the button, and there will even probably be a few picking their noses in every image you shoot. If you are dealing with 50 plus subjects, remember that there are 50 plus individuals in the picture, and it's hard to flawlessly manage that many people at once. Just try your best to be sure that everyone is at least looking at the camera.

communicating

While I don't yell, the bigger the group, the louder I speak. And I make sure to use my voice to engage all my subjects. As I arrange the details, I offer direction to groups of people such as, "All the ladies seated in the front row, please cross your legs at the ankle." Or, "Everyone standing in the middle row, turn your bodies to the center." Before I shoot one of these organized mob scenes, I make a little speech. I say things like, "Ladies and gentleman, this is a huge group and I need your help to pull this off…please, please, look at the camera, because I can't watch each of you individually." If there are little kids on the floor in the front row I might say, "Ladies and gentleman, there are a lot of kids in this picture and I need your help to pull this off. I'm going to be watching them, so it's the job of all the adults to watch the camera. Moms and dads, please don't look at your kids, look at me and I'll take care of looking at them." Invariably, there's one uncle (it's almost always an uncle!) who uses two fingers to imitate rabbit ears on the person next to him, or makes faces as I shoot, or whatever. When this happens, I leave my camera position and walk up to that individual and say (nicely of course), "Hi, I really need your help; this is a big group, I'm crazed and going nuts. Please help me to get this thing over with." Sometimes others in the group get this person into line and sometimes it doesn't help at all. After one try, I give up and push the button while trying hard to never lose my cool.

Before I shoot the group I tell them I'm going to count to three, and sometimes I push the button on two to catch some of the anticipating blinkers off guard. The bigger the group, the more pictures I shoot, and after each shot I always say, "Just one more, you're almost done," even though it's rarely true. Note that there is a law of diminishing returns working here; after six or seven shots you start to lose the group's attention, so the portrait doesn't get better, only worse over time.

NOTE: Even though this is the posing chapter, I must add a very important technical note. Remember that your depth of field extends one-third in front of your point of focus and two-thirds behind it, so focus on a subject one third into the depth of the group. The last thing you want to happen after going through the effort involved in organizing and pulling off a 60-subject group shot is having the back row of subjects out of focus.

putting it all together

At the beginning of this posing journey I explained that the very best posing is invisible and that is the foundation of the art of portraiture. Whether you're posing a single subject or a huge group, the goal is to have the subject look great, and even more importantly, comfortable, relaxed, and natural. Too many young photographers give up all too easily. They often seem to be in a rush to push the shutter button. I think part of the reason may be that they are afraid their subject will think they are at a loss for what to do, or they themselves don't know what to do. There is no easy fix for this other than practice and experience. And, with enough of both, you'll become comfortable with your ability, and your subjects will feed off of this and become comfortable themselves. So before you push your shutter button, take a second or two to ask yourself if the subject does indeed look great, comfortable, relaxed, and natural. And when you ask these questions, be hard on yourself and don't settle for anything less than the best you and your subject can be. In the end, once you get that perfect portrait, I guarantee your subject will thank you.

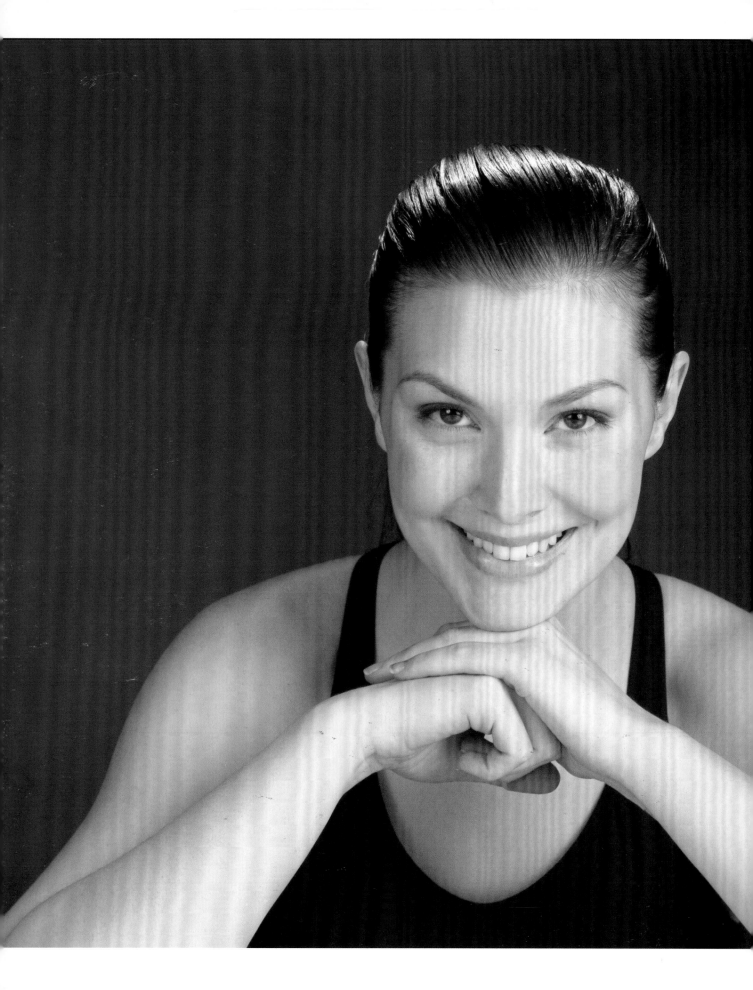

chapter eight
minimalist makeup

Although I believe that Photoshop and other image enhancing programs are a boon to photography, I also try to minimize my use of them whenever possible. As I've already written, if you shoot 100 eight-hour days a year as a professional photographer and spend 1 hour on your computer for every hour that you shoot, you are looking at 800 hours per year sitting in front of your monitor. Using a 40-hour week, 800 hours represents 20 weeks, and that in turn represents approximately 5 months of post-production computer time.

Although some photographers may absolutely love the magic they can create during this computer time (as I do), given a choice, I would still rather be shooting pictures! I can also make much more money selling my work during that same five months of theoretical computer time. With these thoughts in my mind, I prefer to shoot "clean" whenever possible.

Shooting clean extends to more than just being technically correct with the photography part of a portrait assignment.

In many cases, it also extends to making sure the subject is presentable before I even think about setting up a light or reflector, or pushing the shutter button. This means being aware of the advantages of using makeup to help your subject be the best that they can be. For those of you that may abhor the idea of altering your subject with the application of makeup, I can only ask that you follow along with me for a little bit; if you still find the idea abhorrent, then skip this chapter!

the rationale

Although some may not believe this, every politician, executive, spokesperson, candidate, actor, and actress you see in film, on television, and in print media has had makeup applied. In fact, other than a very few close confidants, nobody has seen the famous faces constantly gracing (or disgracing) gossip magazines without it! Many of the most successful stars of stage and screen have a makeup expert travel as part of their staff. Why should our portrait subjects be shortchanged by being treated differently? The average portrait subject who has nowhere near the raw attributes of the stars, rarely thinks about makeup before they come to a portrait session!

Believe it or not, using makeup can also benefit you financially. Consider that using makeup as part of your portrait session is something the subject can easily see and appreciate, which can contribute to how much you charge (you might be hearing a "ka-ching" right now). Conversely, sitting in front of your computer fixing a subject's shiny nose is something they never see, making it harder to charge for. Although some may still find makeup application abhorrent, I find it more unpleasant to fix a shiny nose or forehead in 100 pictures on my computer when I could have taken care of the problem in 15 seconds before I pushed the shutter button. While including a

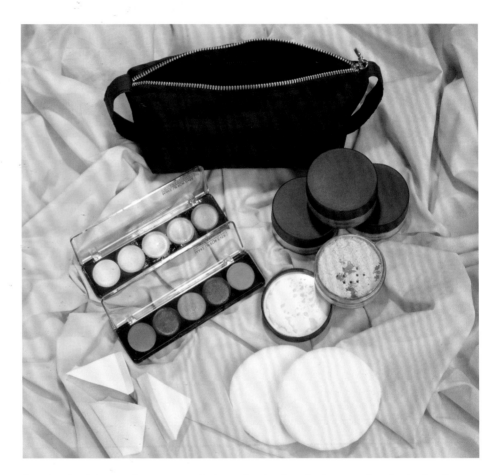

Sometimes I can't have a makeup person available on a location shoot. For those occasions, I've developed a minimalist makeup kit that I carry along with my normal photography gear.

professional makeup artist as part of your service is the type of thing that can help you justify a higher fee for a portrait sitting (remember that all additional services you sell should have a mark-up added to what it costs you), I believe that by applying minimal makeup when necessary, you can save countless hours of post-production computer time. Plus, the client will usually regard this as a valuable part of your services.

There's no way you can expect to learn everything there is to know about makeup and its application from a single chapter in this book; there are entire books devoted to this one topic. Also, because you are a photographer and not a makeup artist, you don't necessarily need to know how to use lipstick, eye shadow, and other makeup to take someone's portrait. However, you can and should become proficient with minimal professional makeup techniques that are easy to use, make your subject feel good about their looks and your abilities, and save you post-production time. For me this boils down to just two techniques: powders and cover-ups.

using powder

Powder is used to eliminate shine on your subject's face caused by either perspiration or oily skin. Typically, the forehead, the tip of the nose, the nostril cheek joint, the upper lip, the area beneath the lower lip, and the chin are areas of concern. Powder comes in a variety of colors to match various skin tones, from a pasty white through a rosy pink to a medium chocolate color. Regardless of the shade(s) you choose, you're interested in matte powder— forget about the ones with iridescent sparkles in them! Thankfully, although there are dozens of different shades available, three or four basic shades can be mixed together to match most of the skin shades you'll encounter. Most important is how to apply powder and the tools you'll need to do so—you don't want your application reduced to an imitation of an old vaudevillian comedy sketch.

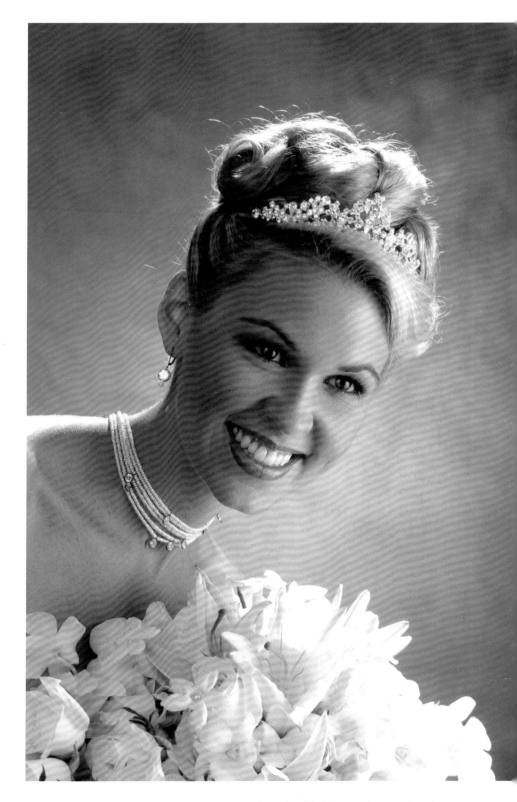

Why rely on Photoshop? Using makeup can make your subject look and feel better, and save you lots of post-production time.

 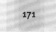

Packing the Puff

Powder is applied with a puff, which needs to be filled to work. (The makeup artist who taught me the process called it "packing the puff.") Basically, you take a clean powder puff, fold it in half, and pour a small amount of loose powder into the fold (figure 1). You can mix differing amounts of various shades of powder to approximately match your subject's skin tone, but the real operative word, no matter how many different shades you use, is "small" when it comes to the amount. For a 4-inch puff you'll need a total of about a half teaspoon of powder. You then grasp the folded-up edges of the puff between the thumb and forefinger of both hands and grind the powder into the puff (figure 2). After the first grinding, open the puff, turn it 90-degrees (figure 3), refold the puff, and grind away again. The end result is the powder being absorbed into the puff so that, when you're done grinding, there is no loose powder on the face of the puff. To be sure the puff is properly packed, unfold it and tap the center of the puff with your forefinger. If you've done it correctly, your finger tap will release a tiny cloud of powder around your fingertip (figure 4). Don't get nervous about any of this; although it may take a bit of practice, finding the right amount of powder to use is not brain surgery.

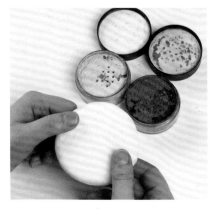

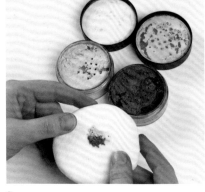

figure 1

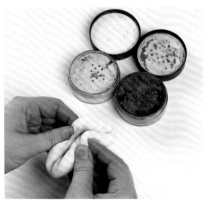

figure 2

figure 3

figure 4

Now that you have a "packed puff," it's time to learn how to powder your subject.

Application

Although some of you might want to smack the puff against the subject's face (and invite the vaudeville routine analogy again), that's not how you use a packed puff. Instead, you unfold the puff and refold it the opposite way so that the surface of the puff with the powder on it is facing outward (figure 5). Then, while holding the edges of the folded puff between your thumb and forefingers, you apply the puff to your subject's face in a light rolling motion. At the end of each rolling motion you lift the puff slightly off the subject's face and do another rolling motion on top of the first one but at a slightly different angle. The purpose of doing it this way is to soften the edges of the powder's application so that it blends smoothly with the subject's adjacent, un-powdered skin. Like packing a puff, this may take a bit of practice but the result you're looking for is one in which the powder is so well blended onto the subject's face that it is unnoticeable. If you can see where the powder starts and stops, chances are good that you were too heavy handed in its application. A light touch, a little powder, and no telltale signs of the application are what you want to end up with. It's one of those things where less is better.

figure 5

Two Nice Touches

I buy new powder puffs by the dozen and always make it a point of opening a new puff in front of my subject. Using a new puff for each subject is more hygienic than using the same puff for a bunch of subjects, and it's a nice touch. I make small-talk while mixing my colors, packing the puff, and glancing at the subject to gauge color, which helps in forming a rapport with the subject. I have found women to be much more interested in my technique than men and, further, they almost always notice and appreciate that I'm using a new puff for them. The second nice touch is something I use only for my female subjects, but I have found it to be a wonderful marketing device. In my minimalist makeup case, which I always carry when I don't have a makeup artist on set, I carry a few quart-sized zipper lock plastic bags with my name and phone number written on them. At the end of a session, when I've finished powdering a female subject, I give them the puff packed with their custom-mixed powder in one of the plastic bags. I can only say that they light up and treat my gift as if I had given them an original Rembrandt!

As a last point, and in all honesty, I will often use one puff for a few people when they are related (sisters, the kids in a family, a mother and daughter, etc.). Or I'll prepare three with different shades of powder for minimal touchups when photographing dozens of employees in a short time. But when it comes to higher echelon executives, it is always one puff per person.

overcoming objections

Often, male subjects will object when I say I would like to powder their faces before we shoot. I have found two parries that almost always reverse my subject's position. I start off by saying something like, "That's an interesting position to take.

Do you think the President ever sits for a portrait without makeup? In fact, do you think any Senator, candidate, executive, actor, or star does? If you do, I can assure you that you are mistaken." If my subject is old enough to have seen them, I'll even dust off and use the example seen in the Kennedy-Nixon debates (and the disastrous results for Nixon who looked sweaty and haggard partly because he wasn't wearing makeup) to reinforce my point. If I get a brusque response such as, "I don't care what they do, it's not something I do." I then add that I will gladly not apply any makeup but they should be aware that they may face a high dollar digital retouching bill to be satisfied with the portrait, and that I can't guarantee the result will look as good. I think many of my male subjects' objections are based on a macho slant, but usually by pointing to powerful people who do allow it or pointing out a negative effect on the bottom line, I am able to turn the tide.

caveats

Powder is a bit messy and there's nothing like a few pink specks of it on a subject's $2,000 pinstripe suit to ruin your rapport with the client! In fact, many professional makeup artists I've worked with go so far as to use a barber's drape to make sure an errant speck doesn't get on the subject's clothing. I've seen other makeup artists use bibs or have subjects loosen their collars and tuck folded paper towels between the neck and shirt collar or around a suit jacket collar when they apply the makeup. I've seen these same artists tuck the paper towels around the suit-jacket collar of their male subjects. Although my minimalist makeup kit includes a barber's drape (ask your barber or hairdresser how to get one for yourself), there are a few other things you can do to minimize the possibility of a calamity.

Try one or more of these ideas for avoiding makeup calamities:

1. Make absolutely sure the puff is fully packed! There shouldn't be loose specks of powder on the surface of the puff.

2. Use a barber's drape to protect your subject's clothing.

3. Have the subject remove their suit jacket before applying any makeup.

4. Use a few overlapping paper towels tucked into the neck/shirt collar or suit jacket/shirt joint, with the free end of the towels folded over the subject's jacket collar and lapels.

5. Have your subject sit on the front edge of a chair and lean slightly forward as you apply the powder; that way any free-floating specks of powder will fall to the floor as opposed to landing on their clothing.

6. If you haven't followed suggestions 1 through 4 and a speck or two of the powder gets on a subject's clothes, don't try to rub it off! That will only make matters worse because it will smear the specks into terrible lines of the stuff. Instead, blow it off with either a rubber bulb or your breath. As a general rule, if you try blowing, chew a breath mint before you apply makeup. This is a good general rule to follow before every shoot anyway.

7. As with many things about portraiture, if the feeling you project is positive and confident, it's easier to get the subject to cooperate.

cover-ups

Cover-up (often called concealer or camouflage) is a cream-based makeup that is used to cover small skin blemishes. The ones I like best have a variety of similar shades in separate compartments within a single container. In use, cover-up is applied in a pattern of small dots, and in reality it is not unlike retouching a black-and-white print. Like powder, cover-up requires a special tool for application, so we will start there.

sponges

Makeup sponges are small pieces of foam that are often wedge-shaped, though they come in many variations (figure 1). Just like the powder puffs, sponges have to be prepped before being used.

Before you can use a makeup sponge to apply the cover-up, you have to moisten the sponge. This is a three-step process where your goal is to retain a minimal amount of water in the sponge. To accomplish this, hold the sponge under running water, remove it from the stream, and then squeeze it to shed excess water. Next, you squeeze it again, trying to get every extra drop of moisture from it. While you probably think it's pretty dry by this time, the final step is to wrap it in a paper towel and squeeze it once more. As you can understand by this point, what you want is a sponge with a miniscule amount of moisture in it. Like I mentioned for applying powder, less is more. Think about letting a single drop of water splash on a patch of desert sand and you'll get the idea.

application

Look at the color of your subject's skin and choose the cover-up that comes closest to it. Barely touch a pointy corner of the just-damp sponge to that color of cover-up (figure 2) and apply it in a series of tiny dots over the blemish. Apply more tiny dots by using the adjacent colors from the case to vary the color of the makeup so that the final cover-up blends nicely. One trick I've seen many makeup artists use (which I use myself), is to make a mini palette of cover-up colors on the back of their hand. They use different points of the triangular sponge for different colors as they blend the makeup on the subject's face. Once you've finished concealing the blemish with the cover-up, spend a moment to powder that area with your puff and the blemish should be smoothly concealed.

figure 1

figure 2

final thoughts

Like everything else, applying makeup requires practice, and the more often you do it, the better you'll get. Don't expect to "get it" the first time you use it. Practice on some friends or family members willing to be guinea pigs before you do it for real on an assignment.

Makeup is messy stuff, and powder especially reminds me of clingy desert dust. While you can probably get away with it if you're using a film camera, it can wreak havoc with a digital SLR's sensor when you change lenses. Therefore, don't ever pick up or touch your digital camera before you wash and dry your hands, or at the very least use a moistened paper towel to remove makeup traces from your hands.

You may not know where to start if you decide to assemble your own makeup kit, so I will give you a heads up. Large malls often have a few stores devoted entirely to makeup, and their staff can help if you tell them what you're trying to do. If you're not near a mall, an Internet search for "theatrical makeup" will supply many websites where you can order what you need.

equipment

It can be difficult to write about digital photographic technology because of the speed with which it advances—it's like trying to catch a fly on the wing with chopsticks! Almost anything I write about a current, specific digital camera will be partially obsolete as soon as the next generation of that particular camera is introduced. So, instead of talking about specific models, I will cover digital single-lens reflex cameras (D-SLRs) in general terms. I'll also provide information about things like features, lenses, and tripods.

Where should I start when talking about cameras? Well, how about something incendiary like this: With only a few caveats, it doesn't matter what brand of digital camera you use. Yes, I know, there are millions of posts and Internet discussions extolling the virtues of one brand over another. There are even people who post their camera model as part of their digital signature, as if using the latest FrannyFlex 8000 makes them better photographers, or that the other brands are worthless. No offense, but at the end of the day, if the pictures are great, they are great; and if they are lousy, they are lousy. End of story!

If you're unhappy with the pictures you're producing, I'm willing to bet that most of the problem isn't with your camera, but instead is with your photographic technique. I understand that cameras are "the coolness." They are marvels of electronic and mechanical sophistication. I even understand that one unique, specific feature may make one specific photograph easier to accomplish, but when all is said and done, it's the photographer behind "the coolness" that pushes the button and takes the photograph. With that said, let's look at the specific things you want your camera to do.

the need for speed

People are the squirmiest things with the most fleeting expressions in the universe. In fact, the human blink reflex is one of the fastest of all human reflexes. So the most important attribute of a camera used to shoot pictures of people is speed. The perfect camera for making photos of people is fast to startup (not critically important, but nice), fast in its focusing ability (critical), and fast in the time between pushing the shutter release and the picture being taken (also critical). To really get what you need when you need it from a camera, you want speed in all aspects of camera operation. This all but eliminates a vast majority of the small point-and-shoot cameras that dot the digital landscape, narrowing the field to the various interchangeable lens D-SLR cameras.

In addition to how fast your camera operates while taking pictures, you have to consider the speed with which your camera processes pictures, as well as how many pictures it can take before you have to wait to take more. That speed is dependent upon a three-part chain, any one of which can be the weak link. Simplistically speaking, here's how it works: After the light hits the camera's sensor (sometimes called a chip), the information moves through a tube (called a bus) to the processor (another, but different, chip), then through another bus to the recording medium (the card). The problem is that all three parts (processor, bus, and card) have to have similar capabilities or the slowest one becomes a bottleneck in the flow of digital information (see sidebar, at right).

Bottlenecks

A faster card won't necessarily speed your camera up if it exceeds the capabilities of the bus and the processor. Likewise, if you buy a camera with a fast processor, but you use a card that is an older generation and slower, the card will become the limiting factor in the chain. As digital cameras evolve, there will always be one part of the chain that lags behind—an example illustrated by the various generations of SanDisk Extreme cards. Currently, SanDisk offers a series of cards in its premier Extreme line, but if your camera is two generations old, you probably won't get any faster performance from the latest and fastest Extreme card than you would from an older generation card.

Equally true, if you plug the latest SanDisk Extreme card into a USB 2.0 card reader to transfer the information from the card to your computer, you won't exploit the card's potential for speed because the USB 2.0 bus is slower than the card's capabilities. This means there is a similar chain in your computer that can also slow the digital process. So unless you have one of the latest D-SLRs, there is little need to upgrade to the newest SanDisk Extreme cards. Playing the upgrade game only increases the performance of your systems (camera and computer) if everything in the chain is upgraded; otherwise, you'll just be wasting time and dollars.

Over the years, Sandisk has increased the speed and capacity of its cards (as have many other manufacturers). While their latest version can transfer 40 mb/second when used with their Firewire 800 card reader, earlier versions moved data at a maximum of 20 mb/second. Obviously the latest Extreme cards can download data twice as quickly when used with the latest card reader. This means that the downloading time part of your post-production workflow is cut in half.

resolution and the megapixel myth

Check this out: To get twice the resolution of a 6MP camera you would need a camera with a 24MP sensor. Does that sound unbelievable? Let me prove it!

Imagine a hypothetical 6-pixel imaging sensor that is 2 pixels high by 3 pixels wide. To get its total pixel count, multiply the 2 pixels by the 3 pixels, resulting in a total of 6 pixels. Now, let's say we want the sensor to record twice as much information by doubling the amount of pixels both vertically and horizontally. The new sensor is 4 pixels high by 6 pixels wide. So when we multiply 4 pixels times 6 pixels, we end up with a total of 24 pixels (4 x 6 = 24)! Although my example involves mere pixels instead of megapixels, the ratios remain the same. What this means is there is very little real-world difference between 10MP and 12MP sensors. For example, compare a Nikon D200's maximum resolution (10.2MP) against the maximum resolution of the newer Nikon D300 (12.3MP). For the sake of simplicity, I'm going to skip over a lot of complicated pixel count comparisons and also assume that any prints you make will be based on 300 pixels per inch (ppi). What it comes down to is that the D300 can produce a print that is approximately 1.3 inches (3.3 cm) longer and .75 inches (1.9 cm) higher than a D200. So in the end, the amount of megapixels in your camera is not as important as it once was, when much smaller sensors couldn't deliver full-sized printing options.

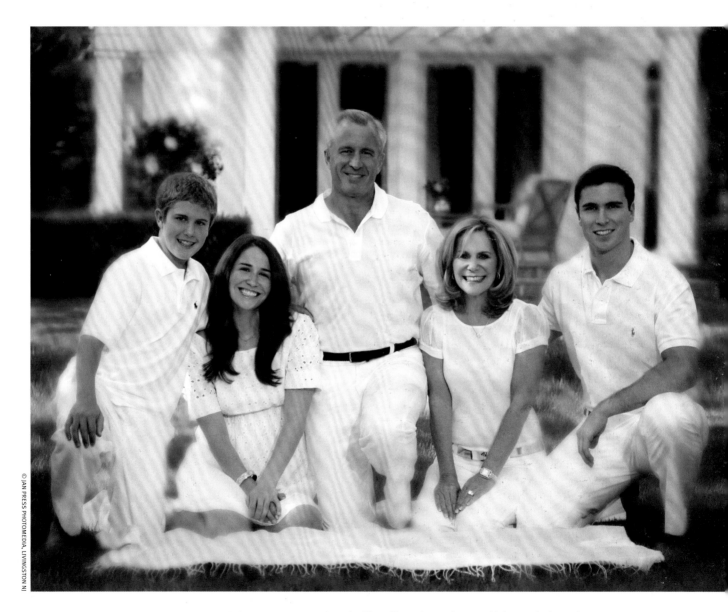

Some families will want large prints, so a high megapixel count in your camera is important. However, only small gains are made in print dimensions for every couple of megapixels, so you'll want to carefully decide when it's worth upgrading.

pixel size and the funny little μm symbol

Pixel size is measured in microns. A micron (μm) is 1 millionth of a meter (approximately 4/10,000 of an inch; a human hair is approximately 75 μm thick). To put this in perspective for a digital camera, a 2 μm pixel is small while a 9 μm pixel is huge. Regardless of the camera's MP count, big pixels are good when compared to small pixels. Here's why: A single pixel is like a tiny little bucket that light rays (also called photons) fall into. But some rays hit the edge of the bucket and ricochet into adjacent buckets. This phenomenon creates a thing called noise that degrades image quality. As the pixel gets physically smaller, a single photon bouncing into an adjacent pixel has more of an effect than with a larger pixel because the smaller-sized pixel has less total photons falling into it. For example, if 100 light rays can fit into a big pixel, a few extra pixels ricocheting into it isn't as problematic as the same thing happening on a smaller pixel that can only accept 10 photons. This is why the image quality from compact 10MP digital cameras (with very small sensors and hence very small pixels) can't compare to the image quality of a D-SLR that has less resolution (in MP) but has bigger pixels. This becomes even more important as the ISO is raised.

While more megapixels offer higher resolution, bigger pixels give you better image quality, better color quality, and less image-degrading noise. Given a choice of two imaginary D-SLRs with equal-sized imaging sensors, one a 12 MP camera with a 6 μm pixel size and the other an 18 MP camera with a 3 μm pixel size, I'd choose the 12 MP, 6 μm pixel camera every time.

the LCD display

When they were first introduced, most D-SLRs had small LCD viewing screens with, relatively speaking, a small number of pixels making up the image on the screen. While the very fact that you could see and review photographs in the camera was useful and exciting, these LCDs were barely effective for checking focus or pictorial value because of their small physical size and low pixel resolution.

However, the sophistication of the D-SLR has improved at breakneck speed. The 2.6MP Nikon D1 (introduced in 1999) featured an LCD screen measuring 2 inches (5.1 cm), and the 3.1MP Canon D30 (introduced in 2000) had a screen of 1.8 inches (4.6 cm), with 130,000 and 114,000 pixels respectively. Today the latest high-end offerings from both Canon and Nikon feature 3-inch (7.6 cm) LCD's with 230,000 and 922,000 pixels respectively, which are both large enough to accurately evaluate focus and pictorial value. In general, a useable LCD should be at least 200,000 pixels on a 2.5-inch (6.4 cm) LCD. Although bigger is almost always better when it comes to LCDs and the number of pixels on them, the two specifications just listed are very useable for almost all portrait purposes.

While the latest, largest LCD screen with the greatest number of pixels is a nice feature to have, previous generation D-SLRs screens are still very useable.

Currently there are two types of interchangeable lens D-SLRs available. The majority of D-SLR cameras have an imaging sensor that is smaller than the frame of a 35mm film camera, but there are a few models, called full-frame cameras, with a sensor that is the approximate size of a 35mm film frame. Regardless of whether the camera is a so-called full-frame or small chip design, it should be noted that most have a format that mimics the 3:2, 35mm film proportions.

Some photographers feel that a D-SLR with a full frame sensor is the only pro-grade machine and a worthy successor to the venerable 35mm film SLR. I don't understand this. Often, digital photographers rush to embrace digital technology yet get hung up on the 35mm frame size, but it is not the Holy Grail. In fact, if we look at history, it turns out that the 35mm format happened by a fluke.

When Oscar Barnack made a small camera in 1923, the first 35mm camera was born. Barnack decided to design the camera around motion picture films that were 35mm wide with sprocket holes running along each edge. The sprocket holes took up about 10 mm of the film's width, and it was the remaining useable film that determined one dimension of the frame, 24mm. But unlike Barnack's final design, 35mm motion picture cameras used the 24mm dimension as the long side of the rectangular format. Probably because motion picture emulsions of that day didn't have the quality of today's film emulsions, Barnack decided to extend the motion picture format by turning the rectangular format 90°. Further, he decided upon a 3:2 ratio, and that resulted in a 36mm long dimension.

What if the motion picture film of that day was 40mm wide, or 30mm wide? Would today's photographers, who rally to the 24 x 36mm format like religious zealots, be rallying to a 29 x 44mm or a 19 x 30mm format instead? I can understand rallying to the proportions of a format like 3:2, even if there are no magazines, books, or packages of plain paper using that format, but those same 3:2 proportions can be expressed in as many ways as there are numbers! Why do photographers, who rush to embrace the digital revolution, refuse to forsake an old format that was created to exploit another use from an even older product? I have some ideas, and a lot of their rationales revolve around lenses.

Cameras with small sensors don't capture the same field of view as a 35mm or full-frame camera when an identical lens is mounted on each. This is due to a cropping factor caused by the smaller sensor, which is often called its focal length equivalent. You can use the focal length equivilency number to compute what focal length would produce an identical field of view on a full-frame camera. To do this, multiply the actual focal length in use by the camera's equvalency factor (usually around 1.5x). This will give you the focal length that would produce the same view on a 35mm or full-frame camera. For example, a 50mm lens on a small-format D-SLR will have a field of view like that of a 75mm lens on a full-frame camera, and a 200mm lens will have the field of view of a 300mm lens.

Full frame D-SLRs, like the Nikon D3, have a sensor that is roughly the same size as a 35mm film frame. Some photographers feel most comfortable shooting with these models, while others appreciate the lighter weight and smaller size offered by cameras with smaller sensors.

If you are a life-long 35mm SLR user, it may be harder to acclimatize yourself to the newer fields of view. Some say that experienced photographers are creatures of habit and develop a feel for what focal length they need for a specific picture. Others say that small-sensor D-SLRs cameras are limited in wide-angle capabilities compared to full-frame cameras. Still others say the cropping factor resulting from a long lens doesn't offer exactly the same perspective as the supposed equivalent when an even longer lens is used on a full-frame camera. All of these rationales may be true, but I have found none of them justify the extra weight and expense of full-frame cameras and their full-frame lenses.

Obviously, a full-frame sensor (because it is physically bigger) can have larger pixels than a smaller sensor with the same pixel count, and this can be considered a great advantage. While a full-frame D-SLR may have 12MP on its sensor, a newer model might have 20MP, which means its pixels must be smaller than the 12MP model. Equally true, a 12MP small chip D-SLR might have the same sized pixels as a 20MP full frame D-SLR.

Small sensor D-SLRs can be smaller and lighter than full-frame D-SLRs, but this miniaturization can't go on forever because the lower limit of their size is dictated by both the size of the imaging sensor and the size of the human hand. At some point, as you shrink the size of a D-SLR, it will get impossible to push the camera's control buttons with normal-sized fingers.

The lenses for small-sensor D-SLRs are both smaller and lighter than their full-frame counterparts. This compactness, combined with their lighter weight, is why I have happily settled on the small-sensor D-SLR for my photography: It's a new format suitable for a new age! In fact, I occasionally compare tech notes with my friend Bob Krist, an amazing photographer for *National Geographic Traveler* magazine. While we shoot different types of assignments, both of us have settled on small-sensor D-SLRs, and both of us produce the majority of our photographs with just two constant aperture zoom lenses: either a 17–50mm (or a 17–55mm) and a 50–150mm Sigma telephoto. While the two camera bodies we both carry are lighter, smaller, and less expensive than their full-frame counterparts, more importantly, our lenses are also smaller and lighter than the equivalent lenses used on full-frame cameras.

It's a simple fact of life that inexperienced photographers lust after extreme lenses. They want the longest or widest lenses available, but the reality is this: For general photography, and portrait photography in particular, the more extreme a lens is, the less useful it is overall.

Obviously, photographers who shoot sports, wildlife, or other subjects from afar need super long lenses. Likewise, photographers who shoot architectural subjects like buildings, interiors, or bathrooms need super wide lenses to get the entire scene into the frame. For general photography, however, moderate focal length lenses are much more useful. I am willing to say that 99% of all the portrait situations you'll encounter can be covered beautifully with lenses ranging from 24–85 mm on a small-sensor D-SLR, or with 35–135mm lenses on a full-frame D-SLR. Does this mean there is never going to be a portrait situation where you could use a longer telephoto or a wider-angle lens? Of course not! But it does mean that I prefer having an 85 mm f/1.4 or f/1.2 lens for portraits to augment a midrange zoom because of the advantages a large aperture's shallow depth of field offers over a 300 mm f/2.8 lens. If you think about it, they call them normal and portrait lenses for a reason!

Below you can see the Sigma 50–150mm f/2.8 zoom (left) compared to a Nikon 80–200mm f/2.8 zoom (right). Personally, for portrait work using a small chip camera, I find the 80-200mm too long for many situations, and when adding in the size and weight advantages of the Sigma, the choice between the two was easy to make!

Note the size (and consequent weight) difference between these two lenses. The smaller one used on a small chip camera has the equivalent focal length of the larger lens used on a full frame camera.

how normal and portrait lenses work

Normal lenses produce photographs that approximate the human eye's natural field of view. As stated previously, that's 12–18 inches (30.5 x 45.7 cm), or a comfortable arm length, for an 8 x 10 print (20.3 x 25.4 cm). In other words, the subjects in the resulting pictures look normal.

Is there a better way to show our subjects than by having them look normal? Should our goal be to have our subjects look abnormal? In reality, moderate wide and long (the so-called portrait) lenses all have the ability to make our subjects look normal. These lenses are close enough to the specific normal focal length that they don't impress a signature on the portrait (for more on signatures, see page 133). Sometimes a lens' signature is so overpowering that it becomes more important than our subject. An example of this is when a viewer looks at a portrait you've taken and says: "Wow, that must have been taken with a super telephoto lens!" If that's their first comment, then obviously the subject's importance becomes secondary to the effect caused by the lens.

Moderately long lenses, aptly named portrait lenses, don't let their signature overshadow the subject. Also, they have a characteristic called compression that generally improves most portraits. To understand compression, consider that the distance between an average subject's nose and ear is approximately 6 inches (15.2 cm). Take a similar measurement of the distance between a subject's eye to nose tip and you'd find it is between 2–3 inches (5–7.6 cm). These two measurements will remain constant regardless of the lens you choose to use.

If you mounted an 18mm lens on your camera and filled the frame with a subject's face, you'd find the distance from the imaging plane (the sensor) to the subject's nose tip would be approximately 12 inches (30.5 cm). If we mounted a 100mm lens instead of the 18mm lens and framed the subject's face the same way, the distance from the imaging plane to the subject's nose tip would now be about 60 inches (1.52 m). But the distance between the subject's eyes and their nose tip is still 3 inches (7.6 cm). Because 3 inches (7.6 cm) is a much smaller percentage of 60 inches (1.52 m) than it is of 12 inches (30.5), the difference in size between the subject's eyes and their nose tip is much less pronounced with the 100mm lens than it is with the 18mm lens. This means the subject's nose won't overpower their other facial features; it is also an example of compression.

Here you can see the same face shot with three different lenses on a smaller format camera. From top to bottom, a 16mm lens, a 50mm lens, and a 100mm lens. Note how as the lens focal length increases, the nose becomes less prominent and the face seems to flatten out. The longer the lens, the more compressed the face appears.

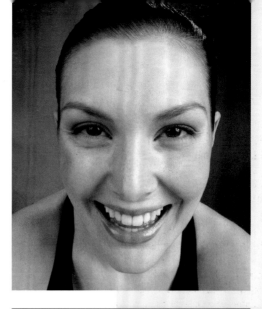

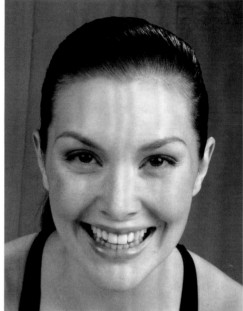

Grasping the concept of compression, you may assume that more of a good thing is always better, but don't immediately run out and buy a 300mm lens. There are a few reasons why that 300mm might not be as good a choice as a 100mm lens in a portrait situation.

1. Eventually, the compression produced by longer lenses becomes so great that the subject loses it three-dimensional feel and starts to look flat.

2. To frame a subject using a 300mm lens in the same way as a 100mm lens at a distance of five feet (1.52 m), you'll need to move 15 feet (4.57 m) from the subject. Consider that you must add 5 extra feet (1.52 m) for some breathing room between the subject and background, and 2 feet (70 cm) more for you to get behind the camera. Now you are over 20 feet (6.1 m) away from your subject. If you add a second or third person to the photo, you'll need a bowling alley for a group shot!

3. Once you get 10 feet (3.1 m) or more away from the subject, you lose all semblance of intimacy with them. At such long distances, it's difficult for your subject to even hear directions you might offer.

4. Consider just how much weight and volume of equipment you can carry and still be productive. A heavy, bulky lens that can only be used for one photograph in 500 (because we're only talking about portraits here) is rarely worth carrying, no matter how special it is!

5. Finally, for the professional, it is always important to consider the cost of equipment. The cost of all equipment is just another business expense that takes away from the bottom line, and profit is a professional's lifeblood. Professionals use older or beat up equipment because they try to wring every penny out of its cost. A high-priced, rarely-used lens is not always a worthwhile business expense.

Many new photographers are interested in extreme lenses, but for most portrait situations, like the studio portrait seen here, you don't need a 300mm lens. Typically, such a lens will require you to set up too far away from your subjects, it will contribute to over-compression, and it will be heavier. In most cases, a 100mm lens is all you need.

the f/stops here

Let's consider which f/stop you might want to use for your portraits. Inexperienced photographers often buy the fastest lenses available and, since they spent the money for all that beautiful glass, only use them at their widest apertures. There are both positive and negatives to this strategy.

On the plus side, the large aperture allows correspondingly short shutter speeds, which are a boon in alleviating the image degradation caused by camera shake and in allowing you to take portraits in low-light situations. And, at the relatively close focusing distances involved in portraiture, large apertures offer razor thin depth of field. Using an 85mm lens at f/1.2 or f/1.4, for example, throws intrusive backgrounds totally out of focus, which is a very good thing.

On the negative side, most lenses perform much better when used at apertures near the middle of their range—about two or three stops down from wide open is a good rule of thumb. While razor thin depth of field, where a subject's eyes are in crisp focus while every other feature on the subject's face is a little softer, makes for an interesting portrait of a single person, it's effects can be disconcerting in a two-up or three-up portrait where one subject is razor sharp and the other ones are slightly out of focus. Lastly, the characteristically greater depth of field at smaller apertures provides you with a safety net in case you miss perfect focus by a slight bit. Taking all of this into account, when I'm dealing with multiple subjects, I much prefer the safety of using f/8 compared to the possible pitfalls of working at f/1.4.

hoods

To realize the importance of lens hoods, let me state an almost universal fact: I do not use a normal, zoom, or telephoto lens without a lens hood attached. Never? Well, almost never! In fact, the only time I would consider not using one is when all the lighting for a photograph comes from behind me. In that instance there's little chance of the light creating image-degrading flare. But, even in that instance, I'll generally be using a lens hood anyway. If you add the fact that lens hoods also protect the front element from greasy finger prints, dust, sand particles, and even water droplets, you'll find that the times when you shouldn't be using a hood gets close to zero. Why pay hundreds or thousands of dollars for the highest quality glass with the fastest apertures and then diminish its quality by not using a $30 accessory?

filters

Software filters have replaced the glass and gelatin filters prevalent in the film era, and using software filters means one set of Photoshop plug-ins will fit all your lenses regardless of their diameter!

However, there are two filters that I haven't found a replacement for. One is the polarizer; while this filter is great for landscapes, it isn't very relevant in most portrait situations. My other favorite filter isn't made of traditional glass, but instead is a piece of black veil material called tulle (pronounced similarly to tool). There are many different grades of tulle available, and I find the best is similar to a common white bridal veil, except it's black.

I've tried the white tulle and found it causes flare, but the black version seems to take an edge off a subject's wrinkles without causing flare or having a strong signature. Tulle is quite inexpensive, so I buy it by the yard. I then cut 6-inch squares to stretch over my lens. I almost always limit its use as a soft focus filter to female subjects, because older men often look better when left "craggy." Also note, if you use a handheld meter, you have to *increase* your exposure (either a larger aperture or a longer shutter speed) by a half stop to get the proper exposure.

Because small chip D-SLRs use only the center of a full-frame lens' circle of coverage, you can use lens hoods designed for longer lenses when using a full-frame lens on a small chip camera. In this photograph, two 50mm f/1.4 lenses are fitted with two different lens hoods. The lens on the left is fitted with a hood from a Nikon 105mm lens, and this hood doesn't vignette when the lens is used on a small chip D-SLR. The same lens on the right is fitted with a lens hood that won't cause vignetting when used on a full-frame camera. A longer lens hood is always better as long as it doesn't cause vignetting.

the portable photographer

Photographers can be such equipment buffs, so I thought I should include a list of the D-SLR equipment I usually carry.

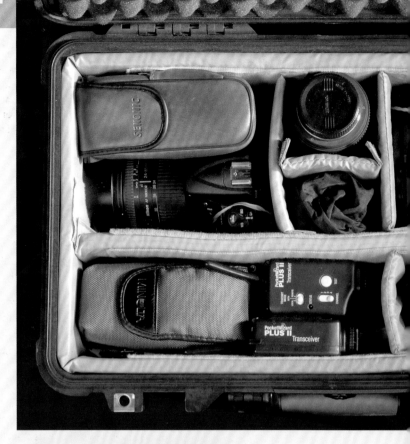

2 Nikon D-SLRs; note the rubber bands around each body—they're to make sure a PC cord doesn't come loose in the middle of a shoot

1 Nikon 17–55mm f/2.8 zoom lens with hood

1 Nikon 24–85mm f/2.8-4 zoom lens with hood

1 Sigma 50–150mm f/2.8 zoom lens with hood

1 Nikon 50mm f/1.4 lens with hood

1 Nikon 85mm f/1.4 lens with hood

2 Extra camera batteries

3 Pocket Wizard Radio slaves (two transceivers and one transmitter)

1 Sekonic L-358 meter with Pocket Wizard module

1 Minolta FlashMeter IVF (pronounced "4F")

1 Zip Lock bag of spare Pocket wizard to PC cords (6)

1 Ditty bag of tools

1 Ditty bag for spare batteries (which I date so I know how old they are), spare meter, and Pocket Wizard batteries

1 Small roll of gaffer tape

8 4GB Sandisk Extreme IV CF cards in a ditty bag

4 2GB Sandisk Extreme IV CF cards in a ditty bag

3 Sharpie CD-safe pens (dual point)

 Business cards

 Model releases

 A copy of the day's assignment contract

 A few 1-quart Zip Lock Freezer bags

tripods

While some might feel that a tripod doesn't fit their freewheeling style, every professional photographer I know considers his or her tripod a close friend. And, although it is true that you sometimes might hate a close friend, that doesn't mean they're not still a close friend. While it is simplistic to say you should use a tripod all the time, it is equally simplistic to say you should never use one. There are many reasons for using a tripod, and while I can't list all of them, here are a few:

1. Using a tripod opens up a whole range of shutter speeds (and consequently a whole range of f/stops) that are not available to you if you are handholding your camera—even if you're camera has image stabilization technology.

2. The human body is not as stable a platform as we would like to think. A tripod can help overcome potential camera shake from unsteady balance or overworked photographers who just love to drink coffee.

3. No matter how still you think you can hold it, a camera using a portrait or telephoto lens that is mounted on a tripod will almost always give you a sharper result then the same camera and lens being handheld at all but the very shortest shutter speeds.

4. The above reason is even more true at shutter speeds longer than 1/60 of a second.

5. Using a tripod gives your camera presence and makes your subjects think you are more professional.

6. Using a tripod will also make you look and feel more professional.

7. Using a tripod slows you down a bit and gives you time to think about what you are doing and how to make it better. A little contemplation is a good thing.

8. Using a tripod means you don't have to put the camera down somewhere to adjust a light or the subject.

9. Using your tripod lets you see the subject with your naked eye at the exact moment of exposure.

While most of these are self-explanatory, when talking about portraiture, especially single-subject, close-up portraiture, the last one has special implications. For all the advances made to the viewing systems of today's D-SLRs, at the exact moment of exposure all I see through the viewfinder is blackness when the mirror flips up, blocking the view through the lens. The moment I am most interested in seeing is the only moment that I can't see! In fact, sports photographers will tell you that if you're shooting a high-speed sequence and you see the perfect picture through your viewfinder, you have missed the shot.

That's because a picture is not being taken when you see the subject in the viewfinder. This is true for every SLR viewfinder design except a few cameras that were manufactured with a pellicle mirror. Because of this, I prefer to look at my portrait subjects with my naked eye, not through the viewfinder, at the moment of exposure. That is very difficult if you are handholding your camera. If, on the other hand, your camera is mounted on a tripod, you can lock it into position and look directly at the subject as you take the photograph. This is an amazing advantage. With practice you will see blinks and perfect, or perfectly horrid, expressions. It's even easier if you are using flash, because the subject lights up when the flash fires. As an added benefit, if you use this technique, you'll never have the subject tell you your flash didn't fire!

As a mentor explained to me some 35 years ago, when it comes to equipment that doesn't become obsolete due to changing technology, choose brands that you only have to buy once. Do your research and find out what the highest-quality item in a particular class of equipment is, set your sights on it, and don't settle for anything less. Although tripods will not become obsolete, many young photographers buy the cheapest one they can find in order to save money, and often it has to be replaced after a short time. I suggest you scrimp and save until you have enough money accumulated to buy the best tripod available. Some of my tripods are over 35 years old, so by buying the best you'll save money in the long run.

Operating speed is the key for choosing your tripod, head, and quick release couplings. Note that the last item, quick release couplings, almost automatically have speed of operation built into their design—that's why they're called "quick!"

Tripod Criteria:

1. I avoid using tripods with additional leg braces for portraiture because they're slow.

2. I also don't like tripods with geared center columns for portraiture; they're slower than clamp-locking center columns.

3. There's no need to lug a bulky 10-foot (3 m) tripod if you're only going to shoot at a maximum height of 6 feet (1.83 m) or so. Furthermore, the height of an average tripod head is between 4–6 inches (10.2–15.2 cm), the distance from the bottom of every D-SLR to the center of its lens is another 2–6 inches (6.4–15.2 cm) (depending upon the specific camera), and eye level for most subjects is about 4–6 inches (10.2–15.2 cm) from the top of their heads, so tripods that are 60–65 inches (1.52–1.65 m) high work for almost all subjects.

4. Why buy and carry a tripod rated to hold a 25-pound (11 kg) camera when your heaviest D-SLR and lens combination only weighs seven pounds (3 kg)? Buy a tripod that best suits your camera.

5. Carbon fiber tripods are much lighter than metal ones. Carbon fiber tripods are also much more expensive than comparable aluminum ones. It's your back and your budget, so consider your options carefully.

6. Lever locks are much quicker to use than slower threaded collar locks, but in this instance I prefer the slower threaded collar locks for two reasons: (1) Some lever locks are easily broken while, (2) others have levers that have no adjustment for normal wear which means that as the levers wear away from the friction and grating of locking them, they eventually no longer lock the tripod's legs in position solidly.

7. Leg spreaders (the ability to change the angle of each leg individually) are a worthwhile feature to look for. They make it possible to set your tripod up on uneven surfaces like a staircase and you can very quickly get to a much lower camera position by kicking out one leg of the tripod.

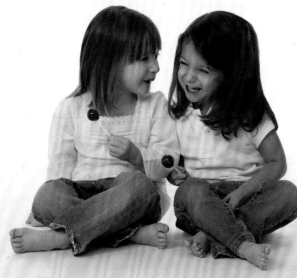

One measure of a good tripod is its range of positioning. Can it be lowered close to the floor for shots like this?

Tripod Head Criteria:

A tripod head is an articulated, mechanical joint that fits between a tripod and the camera. Some less expensive tripods include a head as part of their design, but separate heads are usually better designed and sturdier.

1. **Though less precise for small corrections, ball heads are much faster and better suited to portraiture than pan/tilt heads.**

2. **Adjustable drag is a great feature to have on a ball head. By setting it carefully, you can move the camera without releasing the ball head's lock and the drag will hold the camera in position when you let go of it. This makes for easy framing and very fast operation.**

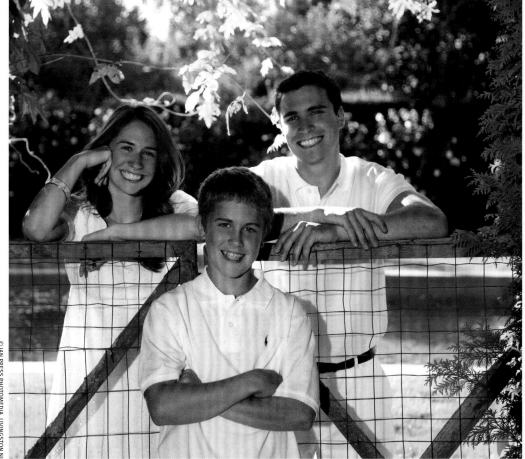

Using a tripod allows you to take pictures in low-light scenarios without the image becoming blurry from camera shake. Choosing a good tripod is important; often, inexpensive models don't offer the durability and stability that you will require for professional use.

© JAN PRESS PHOTOMEDIA, LIVINGSTON NJ

Quick Releases:

Quick releases are handy gadgets that allow you to mount and demount a camera or other gear from a tripod instantaneously. Not only does this save you time, but it also adds versatility to shooting a portrait session. With a quick release, you can go from shooting on a tripod to handheld without missing a beat.

A two-piece coupling system is comprised of a plate that mounts to the camera and a coupling (or clamping) unit that mounts to the tripod head and couples (or clamps) onto the plate. It forms a secure connection between the camera and tripod head while it facilitates fast removal of the camera from the tripod.

While there are a few different quick coupling systems available, my main criterion is that some form of safety interlock be built into the coupler body so that your camera, with coupler plate attached to it, can't fall off the tripod if you inadvertently loosen the coupler's locking mechanism.

Tripod Tips:

Note that #2 described below is the opposite of #1 and #4 is the opposite of #3. This is because you might be willing to compromise stability or speed depending upon many factors such as the weight and focal length (longer lenses magnify image-degrading vibration) of the lens you are using, the weight of your tripod (heavier tripods dampen image-degrading vibrations better), or the level of ambient light, and the shutter speed you are using.

1. Aim one leg at the subject so you can stand between the other two when you're taking photographs.

2. To add stability to a lighter tripod, position it so you can straddle one of the legs. Put your left hand on the leg yoke (the casting where all three legs meet), and drape your body over the tripod as you press down with your left hand.

3. Try not to use the tripod's center column if at all possible. A fully extended center column with a heavy camera atop it can be equated to a dandelion puff swaying in a stiff breeze.

© JAN PRESS PHOTOMEDIA, LIVINGSTON NJ

Using a quick release coupling allows you to easily switch from tripod to hand-held shooting, perfect for when you need to quickly change positions and shoot a variety of poses.

4. If you want to shoot full-length and close-up portraits in the same session, try setting the tripod so that the leg extension plus the full center column extension gets you to your subject's eye level. To go from a bust-length to a full-length, drop the center column completely and you'll find yourself at a position that's only slightly above bellybutton height. Do this with care.

5. If your lens is equipped with image stabilization (IS) or vibration reduction (VR) turn it off when working on a tripod.

6. Never, ever grab your tripod at the joint between the leg and the yoke if you have to move it or carry it to another location. The leg joint you grab will fold in a bit when you lift the tripod and then reopen as the tripod is being moved. It will pinch your palm or your finger, which is extremely painful (figure 1).

7. A quick release coupling system will save you time when mounting and dismounting your camera to and from the tripod head. Remember to exploit this feature. Consider starting off a portrait session with your camera mounted on your tripod, but then slip the camera off the tripod and continue the session handheld to explore other camera positions (figure 2).

8. While today's most commonly used standard for a tripod screw thread is 1/4"-20, some equipment accepts a more robust 3/8"-16 thread. If you tripod head offers this size post, use it to mount your tripod head and quick release if it accepts it. (Today's D-SLRs only accept the smaller thread.)

9. Get some removable, non-permanent thread-locker fluid (Loctite is one brand) and put it on the screw threads between your tripod and tripod head, and also the screw threads between your tripod head and quick release coupling.

10. Tripods are amazing tools that can open up exciting possibilities for your photographs. However, handholding should not be overlooked. You should be free to use both at different times, depending upon the task at hand.

figure 1

figure 2

10

chapter ten

the business side of portraiture

It would be nice if I could start by saying, "After reading this chapter you will be able to make a comfortable living doing portrait photography, you will pay your bills and show a profit, and you will put aside enough money over the course of your career so that you won't end up spending your old age struggling to survive." Sadly, I can't make you that promise. In fact, photography as a profession is a difficult row to hoe. There are many reasons for this, some created by advancements in camera technology, others created by society, and still others within you. With that said, it's obviously still possible to make a career out of portrait photography; it's just important to be realistic about this choice. So let's first review the challenges facing the portrait photographer, followed by ways to improve your chances of making it.

In recent years, the entire business of photography (not just portraiture) and making a living at it have changed drastically; first with the advent of camera automation, and then with the advent of digital photography. Nice photographs that took a lot of knowledge, careful technique, expensive equipment, and just plain hard work a few short years ago are now commonplace because of advances in technology. Furthermore, with the availability of more automated, less expensive equipment (relatively speaking), a whole new generation of photographers has bought a camera, set it to "A" or "P," printed up business cards, and hung out a shingle proclaiming their professional status. This has resulted in a glut of professional and quasi-professional photographers selling their wares to a public that has also gained the ability to take great looking photographs just as easily; both of these facts, in turn, have lowered the prices most professionals can charge for their services.

Automation has allowed some large chain-stores to sell portrait photography at a marginal profit and make up for their low margins with huge volume. Then, as if to add insult to injury, some of these large chains offer in-store portrait services as a loss leader just to get customer traffic into the stores so they might be enticed to buy more profitable merchandise.

The portraiture business has changed in recent years, but as a creative professional, you can still have a successful career by offering services the large portrait studios can't—like on-location shoots.

© CANON USA

With digital cameras getting more advanced all of the time, it's easy for novices to get good pictures and try to sell themselves as pros. In an already crowded professional field, one often has to be both a creative photographer and a savvy businessperson to succeed.

digital reality

To complete this picture, the digital revolution has turned photographers into cash cows for camera manufacturers while simultaneously adding to the non-profitable part of their workload to the detriment of the profitable part. While I know this to be true, I'm sure some of you are ready to pummel me with the well-worn argument that digital photography has saved photographers great bags of money because there are no longer the film and processing costs associated with using film. But before you attack me with pitchforks and Uzis, I ask that you follow along for a moment as I lay out a few reasons and observations that might validate my statement.

Before digital, because every camera used a standardized size and type of film, it was possible to buy the least expensive camera and use the best film in it. The film was the great leveling factor and it was possible to use a 30-year old camera system with the latest and greatest media. While this was great for photographers trying to wring every nickel out of their equipment budget, it was not so great for camera manufacturers looking to constantly sell more and better cameras. Conversely, digital cameras, with the sensor built into them, don't have the longevity of film cameras, which means that today's digital photographers are on a constantly moving treadmill caused by new, upgraded cameras being introduced at an alarmingly fast rate.

Professional photographers, who must play the upgrade game, are forced into opening their wallets much more frequently. Some of you will (rightfully) argue that by investing in high-quality lenses, the upgrade costs are made more palatable because the only part of the system needing an upgrade is the camera body.

While digital photography certainly saves costs on consumables like film, the need to constantly upgrade camera and computer equipment cuts into these perceived savings.

Others of you will argue (again, rightfully so) that there is no need to upgrade a camera for a paltry gain of a few megapixels when it's not necessary to have the very latest equipment to take beautiful pictures, and that each new version of a camera knocks the price down of the previous version on the used camera market. But sadly, there's more to shooting with a digital camera than just having the latest camera body because you have to include the additional expenses of a computer system, storage capacity (both in cards and hard drives), and software into your upgrade cycles. Although computer upgrades are nice, they become mandatory once software upgrades demand higher system requirements. So I think it's fair to say that while shooting digital does save money on consumables, there are other costs that need to be added into the affordability equation.

And what about that non-profitable part of the workload I mentioned? As we've seen in some of the preceding chapters, there are things you can do during a shoot (like adding makeup services) that are seen by the customer and are thus easier to charge for. Spending hours correcting images in Photoshop might not be as easy to pass off on a bill, and it can take a lot of your time. As I mentioned in the introduction, if you shoot one hundred 8-hour days per year, and if it takes 1 hour of post-production time for every hour of shooting time to download, edit, archive, and do a general clean up of your work, at year's end you will have been sitting in front of your computer for 800 hours, which is twenty 40-hour weeks, which is five months of the year. That's five months of time when you can't be shooting or selling more assignments (or sleeping, or eating, or vacationing). Hopefully you'll learn to streamline an efficient digital workflow, but the fact remains that digital does require processing time. That being the case, many photographers do charge a digital processing fee (or they roll this time into the overall cost of the shoot).

If it sounds like I'm bashing digital photography, that's not the case—I love digital; in fact, I have embraced it for years and I'm happy if I never shoot another frame of film in my life. But if I were to list all of digital photography's fabulous attributes, neither low cost nor less time consuming would make my list. So love it, embrace it, and stroke your cool camera, but as a professional you must always be realistically aware of the costs and time involved in your work.

speaking of time...

Photographers are the worst when it comes to attaching value to their time, and to exacerbate the problem they are also awful at realistically judging how much time something takes to accomplish. It's a bad double-whammy! I am constantly amazed at photographers who can book a one-hour location shoot with a straight face. One-hour location shoots simply do not exist! Look, it takes 30 minutes to collect your paperwork and equipment, 15 minutes to load the car, 30 to 60 minutes to drive to the assignment, park, and unload, 15 minutes to say hello, listen to the client (smiling, always smiling!) and set up, 60 minutes to shoot the assignment, 15 minutes to breakdown and say goodbye to the client, 30 to 60 minutes to drive back home (or to your office or studio) and unload the car, 60 minutes to download, edit, backup, and do a general cleanup of your work, and 15 minutes to complete the assignment's paperwork. The total is over 4 hours even if I use a shorter driving time. Instead of it being a one-hour shoot, if you start at 8 AM, you'll be done a little past noon. Whoops—a half a day is gone, it's time to break for lunch!

run a smart business (and have fun)

Okay, by now you might be feeling a bit depressed. The competition is both stiff and inexpensive. The time and the costs involved are serious. Your ability to price your time fairly is difficult, and you may often have no idea how much time is needed to do the assignment! Why-oh-why would anyone want to do this? In the first (and most important) place, it's fun! And while some photographers may think their camera is "the coolness," in actuality, taking pictures is. And, lest I forget, I don't mind working from 8 AM to midnight as long as the boss pushing me to do it is me! These are very powerful reasons to want to be a photographer. The very first wedding photographer I ever assisted called me a name roughly equivalent to "idiot" (only worse) when I said I wanted to be a wedding photographer. But later I realized that if he was right, and I was an idiot, then he was an idiot too, and if he could be one, I certainly could be one! I'll leave you to decide whether it is indeed an idiotic choice for a livelihood or not, but let me offer some suggestions to help your professional life! Some will be one-liners, some will be anecdotal, and some might be voluminous, but the more of them you live by the better your chances of success. Consider them to be spinach (or broccoli, or cauliflower, or any vegetable you hate)—hard to swallow, but in the end you'll be healthier and stronger.

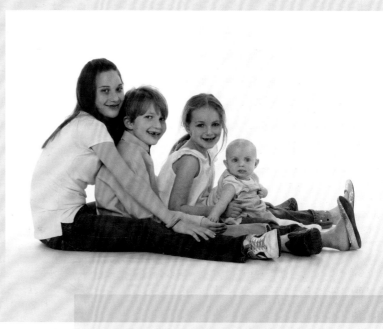

© IAN PRESS PHOTOMEDIA, LIVINGSTON NJ

Cameras are no doubt an expensive part of the business, especially since you really need two of the same model! If you try to shoot with an old or unfamiliar back up, there's a good chance you'll miss getting a winning shot like this one on the days your good camera is in the shop.

1 learn what things cost you and how much you need to charge

Be very aware of all the hidden costs in everything you do. Case in point: I just picked up a new digital camera. The camera sells for $1,799, but by the time I added in shipping and sales tax, the price was roughly $1,975. Then I had to upgrade to the latest version of Photoshop to be able to convert (heck, just to open and see) the camera's RAW files; the upgrade cost was $200. Adding this camera to my insurance policy (all peril, worldwide) costs about $30 per year, so over a three-year life, the insurance tab will be $90.

My $1,800 camera just cost me closer to $2,265 and it'll probably last me two to three years. That means that over three years, it'll cost me about $60 per month.

But wait! I don't need one camera...I need two! If you don't believe me, just wait until the day your single camera breaks down. As a pro, I can tell you that no camera means no money, so there's no such thing as not having a backup. And please ignore the argument that your backup camera can be of a lesser or older vintage. Imagine you're driving a road race in a Ferrari; now make believe it breaks down and your pit boss puts you in your backup vehicle: a pickup truck! Worse still, imagine it's a 1950's pickup

truck. You lose. Seriously though, it adds to the difficulty of doing great portraits to work with a slow, low-resolution camera if you're used to a fast, high-resolution one. Okay, so the two new cameras will cost me $120 per month. At first, I really wanted the higher-grade model of the camera, but for me to buy two of them, after sales tax, shipping, insurance, and software upgrades, the total would have been approximately $11,000, thus costing me about $300 a month! If I were a well-heeled hobbyist or a retiree on a big pension, then it would be fine doing that— but I'm not! I'm a businessperson first, and for my assignments the less expensive model is just fine. Plus, I am mollified by the fact that the less expensive model is lighter and smaller because I lug my cameras and supporting gear day after day. I don't have the luxury of saying I'm tired today so I won't shoot any pictures. The main point is this: Consider all of your costs, and be sure to compare them to what your needs, and not your desires, really are. The following suggestions will help you start figuring out a budget.

Keep a Log

Buy a little spiral notebook and start to keep two logs on every assignment. First, a time log: How long does it take to book the job, type up the contract, scout the location, drive to and from the location (each time, if multiple trips), shoot the job, do your post-production, deliver the files, and send out the bill. Next up is an expense log: List everything you spend out of pocket money on— everything! Mileage at $0.65 per mile (check the IRS website for updates to standard business mileage as gas prices climb), tolls, parking, paying your assistant, buying coffee for your assistant, DVDs, DVD cases, postage, envelopes, paper, everything! Don't worry, you won't have to do this forever, because soon enough you'll get an idea of what it costs you in time and money to produce a day's (or a half day's) work.

Make a List

Make a list of every yearly expense you have. Your car, saving for a new car, rent, insurance (car, liability, equipment, medical, dental, disability), telephone, internet connection, office supplies, camera repairs, new (or more) camera equipment, clothes, clothes cleaning, laundry, soap, toilet paper, food, a beer or two, a vacation, saving for retirement, saving for an emergency, saving for a down payment on a house, taxes, *everything*! Don't worry if it takes a year or so to fill in all the blanks; you're in this for the long haul. Just make a list and keep updating it. It's the only way to know how much money you need to make in order to earn a living.

Plan for Technology's Life Span

Choose a life span for your computer and camera gear. Two years? That's a bit short. Four years? That's a bit long. Maybe three years is realistic. Take the cost of your camera, computer, software, card readers, external hard drives (I fill three mirror-image TB drives every 13 months or so), and all other digital stuff and divide it by three; that's what "the coolness" of technology costs you per year.

Plan Your Year

Figure out how many days a year you can actually shoot. Personally, I don't think you can shoot professionally for more than a 100 or 150 days a year, and getting to the 150 mark is tough— really tough. Don't believe me? Check this out: For every shooting day you'll need a day of pre-production and a day of post-production. Even if you shoot clean as a whistle (as I suggest), you'll still need (to name but a few) time to book the assignment, write the contract, download and archive your work, get the work to your client, bill them, and collect your money – everything takes time. So 100 shooting days will take you roughly 300 workdays to accomplish. Adding in one day off a week and taking a two-week vacation just brought you to 365 days. The way to get to 150 days a year, the saving grace so to speak, is that sometimes you'll get a three-day or a two-week assignment; in those instances, the one day of pre- and one day of post-production for each day of shooting doesn't apply as it does on a single day shoot. Often you can "pre and post" a two-week assignment in four days, so this type of assignment is a plum! Regardless, take the total of all your yearly expenses added to your daily assignment expenses multiplied by 100 (for 100 days shooting per year) and then divide the combined total by 100 (again, for 100 days shooting per year). The result will be what you have to charge on each day you're shooting. Be realistic, be fair, but don't cheat yourself!

Don't Expect Overnight Success

Realistically speaking, there is no way you're going to hang out a shingle today and have 100 assignments a year tomorrow. Some pundits will suggest that you assist other established photographers to learn the ropes, but honestly, in rural areas and places without high population density, many established photographers shy away from hiring young photographers whose only goal is to become their competition. However, while it doesn't hurt to ask, and you can start off this way, don't expect to be welcomed with open arms if you walk in with the attitude that you're looking for a job as a photographer when you have no experience in the real world. Probably the worst thing you can do is to think that having $4,000 dollars to spend on a D-SLR, a lens, and an auto flash makes you a professional. That's a huge turn off to anyone who has spent years in the trenches establishing themselves, so consider being humble instead. Additionally, consider looking for part-time work in fields related to being a photographer, such as working in a camera store, photo lab, or even a custom frame shop as you grow your own client list. We live in an era when everyone wants instant gratification; we want it now or, better still, yesterday, but a career in photography can span 40 or more years so it makes more sense to not expect or demand overnight success. Things that come too easily aren't worth as much anyway!

© LaCIE

As a pro, your life is your images. Without your photographs, you have nothing to sell to your clients and having nothing to sell means you don't have a business! Back everything up using external hard drives and DVDs.

2 plan for the future

The most important thing about any assignment is getting the next one. Always try to look ahead. Treat today's client as if they are the most important person in your world, but remember that tomorrow's client gets the same treatment on his or her day. You're going to make mistakes; learn from them, but don't dwell on them—get the next assignment!

Cater to the Right Clients

Locate and cater to the local carriage trade. What's the carriage trade, you ask? Before cars existed most people walked to where they had to go. The rich people, the ones you would have wanted as clients, rode in carriages! Develop ways to cater to this class; often, different forms of advertising help.

Always be on the look out for new venues for your photography. It's even better if you find a potential client whose talents can help your photography. Case in point: hair salons and stylists always need portraits that show their work to potential clients.

Photographs of children can be more successful if you learn where fabulous outdoor scenes exist in your area. Explore your town or city and find scenic spots that will make great portrait backgrounds. Magical places exist everywhere—find them!

Advertise

First, a confession: I'm not a big fan of websites. Every photographer has one, and secondly, why should I care about having everyone on the planet know about me when I'm only interested in 100 assignments a year? If you can afford one or make it yourself, great; they are certainly one useful marketing tool in your bigger toolbox. But if you can't afford one yet, don't think you can't start a business without it. You could also consider using some of the portfolio websites out there that you can join and post your work on for free or for a small annual fee. These will help get your work out in front of potential new clients when you're first starting out.

Although I live in a large metropolitan area, I have used local, targeted mailings to pinpoint potential clients. Search "mailing lists" online, but not before you find out which of your local zip codes are the wealthiest neighborhoods. I send holiday cards to everyone (figuratively speaking) and gifts to important clients. Every time I shoot a portrait that knocks me out, I email copies to my clients and friends, but only after asking if it's okay before I do it. If there's a nearby mall catering to the carriage trade, find out about renting wall space and putting up a display with a nice printed card explaining your style. But never discuss price on a giveaway and always have someone check your spelling and grammar. This chasing after work doesn't have to go on forever. I very rarely show my portfolio and my sample books anymore. At this point in my career, most of my clients are repeat customers and new customers know what I can do before they call me. This is not said to be boastful, but instead, think of it as proof that all of the suggestions made here really work! It's also an example of the best form of advertising out there: word of mouth. If you're professional and talented, you'll soon see this gets you more business than anything else. It should also be a reminder to treat every client as if they were the most important person in your world, no matter how small the job. You never know what may come of it down the road.

© LIZ AND JOE SCHMIDT

When I asked Liz Schmidt where she got the hat for this portrait, she said she had it in her prop closet! Maybe you should start a prop closet, too.

3 keep your overhead low

You don't need to carry the expense of a large, fancy studio until you have the work to support it. Every dollar, every penny you save on overhead goes into your pocket as more profit. The goal at the end of a long and fruitful career is to have enough bucks socked away that you can go out and shoot sunsets (or whatever) till the cows come home if you care to. Keeping your costs low in the beginning will also increase your chances of making it in this business. The first few years will most likely be the hardest financially, so keep this in mind every time you think you "need" something, be it a piece of equipment or anything else. Only spend on the items necessary to successfully run your business. And as your business grows, so too can the expenses that support your trade.

4 become a pack rat!

For a long time I shared a studio in New York City that was the entire floor of a loft building. The floor was 30 feet (9 m) wide by 100 feet (30.5 m) long. The back 30 feet (9 m) of the space was filled with metal shelving that was filled with props. If you are interested in portraiture, start saving props. Hats, pieces of velvet, painted muslins, costume jewelry, foam moons, painted muslins, and artificial flowers—almost anything can be a prop. Bag the items in large, labeled trash bags so they don't become dusty, ratty, and ruined. Having a variety of props available will add to the perceived value your client can see, and you never know when your little girl portrait subject needs a hat to make the perfect portrait!

© LOUISE BOTTICELLI

is turned, a portrait print is a stand-alone item that is examined much more carefully. Because of this your goal is perfection, and working a file to perfection in Photoshop takes more time (especially if you haven't shot clean). Someone, namely your client, has to pay the freight for that perfection. Some clients try and tell me that my price for an 8 x 10 (20.3 x 25.4 cm) is outrageous; they claim it's only a piece of paper. Sadly, some would-be pros may feel the same way. But the point always worth remembering is that you're not selling a piece of paper— you're selling what you put on the piece of paper (and all of the time, equipment, and expertise needed to produce it). In truth, when a client gives me the "only a piece of paper" speech, I always respond that they are right and I will sell them all of the pieces of blank paper they want at ten cents apiece; but they don't want a blank piece of paper, they want what I put on it. Remember this always!

5 use a professional lab

Consider using a professional lab to print your photographs instead of doing it yourself. In the first place, it'll be cheaper. Second, they will probably do it better than you; after all, a great printer does his or her job 40 hours a week, whereas you are taking pictures for a good portion of your time. Why should you carry the overhead (in cost and time) of printing your own work when you can have someone else do it better? If you do have a problem with quality, a good lab will have suggestions, so ask them how you can improve the files you give them to get what you want. In the long run, this approach will make you a beloved customer and when you need something in a hurry or need them to jump through a hoop for you, they will. But don't ask for things in a hurry when it's not necessary. Nobody liked the boy who cried wolf, and they'll be far less willing to help when you really do need it.

6 don't undervalue your work

I can get a great 8 x 10 (20.3 x 25.4 cm) print for $2.50 from my lab. I charge my clients $25 for an 8 x 10 (20.3 x 25.4 cm) wedding print, while the same 8 x 10 (20.3 x 25.4 cm) is $60 when taken at a portrait session. The reasoning behind this is simple. While a print in a wedding album is looked at briefly before the page

7 increase your chance of print sales

If a customer wants a family portrait that includes mom, dad, and three kids, shoot the family portrait but then do all three kids together, each child individually, mom and dad together, and each parent alone. While some families might balk at this, you should point out that the kids are all dressed up, your lights are all set up, it'll only take a little more time and there's no extra charge involved. This gives you the possibility of selling many more portraits—consider it ammunition for your proof passing session that gives the client more options to make into final prints. Some photographers will shoot 200 images of the five family group together; I prefer to shoot the same 200 images but break it down into smaller groups. Who knows? You might end up selling the 24 x 30 (61 x 76.2 cm) family portrait to hang in the living room and an 11 x 14 (28 x 35.5 cm) of each kid to hang on the stairway wall. You might even consider limiting the proofs you give to the

client to just the family portrait they originally wanted, and when the client asks about the others, say that they are great but you wanted to save them as a surprise for when the client came in to discuss the family portrait.

Some photographers may be opposed to this idea. They may think it's a nefarious scheme to artificially pump up the portrait order, but it's by no means nefarious—it's just business! If you take great portraits and they make your clients happy, then it's your job to sell enough of them to stay in business. This way, you can make more portraits for other clients and make more people happy! And there's no pressure on the customer to buy more prints; they are simply offered as an option your client might not have originally considered, but may be grateful for.

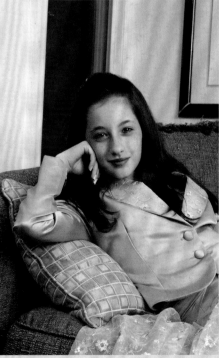

I was hired to shoot a portrait of a young teenage girl. I shot two different versions of a close-up portrait, but also included a full-length portrait as well. While the parents would only pick one of the two close-up portraits, the full-length portrait gave them another, totally different picture choice.

8 *diversify within your field*

I shoot family portraits, commercial portraits, weddings for myself, weddings for other studios as a sub-contractor, catalogs, I shoot for companies on location, I write books, and I teach workshops. Beware of becoming a one-client photographer; eventually that client will do one or more of the following: (1) Get fired. (2) Get bored with you and start looking for other talent. (3) The client or company will move to another state. (4) They will go out of business. (5) They may even die! As the old saying goes, don't put all your eggs in one basket.

© LIZ AND JOE SCHMIDT

Develop specialties! People love their pets and treat them as family members, and will therefore spend lavish amounts on them. Niches like these can become very lucrative.

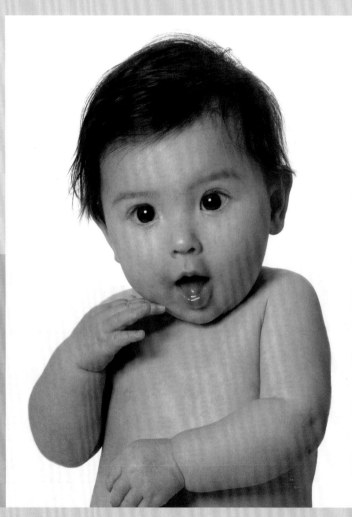

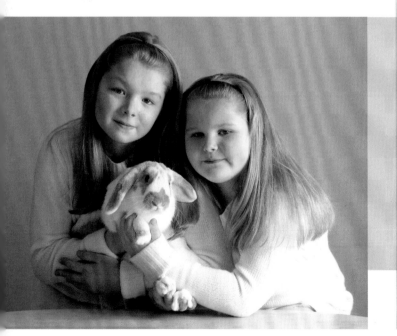

Children are always a very profitable part of the portrait business thanks to multiple print orders.

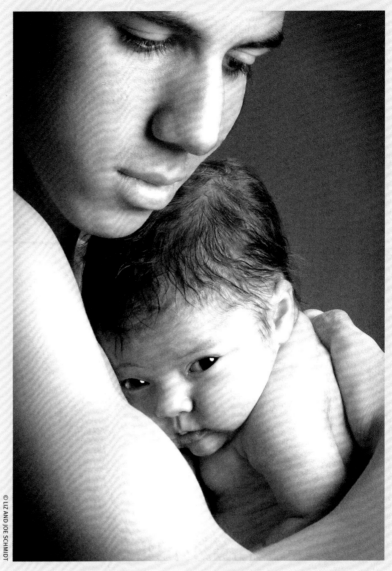

© LIZ AND JOE SCHMIDT

Erica

April 1, 2008
7 lbs 8 ozs
Proud Parents: Linda & Steve

© LIZ AND JOE SCHMIDT

Making new parents happy with great portraits can create life-long customers. Consider ways to offer more to your clients, like birth announcements.

9 diversify outside your field

Look for related businesses that augment your services. I know a wedding photographer who opened a tuxedo shop next door to his studio. Portrait photographers can develop a lucrative custom-framing sideline that can be as profitable as their photography business. Don't be limited to these two ideas. Be creative.

My friend Len DePas loves cooking and food. Over the years, he's developed a food portfolio that includes portraits of famous chefs in his area. Restaurants, magazines, and books always need photographs of food! The relationships that Len has developed with the chefs in his area has opened a whole new side to his photography business.

10 join an organization

Consider joining a professional organization such as the PPA (Professional Photographers of America, Inc). Even if you can't join immediately, try to find out about and visit at least a few of their trade shows. In my area, New York, there is a yearly trade show called PhotoPlus Expo, and every year I make it a point of going. While I stop by a few camera manufacturer's booths, my primary interest is in items that I can sell to my customers. Things like watercolor prints, prints on canvas, or even photo-realistic wall tapestries are all specialty items that can be sold at a much higher markup than standard photographs. Offering items of this ilk can do wonders for your bottom line. Selling just a few of them each year can be the difference between success and failure and, as an added benefit, just offering them separates you from the amateur newcomers.

© LEN DEPAS

11 *prime the pump*

Do favors for people. Get friendly with your local business organizations. Become active in your local place of worship, and if they have a charity auction, be first in line offering a free portrait sitting and a 16 x 20 (40.6 x 50.8 cm) print as a prize! Every wedding I shoot has beautiful, expensive floral displays. Sometime in the course of the day I get a photo of the flowers and I always make sure that the florist gets a copy of the picture. I never ask for anything in return, and the more free pictures I pass along the more referrals I get.

12 *take a course*

Lastly, if you want to sign up for a course on Photoshop, may I suggest that you check out a local university or junior college and instead take a course on small business administration. In a perfect world you should do both, but if you want to be a professional photographer (or portraitist) I will guarantee you that the course on small business administration will serve you better in the long run—even if it will make you so bored you'll want to cry! Sorry kids, but you've got to eat your vegetables.

This list is obviously not the be-all-and-end-all list for making it as a successful portraitist; it's just some of the ways I have made my business better. What it should tell you is that you're going to have to be a creative and savvy businessperson in this career, not just a great photographer. Take time to consider what opportunities exist in your area and how you can make them work for you. As long as you're professional and friendly, no one is going to be put off by a motivated businessperson showing initiative. So go ahead and put your work and yourself out there.

Be a creative businessperson. I shoot the main floral arrangement for every wedding I photograph, and send the pictures to the florist for free. This often results in referrals to their clients.

Photographers, being creative types, are usually terrible at paperwork. But drag that it is, paperwork is how businesses get things done. There should never be any question about what you said you're supposed to deliver to a client or what a client will be paying you after the assignment is finished. Today, with every digital professional owning a computer, this is not the onerous task it once was. Although it's relatively simple, let's take a quick look at the whole process, from getting the assignment to getting paid.

 If you're selling widgets in a storefront, things are easy. The customer walks in, decides which widget they want, pays the price (plus tax, if applicable), you put the widget in a bag or box, and they leave with widget in hand. Things are not so simple with photography because the customer hires you to perform a service that is started at one time, and the final product is delivered at some future time. And while a customer would never think to walk into a Target or Nordstrom's store, look at a $50 item, and then offer the clerk $25 for it with a take-it-or-leave-it attitude, in service-oriented businesses such as photography it happens all the time. Worse still, in professional photography it can even happen *after* the photographs are taken! For these reasons, you need some sort of contract between yourself and the customer that describes what you are going to do, what you are going to deliver, what the customer expects to receive, and what the customer will be paying for your services and products.

I work a lot of assignments with multiple photographers. To keep our equipment from getting mixed up, I write my name on things like my umbrellas. Sometimes I also need subjects to look at a specific spot in the umbrella and I have them focus on the name. It gives them something to look at, and it's a bit of free advertising reinforcement for me.

make it professional

By making your paperwork look more professional, the customer is less likely to think your prices are negotiable. Obviously, you're going to need business cards, but you also need a letterhead, a printed price list, a business envelope, and some sort of adhesive label for larger, print-sized envelopes that all have consistent design. All of these can be created on your computer pretty easily, but you might want to investigate having a designer do it professionally. After all, you expect your customers to use you, a professional, for their photographs so why wouldn't you want to use a professional designer for your design work? However, consider using a generally available typeface so you can make changes or additions to your stationary yourself at some future time. When planning this "identity package," don't be "Charlie" the photographer on your business cards and "Charles Percival Smith III" the photographer on your stationery and expect your customer to accept your prices without a negotiation. The whole idea is to give your business paperwork a consistent and

You sell portraits, right? So why not include a self-portrait on your business card? Not only will it help your business, but it may give potential clients the idea to use your services on their own cards.

professional look. In the advertising world, big corporations call this *branding* — making everything about you and your business consistent so it sticks in potential customers' minds. There is no reason why a tiny, fledgling photography business shouldn't use the same technique to give its business paperwork a consistent and professional look.

While any agreement between two parties listing each one's responsibilities to the other is a contract, it can be called many things. Whether you call it an agreement, an order form, or anything else is not important; what is important is that it protects you. Don't worry about it protecting your customer; while that may be a nice added feature, it's primarily your contract and it should cover your interests. That being said, here are some things to your contract should include:

1 What you are doing. What you are delivering. What you are being paid.
The reality of today's competition is such that there are photographers who will actually shoot a portrait session for nothing and depend on their print sales for their profit, but I refuse to do this because it reduces to nothing the skill and talent that are required. Note that something that costs nothing is worth nothing and is treated as such by your clients. But, I don't know the realities of the competition and the business expenses in your area. Instead of charging a sitting fee, some photographers will offer "portrait packages" that offer the customer a specific number of prints in specific sizes for a fee that is greater than the cost of the prints alone. This way your sitting fee is not delineated as a separate item, but instead is incorporated into the package.

Examples of portrait packages might be:

Package A:
One 8 x 10 portrait (or two 5 x 7 portraits),
plus six wallet-sized photographs
for $125.

Package B:
Two 8 x 10 portraits and two 5 x 7 portrait
(or five 5 x 7 portraits without the 8 x 10),
plus six wallet-sized photographs
for $250.

Package C:
One 11 x 14 portrait,
two 8 x 10 portraits,
two 5 x 7 portraits
(or one 11 x 14 portrait and six 5 x 7 portraits),
plus 6 wallets
for $450.

These examples aren't the only price and package configurations you should consider using. You'll have to take into account the demographics of the area in which you run your business and come up with plans that are best suited for you. But these examples can act as a guide for how to think about putting packages together. Regardless of how you choose to charge, make sure that it's clearly stated in writing up front in your contract. This will avoid many headaches based on miscommunication.

A quick note regarding pricing: If you're just starting in the business, you shouldn't rule out trading some photos with a gorgeous subject for a signed release form. However, realize that if you were to do this, it is because a signed release has value! You can use the pictures to promote your skills and business.

2 Create a payment schedule

This should include a retainer before or immediately after the assignment, deposits before print orders are made, and the final payment upon delivery. The retainer can be as little as $50 or as high as $200; the real goal here is not the amount of money but proof of the client's intent. Once the client has given you a retainer they now have something invested in the portrait session. Some families or companies might become regular, repeating clients and if that is the case you might develop a trusting relationship with them and decide to forgo the retainer fee altogether. I do this all the time and feel okay about it with clients I trust. Next up, when the client returns the proofs with their selections, a deposit that leaves only a final balance of $50 or $100 before you make final prints. The last point on the schedule is that you receive your final payment upon delivery of the photographs.

The reasoning behind breaking your payment schedule down into three parts is multifold, and, like posing and lighting a subject, it's partially a game of smoke and mirrors. First, it makes the payments more palatable for your customer. Although the total for the assignment might be large, the customer doesn't usually think of the total, but more along the lines of how much each individual payment costs. Second, if you get 75% of the print order up front, it's not all of your money on the line should the customer default. Lastly, I suggest that you work the figures so that the final payment is relatively small and you only accept cash for it. The last thing you want to do is chase after a customer for a $50 bounced check—it's not worth your time and effort!

3 Cover the rights you are selling

The minute you push your shutter release button you are creating "a work" that is covered by the U.S. copyright law. You do not have the right to sell an image of your subject, and technically, your subject doesn't have the right to use an image of yours without your permission. I say "technically" because, in truth, there's no way you can easily monitor whether or not a client will plop one of your prints on their scanner and run off a dozen copies on their inkjet printer. Regardless of some client's willingness to flaunt the law doesn't mean that you should consider doing the same. Instead, make it all legal. All of my contracts and agreements state that I have the right to use any photographs I take for self-promotion (which is purposefully a very broad term), and your contract/agreement should do likewise.

4 Your agreement should limit your liability

While you might think that a customer who is totally unhappy with a portrait you take would be satisfied if you were to return any and all fees you had already received, what happens if this is not the case? What happens if they were to claim you caused them emotional harm with the portrait you took? Although this may seem farfetched, it should be covered in your agreement. A simple statement that says the photographer's liability is limited to a refund of any monies collected will cover you in the unlikely event this happens. But, if it were to happen, make sure you ask for and get back any low-resolution proofs or low-resolution files you've delivered before you give back any refunds. This is also a good reason for not giving your client high-resolution files right after the shoot. You might feel inclined to include a high-resolution CD as part of your final package, but that is a big mistake because it will kill the print order. You might offer it as an incentive if the customer buys a huge amount of prints (over $1000, for example), but even then I would be careful of doing this in a portrait assignment situation.

5 Make it official

Your agreement form should be signed by both you and the customer. I find that this reinforces the collaborative effort that a great portrait requires and it makes your right to use the photos for self promotion (#3 above) legal and binding.

Although many clients want something "unique and different," they will usually want to be shown portraits similar to what they want before they'll hire you. Weird, huh? The customer says they want something that's never been done before but then asks to see pictures you've done before to prove you can do it! The mom wanting you to photograph her toddler wants to see pictures of other toddlers you've photographed while the CEO (or their agent) will want to see portraits of other executives before they'll give you the assignment. That's why I have put together several different portfolios over the years. I have portfolios of family portraits, executive portraits, Christian weddings, Jewish weddings, Bar and Bat Mitzvahs, Communions, product photographs, illustrative photographs, and special effect photographs to show to perspective clients. While I won't show my toddler portfolio or my special effects portfolio at an appointment where I'm seeking an executive portrait assignment, I will show similar portfolios that are germane to a particular assignment. Working in digital makes having access to a few portfolios easy and you should have a few of them on your laptop and desktop computers.

Though showing your portfolio on your laptop is convenient, even the largest laptop LCD doesn't have the impact of a larger screen and this is especially true if you're showing vertical images. While a small-sized image can do wonders to hide sloppy technique or a less than perfect subject, it does very little to convince your client that they absolutely must have a 30 x 40-inch (76.2 x 101.6 cm) family portrait on their living room wall and no matter what you charge for a 4 x 6 (10.1 x 15.2 cm) or an 8 x 10 (20.3 x 25.4 cm) print, there's more profit in a single huge print than a flock of little ones.

In the days of film I would visit prospective wedding clients with a case of sample books and watch my client flip through them page by page. Eventually, I converted the same sample images into 35mm slides and projected them on any old light colored wall in my customer's homes. The difference in their reaction was outstanding. The larger projections got "oohs" and "ahs" while the same images in smaller versions just got passed by. There is a lesson to be learned here: bigger images have more impact!

Since bigger images have more impact and selling bigger prints is more profitable, you might want to investigate ways to show and sell bigger prints. In the new age of digital imaging a digital projector used in conjunction with your laptop can open up new possibilities for showing and selling these bigger prints. As an example, one successful portrait studio I know of has a projection room. Their projection room has comfortable seating and low lighting.

They let their client choose a big, beautiful frame (hint, hint), hang it on a white wall and project their client's portraits into the frame. Take a guess what? This highly profitable portrait studio sells a lot of big prints and frames! And, as an added benefit, because of a digital projector and laptop's portability the same hardware used in your projection room can be used to project a set of wedding images on the wall of a client's home.

Although the techniques I'm describing here are not for all photographers, and especially not for young photographers starting out on a shoestring budget, they are mentioned to open your minds to the idea of selling bigger, more profitable photographs.

If you want to be a professional photographer, or a professional portraitist, learn what it costs to run your business and create your work, always treat every client as if they are the most important person in your life (in a way, they are), always look to improve yourself, your photography, and your business, and have the tenacity to never give up on your dream. I have to tell you, it's going to be really hard at first, *really, really hard,* but don't give up on your dream. Make a decision that you are in this for the long haul and stick to it. And, if at some future time, you decide that being a pro is not for you, don't get depressed. Always remember that photography is a great hobby and you can have great fun doing it as just that. Good luck, and good shooting!

© LEN DEPAS

the avatar studios shoot:
shooting a mob and satisfying the client

I thought it would be interesting to take you through an actual assignment step by step. I chose this particular assignment at a recording studio for many reasons; partially because it's hard to organize a 100 subject shoot, partially because I experienced a forehead slapping moment two days before the shoot, and partially because the client chose an image other than the one I expected him to use. But mostly, I chose this shoot because it's so different from the norm. After having read most or all of this book by this point, you'll see how, as I stated in the introduction, every part of an assignment is as important as any other, and all aspects of a shoot (and photography) are interconnected. To pull this shoot off successfully, I had to rely on just about every piece of experience I've relayed to you in the preceding chapters. Let me start off by explaining what the assignment was, then we'll get into the actual shoot (including my forehead slapping moment), and I'll end with the surprise.

Avatar Studios, a historically important recording studio in New York City, was celebrating its 30th anniversary and, in addition to a few hundred guests, the studios founders and the staff that built it were also invited. The studio owner hired a photographer to shoot the party. Imagine a night with a single flash on camera, shooting 2-ups and 3-ups with every subject holding a drink (sometimes one in *each* hand) and you'll get the idea of that photographer's night. The studio owner decided that a 100-subject group shot of the founders and staff that built the studio was a worthwhile addition for the studio's archives. Rightly so, he further decided that this was beyond the organizational, technical, and lighting skills of the photographer he hired. On a recommendation, he contracted me to take the group picture and six to eight photos of smaller groups.

Ten Days Before the Shoot

A little over a week prior to the shoot, I went to see the location and meet my client. Inside the building that houses Avatar Studios are many smaller, individual recording studios designed for specific recording purposes (a drum studio, vocal studios, etc.) but the crowning jewel of the entire place is Studio A. Studio A is shaped like the inside of a giant, hollow beehive covered in tongue and groove planking. It's about 75 feet (22.9 m) across the diameter of its base and attached alcoves and approximately 50 feet (15.2 m) high at its center. The alcoves jutting off its base are deep (as bad luck would have it) and their ceilings are low (as even worse luck would have it). The special sound qualities of Studio A are known to professional musicians worldwide and the studio's owner had decided that it would be the site of his group portrait. But the uniqueness of Studio A's architecture (the walls curve inward as they rise) makes it difficult to light and impossible to use a ladder to get a high enough vantage point to include the required number of subjects. The studio's owner was aware of the camera position problem even before I got there and pointed out a 24 to 30-inch (61–76.2 cm) square hole about 12 to 15 feet (3.7–4.6 m) up the beehive's side wall. I went upstairs to see the view from the other side of the hole and, although it was partially blocked by the ceiling of a mid-level room on the beehive's side, I could contort myself in such a way as to get the lens of my D-SLR to see into the beehive with my eye still behind it. OK, this was good; at least I had a difficult but workable camera position.

Back on the floor of the beehive I made some mental notes about lighting the group, the hive, and the alcoves and, thankfully, I remembered to try and soak in every detail so I looked straight up. There, in the middle of the hive, 45 feet (13.7 m) up, and suspended by two cables, was what looked like a 12 inch (30.4 cm) in diameter plywood ring festooned with recording mikes. Although I suspected the answer to my question, I asked the owner how the mikes were serviced. My face lit up when he said the plywood ring was lowered and raised on the cables. My next question was how much weight the cables could hold, because I wanted to put a battery powered flash on it that weighed a couple of pounds. I was told this wouldn't be a problem. I was excited, told him so, assured him that the photograph would be smashing, and not to worry but I had to go out of town on a location shoot in New England and would be in touch with him the day before the party. We both signed the contract I brought along, we exchanged the signed copies, he gave me my retainer check, and I was on the road to my New England shoot.

This is the Pocket Wizard adapter cord I needed to fire my camera and then have my flash units fire.

Two Days Before the Shoot

Just two days before the shoot, I was south of Boston humming along in my Honda, and thinking about the upcoming assignment when I had an epiphany. Picture me as a cartoon character with an electric light bulb going on over my head. Forget about clamping a flash unit to the plywood circle— *I was going to clamp a camera there instead!* Narrowly missing running under the rear end of an 18-wheeler as I slapped my forehead, I pulled into a service area and got out my cell phone. I called Mamiya America and spoke to a tech rep about getting my Pocket Wizards to fire my camera and then fire my flash units. This was possible but I would need a special adapter cord. I called Fotocare in New York City and found that he had the cord in stock so I bought one and arranged for it to be delivered to the recording studio.

I then called Lens and Repro Company in New York and arranged for the rental of a Nikon 14mm lens because the widest lens I regularly carry is a 17. I then called a friend and arranged to borrow his Nikon 17-55mm zoom lens for the shoot as a backup. I did this because my single group photo had now morphed into doing two versions of the picture, and I might need an identical lens for each version and I wouldn't be able to lower the microphone holder from the ceiling to retrieve my lens between setups. I say this because doing so would slow the change over between the two versions of the photograph to a crawl and I would probably

lose the groups attention while I did it. Almost finished, I called the recording studio and alerted them to the delivery being made and got the name of the person who would accept the adapter cord from the messenger Fotocare was sending. The last item on my list was to call back Fotocare and give them the name of my contact at Avatar. I pulled back into the flow of traffic on the Mass Pike both happy and excited.

The Day of the Assignment

The day of the assignment arrived and I was ready. All of my equipment concerns (including backups) were covered and I had a plan in place—piece of cake. My assistant and I lugged our equipment in and we set up three large umbrellas and one direct flash so that they circled the area in which my 100 subjects would be positioned. Two smaller battery powered flash units were used to light the alcoves that my camera lens would see when I shot from "the hole." The plywood donut was lowered, the mikes removed, and I mounted my camera on it. My idea of using a Bogen Super Clamp didn't work out as planned because it upset the center of gravity of the ring and pulled the camera's lens axis off plumb. This called for Plan B that I had already envisioned on my drive. I unhooked one side of my camera's neck strap and wove the free end of the strap around the ring before reattaching it to the camera. We then ripped gaffer tape into $1/2$-inch wide, long strips and used them to wrap around either side of the camera's prism, over the top, front, and bottom of the camera, and finally around the plywood ring. All the while we were careful to keep the camera's lens hanging straight down, being sure no buttons or levers on the camera were being pushed by the tape, and making sure that we had access to the camera's card slot. Thank God for gaffer's tape!

Although I planned to use a Bogen Super Clamp to mount my camera to the plywood ring, that didn't work out because the clamp pulled the camera off plumb so it wouldn't hang straight down. I ended up using lots of gaffer tape to secure the camera.

I then set the exposure (after confirming my guess with my light meter), set the zoom ring to its widest position, and secured it in position with another, smaller strip of tape. Finally, I changed the batteries in the Pocket Wizard mounted on the camera because having them die in the middle of the photograph would be a major calamity. The camera was hoisted into position and a couple of test exposures were made while we checked that all the lights were indeed firing and I noted the boundaries of the lens' field of view. We then lowered the camera, removed its card, put the card in the second camera, and made sure we had the shot, put a fresh card in the camera, made sure (again!) that everything was working, and hoisted it back into position. I then took the second camera, went up to the second floor and shot a few images of the second set-up to make sure it was ready too. Now, all I needed was the subjects—and their cooperation!

figure 1

figure 2

figure 3

figure 4

Here are four test photos from the shoot. In figure 1, I made sure the alcoves were lit. In figure 2, I made sure the backlighting on the group wouldn't be too strong and flare into my lens; figures 3 and 4 are from both camera positions I would be using.

Getting the 100 subjects together, many with drinks in their hands, was an assignment unto itself. Talk about herding cats! This took a bit of time but was finally accomplished when I personally invited each group of stragglers to join the group in Studio A. I climbed up onto a three-foot ladder and made a speech. In my best basso profundo voice I told everyone that we were going to try and pull off two different photographs and to make it work we all had to work together to ensure success. I asked everyone to look up and see my camera dangling overhead, told them they'd have to squish together to be included, and pointed out that, because I couldn't be up there looking through the camera it was up to them to make sure they were looking up. I fired off 10 exposures using a hand held Pocket Wizard transmitter and, between each exposure, as I waited for the camera to settle down, I congratulated and stroked my subjects. Often, acting like a cheerleader is part of a photographer's job. As soon as I felt I was starting to lose my subject's attention I started to applaud... loudly, telling them they were great and how their efforts would result in an unbelievable photograph.

Before the group started to fall apart, and with camera number one still dangling above, I told them that we were halfway done and I pointed to the square opening in the wall, telling them that I was going upstairs for the second shot. I made a joke about asking them not to all leave as I repositioned myself and took off for the upstairs vantage point with camera number two in hand.

This is the final result shot from the overhead camera. I consider it a real success and it has become a permanent addition to my most shown portfolio.

I say "took off" because, in fact, I ran up the stairs to my next position so as not to lose the group's attention. While the second shot placed a strain on my body, I was much more comfortable about it because I could see the photograph as it happened through my viewfinder. Ten exposures happened in quick succession and I ran back downstairs to once again thank my subjects and tell them to enjoy the rest of the party.

As we had set up the lighting for the large group, my assistant and I had made decisions about where to shoot and how to light the smaller groups so the changeover between shots happened in minutes and this last part of the assignment came off without a hitch. In fact, these last few images were very easy and almost anticlimactic.

I knew the shots were a success before I even looked at the LCD, but was very happy that 15 or 20 of the subjects came over to both thank and compliment me on how easy the whole process was. But that's the job—making it easy on the subjects regardless of the hoops you have to go through to get the image! I was even more gratified when a few pro photographers covering the event for the local media came over to compliment me on a job well done as my assistant broke us down.

Now it's time to reveal my end of the assignment surprise. While I loved the overhead shot, my client chose the one from the less radical viewpoint! I thought about this for a long time. In the end I realized that while my overhead shot was unique, and the group of subjects looked stunning, it didn't include any identifying characteristics of the other star of the show: Studio A! Upon reflection, I learned two things from this that are important for you to remember also. First off, the location your subjects are in can be as important as the subjects themselves. Secondly, it's always a good idea to do at least two versions of any involved, high-end portrait situation because you can never know for sure (or might miss entirely) what your client's real desires are.

This is the photograph my client chose. While I found the other image more exciting, it didn't satisfy my client's needs as well as this one did. It pays to get good coverage and shoot a variety of shots.

afterword

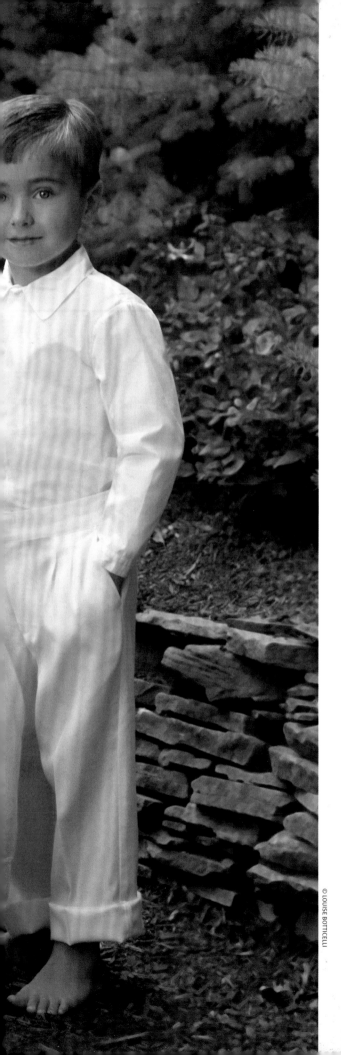

Some might think that after reading this book that all the bases have been covered and there is nothing more to know about portraiture. But you should always be learning; your skills as a portrait photographer are something that grow within you over time. It doesn't happen overnight; very few complicated but worthwhile things do. Instead, think of it as an evolutionary process, one where you will sometimes make massive leaps in your abilities when something clicks, times where you will stagnate and stay on a plateau until the next creative wave sweeps over you, and even times when you'll backslide as you develop and reinforce a bad habit. It's all part of the process; even when you're in a stagnant slump, just realizing you're in that stage of things is a good sign. To continue to improve means staying inspired. Inspiration is all around you: In other photographers' works; in paintings and sculptures at museums; in magazines, television, and films; influential images are everywhere. My suggestion is to become insanely overly critical of your own work. Analyze the photographs you take with a steely eye, always thinking of ways they would have been better if you had only changed this or that. Don't become negative or depressed by this process, rather, let it be a wake up call for you to see just how exciting your creative growth as a photographer can be. Creative growth is not always easy, not always fast; sometimes it's a fight, sometimes it's serene, sometimes it's joyful, and sometimes it's painful, but it is always for the good.

In the introduction to this book I told you to "imagine a well organized, immediately accessible card file of facts tucked into a crevice in your mind and you've got an idea of what's in my head. In this book I intend to open up my card file for you!" The card file has now been opened; it's time for you to get started!

manufacturers' contact

Alien Bees
AC powered flash
(800) 443-5542
www.alienbees.com

Aluminum Case Company
Pouches, cases, and carriers
(773) 247-4611
www.aluminumcase.thomasregister.com

Bogen Imaging Inc.
Battery powered flash, battery packs,
AC powered flash, exposure meters,
tripods, umbrellas, backgrounds, and more
(201) 818-9500
www.bogenimaging.us

Bowens
AC powered flash
(508) 862-9274
www.bowensusa.com

Broncolor/Sinar Bron Imaging
AC powered flash, exposure meters, umbrellas
(800) 456-0203
www.sinarbron.com

Canon USA, Inc.
Cameras, lenses, battery packs, and more
(800) OK-CANON
www.canonusa.com

Chimera Lighting
Light modifiers
(888) 444-1812
www.chimeralighting.com

Delsey
Pouches, cases, and carriers
(410) 796-5655
www.delseyusa.com

Denny Manufacturing
Backgrounds, umbrellas
(800) 844-5616
www.dennymfg.com

Dyna-Lite, Inc.
AC powered flash, umbrellas
(800) 722-6638
www.dynalite.com

Eastman Kodak Company
Cameras, accessories, and more
(800) 23-KODAK
www.kodak.com

F.J. Wescott Company
Backgrounds, umbrellas
(800) 866-1689
www.fjwestcott.com

FujiFilm USA, Inc.
Cameras, accessories, and more
(800) 800-3854
www.fujifilmusa.com

Hasselblad USA, Inc.
Cameras, lenses, accessories, and more
(800) 367-6434
www.hasselbladusa.com

Heliopan
Filters, filter systems, vignetters, and shades
(800) 735-4373
www.hpmarketingcorp.com

Hensel
Umbrellas
49 (0) 931 27881-17
www.hensel-studiotechnik.de

Hitech
Filters, filter systems, vignetters, and shades
(800) 628-2003
www.visualdepartures.com

Hoya
Filters, filter systems, vignetters, and shades
(800) 421-1141
www.thkphoto.com

Kart-A-Bag, Manufacturing Inc.
Pouches, cases, and carriers
(800) 423-9328
www.kart-a-bag.com

Lee Filters USA
Filters, filter systems, vignetters, and shades
(800) 576-5055
www.leefiltersusa.com

Leica Camera Inc.
Cameras, accessories, and more
(800) 222-0118
www.leicacamerausa.com

Lightware, Inc.
Pouches, cases, and carriers
(303) 744-0202
www.lightwareinc.com

Lindahl
Filters, filter systems, vignetters, shades,
and brackets
(800) 787-8078
www.normanlights.com

Lowel-Light Manufacturing
Tripods, light stands, and umbrellas
(800) 334-3426
www.lowel.com

Lowepro USA
Pouches, cases, and carriers
(707) 827-4000
www.lowepro.com

Lumedyne Inc.
Battery powered flash, battery packs
(800) 586-3396
www.lumedyne.com

LumiQuest
Light modifiers
(830) 438-4646
www.lumiquest.com

MAC Group
Medium format cameras, lenses, and accessories; AC powered flash, light modifiers, slaves, remote controllers, exposure meters, and more
(914) 347-3300
www.macgroupus.com

Newton Camera Brackets
Brackets
(888) 417-5370
www.newtoncamerabrackets.com

Nikon Inc.
Cameras, lenses, accessories, and more
(800) Nikon-UX
www.nikonusa.com

Norman
Battery powered flash, AC powered flash, and more
(800) 787-8078
www.normanlights.com

Novatron Electronic Lighting Systems
AC powered flash, exposure meters
(888) 468-9844
www.novatron.com

Off The Wall Productions, Ltd.
Backgrounds
(800) 792-5568
www.otwp.com

Olympus America, Inc.
Cameras, lenses, accessories, and more
(888) 553-4448
www.olympusamerica.com

OmegaSatter / Cokin
Exposure meters, filters, filter systems, vignetters, shades, slaves and remote controllers
(410) 374-3250
www.omegasatter.com
www.cokin.com

Optiflex
Filters, filter systems, vignetters, and shades
(800) 628-2003
www.visualdepartures.com

Paterson Photographic USA
Tripods, light stands, exposure meters, and umbrellas
+44 (0) 121-520-4830
www.patersonphotographic.com

Pelican Products, Inc.
Pouches, cases, and carriers
(800) 473-5422
www.pelican.com

Pentax Imaging Company
Cameras, lenses, accessories, and more
(800) 877-0155
www.pentaximaging.com

Perfected Photo Products
Pouches, cases, and carriers
(818) 885-1315

Photek USA
Umbrellas
(800) 648-8868
www.photekusa.com

Photoflex Products, Inc.
Backgrounds, umbrellas, light modifiers
(800) 486-2674
www.photoflex.com

Photogenic Professional Lighting
AC powered flash, umbrellas
(630) 830-2500
www.photogenicpro.com

Porter Case
Pouches, cases, and carriers
(800) 356-8348
www.portercase.com

Quantum Instruments Inc.
Battery powered flash, battery packs, slaves and remote controls
(631) 656-7400
www.qtm.com

RTS, Inc.
Tripods and light stands, light modifiers, slaves and remote controllers, and more
(631) 242-6801
www.rtsphoto.com

Schneider Optics
Filters, filter systems, vignetters, and shades
(800) 645-7239
www.schneideroptics.com

Set Shop
Photography supplies
(800) 422-7381
setshop.com

Singh-Ray Corporation
Filters, filter systems, vignetters, and shades
(800) 486-5501
www.singh-ray.com

Sony
Cameras, lenses, accessories, and more
(877) 865-SONY
www.sony.com

Speedotron Corporation
AC powered flash
(312) 421-4050
www.speedotron.com

Studio Dynamics Inc.
Backgrounds, props
(800) 595-4273
www.studiodynamics.com

Tamrac
Pouches, cases, and carriers
(800) 662-0717
www.tamrac.com

THK Photo
Filters, filter systems,
vignetters, shades,
tripods, and light stands
(800) 421-1141
www.thkphoto.com

Tiffen Company, LLC
Filters, filter systems,
vignetters, shades, brackets,
tripods, and light stands
(631) 273-2500
www.tiffen.com

ToCAD America Inc.
Tripods, light stands, cases,
and carriers
(973) 627-9600
www.tocad.com

Vivitar USA
Battery powered flash
(800) 592-9541
www.vivitar.com

White Lightning
AC powered flash
(800) 443-5542
www.white-lightning.com

Wing Enterprises
Ladders
(800) 453-1192
www.littlegiantladders.com

Won Background Mfg., Inc.
Backgrounds
+82 (031) 945-4900
www.artwon.co.kr

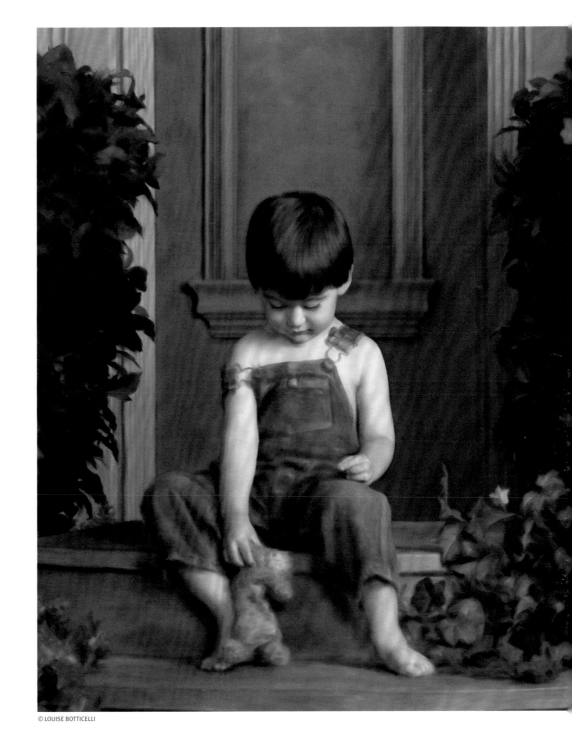

© LOUISE BOTTICELLI

index